The Smile at the Heart of Things

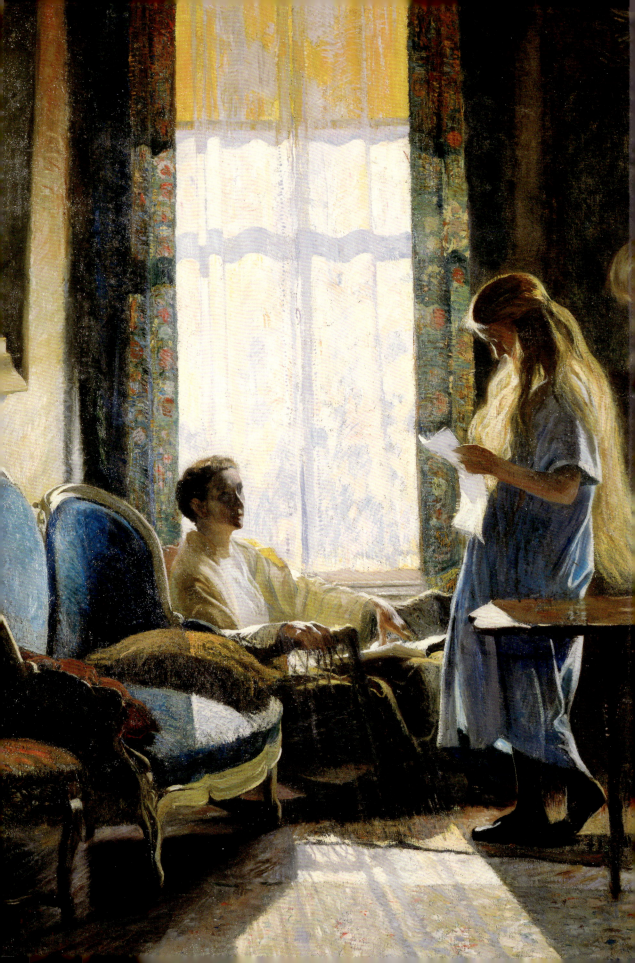

James A. Michener Art Museum
Bucks County, Pennsylvania

Tell Me Press
New Haven, Connecticut

The Smile at the Heart of Things

. Essays and Life Stories . . .

Brian H. Peterson

For Helen: painter, poet, teacher, lover, healer, friend, wife of my soul

Copublished by
James A. Michener Art Museum
138 S. Pine Street
Doylestown, PA 18901
www.michenermuseum.org

and

Tell Me Press
98 Mansfield Street
New Haven, CT 06511
www.tellmepress.com

First edition 2009

Library of Congress Cataloging-in-Publication Data
 Peterson, Brian H.
 The smile at the heart of things : essays and life stories /
 Brian H. Peterson.—1st ed.
 p. cm.
 ISBN 978-0-9816453-3-9
 1. Peterson, Brian H. 2. Art museum curators—United States—
 Biography. 3. Art, American—Pennsylvania—20th century.
 4. James A. Michener Art Museum. I. James A. Michener Art
 Museum. II. Title.
 N406.P48A3 2009
 709.2—dc22
 [B] 2009005594

Three essays in this book originally appeared in slightly different form in *American Arts Quarterly:*
"Randall Exon: A Quiet Light" (p. 77); "Frederick Evans and the Cathedrals of Light" (p. 85), and "The
Wise Silence of Daniel Garber" (p. 105). "The Smile at the Heart of Things: Emmet Gowin's Spiritual
Journey" (p. 113) originally appeared in *The Photo Review* under the title "Emmet Gowin and the
Poetics of Intimacy."

Carl Sandburg excerpts © 1963 by Carl Sandburg and renewed 1991 by Margaret Sandburg, Helga
Sandburg Crile, and Janet Sandburg, reprinted by permission of Houghton Mifflin Harcourt
Publishing Company.

Photo credits: Randl Bye, p. 39; Ricardo Barros, p. 98; Jeff Evans, p. 130

Frontispiece: Daniel Garber, *South Room, Green Street,* 1920 (detail; p. 107)

Dimensions of works are cited with height preceding width.

Editor: Paula Brisco
Designer: Jeff Wincapaw
Color management: iocolor, Seattle
Produced by Marquand Books, Inc., Seattle
 www.marquand.com
Printed and bound in China by Regent Publishing Services, Ltd.

Contents

Foreword 8
Prelude 11

NOURISHMENT 16
Thirty-five Steps
Helen's Journey
Thunderstorm in the Wilderness
All the Lovely Things
Climbing Mount Sparky
Strange Gifts
Saying Good-bye

HONESTY 68
Randall Exon: A Quiet Light
Frederick Evans and the Cathedrals of Light
The Upside-down World of Barry Snyder
The Secret World of Celia Reisman
The Wise Silence of Daniel Garber
The Smile at the Heart of Things: Emmet Gowin's Spiritual Journey

BEAUTY 129
Journal Excerpts, 1975–1982

DEPTH 163
Going Home
The End of Innocence; or, How I Learned to Stop Worrying and Love the Scalpel
The Day Bill Died
Talking with George
Michael and Me
Steve's Train Ride
Bumpa's Back

HUNGER 225

Postlude 241
Acknowledgments 244
Sources 245

FOREWORD

When I was in my mid-twenties, I became the supervisor of a large group of faculty and staff at a local college. We were a "happy shop," and I liked the warm atmosphere. My coworkers were interested in me and my concerns, and I could count on them for support at crucial moments. I had many friends among the faculty and believed that these friendships would continue for years.

It was only after I left my position that I learned an important lesson about the relationship between employees and the boss. While these folks were decent people who wanted to do the right thing in life, most of them, as it turned out, were not my friends. They were workplace colleagues. True friendship is much deeper than the formal associations we maintain on the job.

It probably comes down to survival skills that go back to the tribal hierarchies of our hunter-gatherer ancestors, or perhaps to the dominance relationships seen in dogs and in baboons. People who have power over us need to be humored, not antagonized. Employees who survive in the modern workplace quickly learn how to successfully manage the manager. It's perfectly understandable. I've had to put those skills into practice myself with my own supervisors over the years.

Having learned that lesson, I've become much more careful about using the word "friend" when I think about my professional colleagues. So it's especially significant to me when I speak of my friendship with Brian Peterson. Brian and I have worked together for more than twenty years, beginning with the Photography Sesquicentennial Project in the late 1980s (the Philadelphia area's celebration of the 150th anniversary of the birth of photography), through his early freelance years at the Michener, and on to the decade and a half that he has managed the museum's exhibition program. I have no doubt that when our partnership at the museum comes to an end, our friendship will continue.

Since we both began our professional lives as photographers, it made no sense for me to hire Brian as a curator in those fledgling days of the museum. It was bad enough to have one photographer running an art museum, much less two! But I came to see that Brian has skills and characteristics not often found in one person. He can speak with authority about medieval counterpoint

and twentieth-century social realist painting. Whether the subject is baseball or politics, you can be certain that Brian will know who's on first and who's likely to capture that open seat in the Senate.

Brian is an intellectual in the best sense of the word, but I believe that most who know him respond not to his brainpower but to his genuine decency and interest in the lives of others. Brian is a humble fellow who respects everyone he encounters no matter what their station in life. He always seems to have time to smell the flowers, and he never forgets that our world is a magical place filled with both joy and sorrow.

I know it has often been a struggle for Brian to keep his creative life alive despite the pressures of the job. But he has continued to share his experiences with many of us through his writing and his photographs, and we've enjoyed his reflections on art and artists, on museums, and on the ups and downs of life. In this book Brian is finally able to share his thoughts with a larger audience—though he was reluctant to begin this task because he was concerned about the appropriateness of a book with so much personal content being published by a museum where the author works.

Typical museum publications are often dry affairs, loaded down with footnotes that few people read and with essays in which the personal voice of the author is scrupulously avoided. As you will see, this is not a typical museum book, yet it's full of insight about museums, especially art museums and the mysterious process by which artists become artists and curators become curators. Brian is an artist-curator, or a curator-artist, and this book is his attempt to be honest about who he is—to unite two aspects of his life that he has kept apart for all the years I've known him. He is intensely aware of the ethical concerns that could accompany a book like this one, but fortunately he listened when I insisted that such a publication is not only appropriate but is an important expression of our museum's identity and convictions.

This project would not have been possible without the assistance of a person who shares our respect for Brian's character and creativity. At a particularly difficult moment in Brian's life, this person offered him a "birthday present" in the form of a gift that enabled the museum to release Brian from some of his daily responsibilities so he could undertake this publication. This was an act of uncommon generosity. While our donor has asked to remain anonymous, I must conclude by saying that we at the Michener are very grateful for his help, just as we are proud of what Brian has accomplished with this book. I am pleased to be able to share with you, the reader, my friend's insights about art and life.

Bruce Katsiff, Director and CEO
James A. Michener Art Museum

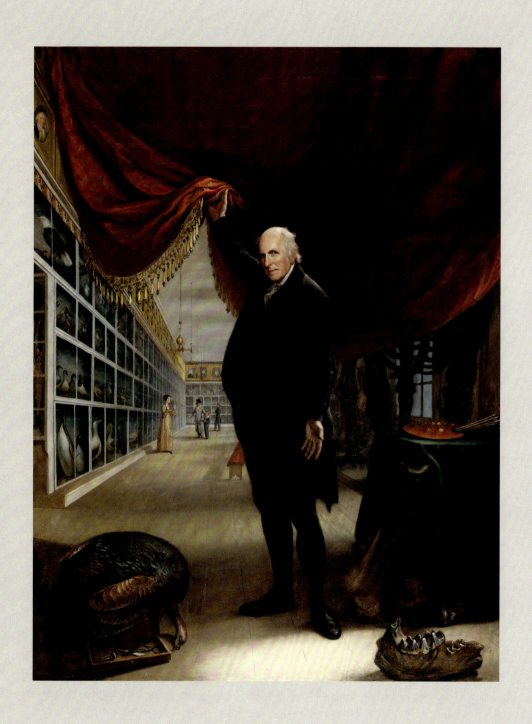

PRELUDE

For fifteen years I've led a double life. I'm not a serial killer, not a spy, not even one of those guys who has another wife in another city and buys her fur coats and fancy vacations while refusing to help with his son's college tuition. I actually knew someone whose father did that. The not-so-happy son was one of my students, and he gave me regular updates on his adventures, which included an unannounced visit to his father's other house in Chicago. When the mystery wife answered the door, the young man calmly introduced himself, talked his way in, snooped around a bit, and located a file cabinet full of financial records that included a receipt for a $23,000 mink coat.

My double life is nowhere near as juicy or sad. You won't be reading about it in the checkout line at the supermarket. For one thing, I'm not a movie star. But the main reason is, the story of my double life mostly happened in my own head. Even my closest friends never saw it unless I told them, which generally I didn't.

Helen knew, because she lived with it every day. Especially workdays. She often teased me about my "work tantrums." After a long day at the office, solving problems and putting out fires, I was like that big pressure cooker my mother used when she made beef stew and jam, with the little plug on top that bobbed and hissed when the steam built up inside.

When I got home from work, Helen would glance nervously at me as I walked in the door and say, "Hoo-boy, looks like a big one today." I guess she saw the steam and didn't want to be there when the lid blew off. For my own sanity, and hers, I would retreat to the den and watch TV for an hour or two, and when I emerged we could finally sit down for dinner and have a civilized conversation.

It's not that my job is so terrible. There are worse ways to make a living than being a museum curator, and I've done a few of them: telephone salesman,

. . .

Charles Willson Peale (1741–1827), *The Artist in His Museum*, 1822. Oil on canvas, 103¾ × 79⅞ inches. Courtesy of the Pennsylvania Academy of the Fine Arts, Philadelphia. Gift of Mrs. Sarah Harrison (The Joseph Harrison, Jr. Collection)

janitor, lawn mower jockey, darkroom flunky, and a pick-and-shovel guy for a swimming pool company. Even in the worst tantrum years, I often reminded myself that I was lucky to have an occupation that I believe in. "People would kill to have this job," I told myself.

How ironic it was to be working in an institution whose purpose is to inject art into people's lives, when the job made it incredibly difficult to bring art into my own life. Making art is what I've wanted to do since I was old enough to have a life, and in one way or another it will be what I want as long as I have any usable life left to live.

I've never forgotten what one of my music teachers said to me when I was a greenhorn teenager who stammered and mumbled my way through a composition lesson and could barely write a minuet much less a sonata or symphony: "Brian, you're a maker."

I was shocked that he saw this, and more shocked that he said it, because his teaching style was usually of the "tough love" variety, with an emphasis on *tough*. But I was not surprised. I knew he was right, though I had nothing but dreams and hero worship to keep me going then, and it took a long time and a whole lot of struggles before I could live up to his faith in me.

I started out as a musician, evolved into a photographer, and eventually became a writer as well. In the 1980s I began to organize art projects and did some freelance curating and gallery management (this was how I ended up working for a museum). Mainly I thought of myself as an artist-teacher. I taught photography at various universities in the Philadelphia area for twelve years and lived very happily with the expectation that art teachers must also be active artists. Then I became a curator, and the double life began.

There's a long tradition of artists working in museums, going all the way back to Charles Willson Peale, who founded the Pennsylvania Academy of the Fine Arts in 1805. In the twentieth century there were such notable personages as Edward Steichen, who became the Museum of Modern Art's photography curator in 1947, and Alfred Stieglitz—not an official museum curator, but arguably the twentieth century's most influential American decision maker in the visual arts.

Museums are so academicized nowadays that artist-curators and artist-directors are treated with some degree of suspicion because they haven't gone through the typical credentialing process. That was a minor annoyance. I had bigger problems: *energy,* as well as time and the nature of the work itself.

There was my creative mind, and there was my professional mind—one on stage at work, the other on stage at home. They were always at war with each other, or so it seemed. During the day I was intensely, even maniacally focused on doing my job with discipline and skill, while at the same time conserving

every drop of energy I could for that sacred hour or two when my own work happened.

Most nine-to-fivers look forward to a conversation with a friend at lunch. Not me. I often wondered what my museum colleagues were thinking as I walked by them, day after day, instead of sitting down, munching on a sandwich, and getting to know each other a little better. But I'd learned that if I had a lunch-time conversation instead of resting quietly in my car, then later, when I wanted to get something done at home, there was nothing good left in me. My brain, my body were drained dry.

There were times when the job got too stressful and I had to close the door to my workshop. Yes, stressful. It's hard to believe, but when you're in charge of putting up fifteen or twenty exhibits a year, life gets pretty complicated, especially when you throw in the budgets, capital campaigns, strategic plans, grant proposals, and all the other nuts-and-bolts chores that museums need middle managers to deal with.

Somehow I made it happen. I kept my two lives completely separate, writing and making photographs in solitude at home, while leading a very different existence at work, full of receptions, meetings, lectures, and an endless string of projects that loomed on the horizon, arrived in a cloud of dust, then receded and were soon forgotten.

This book was born out of a simple question. Why must the two halves of my life be so separate? Everything I do as a curator is shaped by my life as an artist: the teachers who guided me, the experiences that formed me, the values I learned along the way. Everything. And always lurking in the background is my unconventional spiritual life, the slow-moving aquifer that seeps into every leaf and branch of my creative and curatorial trees.

My museum career is probably winding down now, for reasons that will become clear toward the end of this book. I'm feeling a need to pull together all the parts and pieces of my life. I am not two people living two lives, but one person living one life.

A skeptical voice inside me says, "Gee, Brian, what a cliché!" Okay, give me the microphone—it's time to start crooning that old Sammy Davis Jr. song, "I've Gotta Be Me."

As corny as it sounds, Sammy and I are singing the same tune. This book is who I am—the whole thing. I can't be at war with myself any longer.

* * *

My geologist father taught me many things, including some very interesting words: "conglomerate," for example. Not the faceless multinational corporations,

but a rock made up of other kinds of rock that coalesced into one particular rock. That's what this book is: a conglomerate of words. Many of these words are personal, in the form of essays written during a ten-year period starting in the late 1990s, mostly in quiet periods at home. There are journal entries from a particularly turbulent and formative period of my life. There are also many words about art or, to be more precise, about artists.

The nucleus of the book is a group of essays that digs into the essential ingredients of a creative life: Nourishment, Honesty, Beauty, Depth, and Hunger. The overall structure could be called a "rondo," a baroque musical form in which the stuff you start out with keeps alternating with different stuff. The rondo form is defined as A-B-A-C-A-D-A (music theorists love to use big capital letters), except in this book the "A" stuff is different too: a set of variations on a theme that's only stated clearly at the end. So maybe what we're talking about here could be called Rondo Variation Form, subspecies Petersonia (theorists love those Latin-sounding words too), with the sweetest part saved for the last bite, like one of those Tootsie Roll Pops with the candy in the middle that I loved as a kid.

Mostly the book is made of stories—life stories. Not the entire story of someone's life, but a story *from* life that is also a glimpse *into* a life. Sometimes it's my life, sometimes a family member or friend, sometimes an artist who has crossed my path because of my job or my private passions, which have led me to countless artists of all shapes and persuasions. I've never been interested in writing about the movements and trends and styles, though I know they're important. I like to focus on artists themselves, the individual organisms, who they are and what they think about, and how that affects what they do.

The mystery of the individual soul: that subject keeps worming its way into these essays. What kind of worm is it—earthworm? Tapeworm perhaps? You can decide, since you're an individual, no doubt mysterious, because we *all* are.

Sometimes I think that's the greatest mystery—how differentiated we can be, how our personhood can be so discrete and specific—until I remember the mystery of how connected we are, how we're made the same way, think the same thoughts, and enter and leave this world with the same degree of confusion about what it all means.

If you don't have time to read the whole book, feel free to pick whatever chunks of the conglomerate appeal to you. I mentioned the essays on individual artists—if you prefer narrative, there are also two groups of essays that lean toward the informal, memoir style. If you enjoy a more intimate and haphazard record of daily experience, you'll find a healthy portion of that here as well. Or you could tackle the five essays with one-word titles—the "A" parts of the rondo structure. If you read them you'll get the gist of what I have to say, though the

sweet part at the end of the book won't taste quite as good because you didn't travel as far to get there.

I have to be honest. It's really all about me. What I see, what I care about. My creative life, how I got into it, how I failed and pulled myself together and set about the lovely task of living and dying. If this is an exercise in narcissism, so be it. Writing this book has helped me see myself more clearly, and maybe there's something nourishing for other people too in all these "life stories." I'll take that chance, if you will.

... Nourishment ...

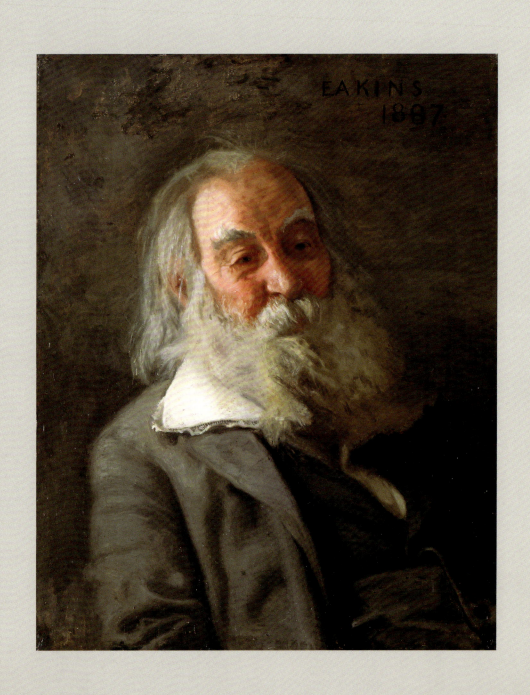

NOURISHMENT

I first learned about nourishment at a bus station in Portland, Oregon. I'm not talking about what the waitress served up at the lunch counter—*nourishing* wasn't the first word that came to mind when I bit into that sorry-looking sandwich. The best thing I found on the menu that day was Walt Whitman, and it happened in Portland because of a fog bank in Spokane.

I had been visiting my sister in San Francisco, and on the way back to Montana I was supposed to change planes at the Spokane airport. But fog had closed the place down. We circled for a while, until the pilot finally informed us that fuel was getting low and he was heading for Portland. It was bad enough that I had never been to Portland—I'd also never traveled by myself before, and it was the first trip I'd taken by plane.

My wallet was empty and I was flying standby, so there was no chance of getting out of Portland anytime soon, fog or no fog. In those days credit cards were for rich people, and the only place you'd find an ATM was in a sci-fi novel. I finally managed to cash in my ticket—after the nice lady behind the counter deducted an amount equivalent to the distance between San Francisco and Portland. I had just enough left for a bus ticket to Missoula and a sandwich or two to keep me alive while I got there. I called my parents, then pulled out a slim volume of Whitman poems to help me pass the time while I waited for the bus.

I don't know what was so special about that moment. I was a lonely eighteen-year-old in foreign territory, on my own for the first time, and that may have made me more receptive. Maybe I was just ready for it. But as I slowly turned the pages, I began to hear Whitman's voice. Not literally, of course. Yet his presence was so palpable that I almost felt that he *was* speaking to me.

I heard his bravado, his honesty, his ambition, his clumsiness, his physicality, his intense immersion in the particulars of life. I heard the crude joie de vivre of his language and the flashes of sublime elegance and beauty: "Out of the

. . .

Thomas Eakins (1844–1916), *Walt Whitman,* 1888. Oil on canvas, 30⅛ × 24¼ inches. Courtesy of the Pennsylvania Academy of the Fine Arts, Philadelphia. General Fund

cradle endlessly rocking . . ." I heard all these parts of Whitman, but there was more—a character to the words, a flavor—like a living organism made up of perverse and exquisite details that somehow coalesced into a self.

Before that day I had studied and written music, read novels and poetry, looked at paintings and made photographs. I was drawn to art. Art suited me. But it wasn't real. Art had been a form of teenage adulation—something that other people understood and other people did. Whitman happened to *me*. I read him not as a child, admiring from a distance, but as a man, an equal. I wasn't worried that his big "I" would absorb my small "I." *I absorbed him!* It was deeply exciting. I wanted more.

How does a salad, a steak, a cup of coffee, and a piece of apple pie turn into my ligaments, my limbs, my lymph glands? Into me? Me taking a walk, having a conversation, watching TV, writing an essay.

My digestive system knows how to convert food into fuel. My blood knows how to move the fuel where it's needed. My cells burn the fuel to do whatever it is that cells do. What do I contribute to this process? Not much. I work in the intake department. My job is to exercise some control over *when* I take stuff in, but mostly I make decisions about the *what*.

As I write this paragraph, I'm eating a salmon salad with peppers, onions, and some red and yellow tomatoes from my garden, smothered in ranch dressing, with a crouton in every third or fourth bite. I know this salad is a proper thing to eat. I've read all those articles about roughage, vitamin absorption, colon cancer, etc. But mainly, as I crunch those garlic-flavored croutons, my body says *mmmm*, yes, tastes good, give me more! I trust what my body tells me—up to a point. I know it will also tell me to eat nothing but ice cream and greasy potato chips.

The body's need for nourishment is a handy metaphor for people who are trying to talk about that other form of nourishment, the kind I got from Walt Whitman. Here's an example from a late poem of Carl Sandburg's called "Timesweep":

There are hungers
for a nameless bread
out of the dust
of the hard earth,
out of the blaze
of the calm sun.

In Louise Erdrich's novel *The Painted Drum,* a woman who has reached a dead end in her life reflects on the refined purposefulness of a spiderweb and asks, "What is beautiful that I make? What is elegant? What feeds the world?"

The granddaddy of nourishment metaphors is in the Sermon on the Mount in the Gospel of Matthew, part of what the Christian liturgy calls the Lord's Prayer: "Give us this day our daily bread."

It's obvious why the metaphor works. The body must have nourishment to sustain itself, to grow. If the poet, the novelist, and the saint are correct, that other, nonmaterial component of the human organism—call it the soul, the inner life, the psyche—also has its hungers and also needs nourishment to sustain itself and grow.

What is this "soul food," this bread? Sandburg says it's beyond the power of words to describe: "nameless bread." But in calling it nameless, he's hinting at one of its qualities. Above all it's mysterious—if we try to describe it, give it a name, something of its true nature is lost.

Matthew throws another hint our way: one bite is not enough. *Daily* bread. The desire for bread is deep and lasting. The hunger for bread needs to be satisfied regularly, even ritualistically. Eating it becomes a way of life. Without daily bread, we might settle for a different way of life—the one where we eat potato chips and Twinkies every day.

So "Give us this day our daily bread" is another way of saying "Keep us focused on what really matters" or "Help us see what's real." Bread like this probably needs to be chewed slowly so that the full flavor can emerge. It's not shallow, cheap, or transitory. It has substance, solidity, seriousness. It nourishes today, it nourishes tomorrow, it never stops nourishing.

For me, in the summer of 1971, newly graduated from high school, sitting on a hard, wooden bench in the Portland bus station, that bread was Walt Whitman. But Whitman was just the beginning. A few weeks later I happened to glance at a book of Rembrandt portraits in a bookstore. Despite the fact that my only source of income was my parents' lawn mower, I bought the book immediately and began to scrutinize those long-dead people who stared back at me with such infinite calm and solitude. I absorbed their faces, their gestures. And their eyes! Those Rembrandt eyes were like open doors—I saw vast empty spaces behind them, dark oceans, starlit skies.

Suddenly the composers began to open those doors too, composers I'd been listening to for years but had never heard: Bach, Beethoven, Brahms, Bartók, and a bunch of other letters. Then more painters and poets, and finally the novelists, one after another.

Looking at my dusty bookshelves now, I feel like an aging Don Juan eying mementos of his youthful conquests. The excitement of the chase—every book

another glorious roll in the hay—drinking it all in, until I was gorged, satiated. Then it was on to the next one: Lawrence, Hardy, Pound, Yeats, Williams, Blake, García Márquez, Sandburg, Tolkien, Le Guin, Erdrich, Hillerman.

I was hungry, and each of these artists tasted good, each one filled me up. But I wanted to taste many kinds of bread. Whether that bread helped form my limbs, my ligaments, or my lymph nodes didn't matter. I was being fed. I was growing. That was all I cared about.

I also learned that daily bread comes in many shapes and sizes. Art was nourishing because it connected me with the creative souls who made the art. But I began to see that people themselves are nourishing too—not just friends and family, but perfect strangers, people who wait tables, sweep floors, and stand behind cash registers all day. Whenever the *I am* meets the *you are*, this is daily bread.

Eventually I noticed that places can be nourishing too. Beautiful places that I might travel for hours or days to reach. Nondescript places that I walk by every day, when suddenly my eyes are open and I can see that astonishing weed in a vacant lot or the miraculous afternoon light falling on a street sign as I drive home from work.

Give us this day our daily bread. These words are saying, "Show us what matters, what's real." But they're also saying, "Help us to connect, with other people, with the universe." There is no nourishment without connection. And connection is always an exchange. I have something to say to you, and you have something to say to me.

I understand the value of introspection. There are great riches to be found by looking inside, and I've spent the better part of my adult life learning how to have a decent conversation with whomever or whatever is in there. But if all I do is talk to myself, with no input from the "not me," that isn't connection—at least not connection that comes under the heading of daily bread. How can I be nourished by what I see in the mirror? There's no exchange with a reflection, no meeting of minds, because there's only one mind present.

Nourishment happens when there's an encounter between separate and more or less equal entities. Being nourished by something, in other words, is not the same as consuming something. Consuming is one-sided. It's voracious. I take something in but get nothing back, because I have no authentic life of my own and thus no interest in the authenticity of anyone else's life. To use the food metaphor: I don't know what my own body really needs, so I only consume empty calories. I eat and eat but can't figure out why I'm never satisfied.

To connect means to join, to bridge the gap, to form one where there were two. But there must be two before there can be one. For me to connect with Whitman, I had to be "not Whitman." In some rudimentary, eighteen-year-old

way, I needed to have coalesced into a singularity. I needed to be *separate* from the world before I could be *in* the world.

Before I met Whitman, my eyes were closed. I mark that day as the moment when I began to see.

But wait—we're genus *Homo,* species *sapiens*—doesn't that mean we're gingerbread men that are baked in the same cookie mold? Our bodies have all the same parts. We all experience birth, death, and everything in between. All babies feel hunger and pain, all babies smile. Our common experience, our common humanity unite us across time and distance. Isn't that what really matters?

But it's also true that we're tall, short, skinny, plump, dark, light, green eyed, brown eyed, dimpled, smooth. We're outgoing, introverted, placid, aggressive, spontaneous, reflective, compliant, stubborn. We have all these traits, in varying degrees—but even more, we have a grain of uniqueness, a seed of self. There's something inside us that loves this seed, whispers to it, cajoles it, sends it dreams, and in every way seeks it out and asks it to grow. The more it grows, the more separate and singular it becomes, the greater its ability to both give nourishment and receive nourishment. To connect.

There is a deep vein of commonality to life, but only an individual can see that vein clearly and feel it fully. This is the paradox at the heart of our relations with the world.

A friend of mine—a gentle, cultured man who was deeply involved in the arts—once told me, with an intense, almost violent tone of voice, that he could have nothing but hatred in his heart for a religion that has at its core such a bizarre form of cannibalism. It was beyond ridiculous, beyond illogical that in eating the thin little wafer on Sunday, people believed they were swallowing some-one's body—the supposed "body of Christ."

I had to agree with him. Take the words literally, and the civilized mind recoils. But there's more to life than the logical and the literal.

In the lead-up to the communion ritual, the priest reads a passage from the Bible in which Christ says, "Take, eat, this is my body." Obviously the godly dude is not suggesting to his disciples that they actually slice him up and chow down!

Suppose what those words are really saying is, "Take, eat, this is my substance —this is the essence of me." Instead of literally eating someone's body, we're metaphorically eating a self-contained "unit" of substance. We're eating bread. The communion ceremony is a ritualized enactment of "Give us this day our daily bread." It's another way of saying we're hungry and a Twinkie is not enough.

Where does that bread come from? Who or what pulls the ingredients together, mixes them up, lets them rise, and bakes them into a dark, beautiful loaf, with its lovely, uneven crust full of crevices and contours, a crust that fights back when the bread knife passes through it?

Carl Sandburg says this bread is cooked up by the dust of the hard earth and the blaze of the calm sun. He's telling us that wherever daily bread comes from, it's elemental—made by the earth and the sun. The Bible, of course, says it comes from God. Each piece of bread is a piece of God.

Call it God, call it the sun and the earth, call it whatever you want. The name is not important. What's important is that we figure out what makes us hungry, then start to eat.

How strange that my first bite of true nourishment—my first communion wafer if you will—was that most earthy and unconventional of poets, Walt Whitman. It's a big leap from "Take, eat, this is my body" to "I sing the body electric," that lusty celebration of the human animal with a lengthy list of body parts and their poetic attributes, a poem that's still shocking today, more than a century and a half after it was written. I think Whitman would have liked the idea that his poems were a form of holy communion for a solitary, half-formed teenager just finding his way in the world. But there are plenty of people who would find that idea controversial, if not downright blasphemous. Thankfully there is no longer a Spanish Inquisition, or I'd soon be nothing but bones and a column of smoke!

Maybe it's not such a radical idea—that art and religion come from the same source and have many of the same goals. Both are in the business of providing nourishment. Both can teach us the difference between Wonder Bread and whole wheat. Both help us answer the questions that Erdrich's character asked, that many people ask when they look honestly at their lives, that I first asked in the Portland bus station: "What is beautiful that I make? What is elegant? What feeds the world?"

THIRTY-FIVE STEPS

Sometimes the drive to work is the best part of my day. I can still taste the earthy-sweet flavor of that huge bowl of cereal. My mind is clear and alert, my stomach is full—but I want more. I want to take something in. In one twenty-five-minute drive, I might listen to a country music station, the news on NPR, a sports talk show, famous hits from the sixties, and a snippet of a baroque violin concerto on the snooty classical station. Or I might get bored with the nonstop stimulation and tackle an unabridged novel.

I once spent almost three months following the sad and twisted adventures of Humbert Humbert, alternating his pursuit of the elusive nymphette Lolita with lyrical sermons about grace and forgiveness delivered on tape by Helen's favorite preacher. Strange as it may seem, Nabokov and Christ generally got along pretty well, though they both grew silent as we passed the latest crop of suburban mansions sprouting up in some long-abandoned grassy field. I wonder what Mr. N. and Mr. C. would have said to the person who named one of these places The Meadows.

You'd think I'd be used to it by now, but I still don't like the idea of "signing in." I know it's necessary for security reasons, and the security guys also need to keep track of who's in the building in case there's a fire. But I always feel like that poor slob in *1984* who's looking over his shoulder for Big Brother. After writing down the exact moment of my arrival opposite my name on the staff list, I say hello to the friendly lady at the front desk. Can she sense how my mood changes when I walk in the door—how my feet start to hit the ground with the grim regularity of a soldier marching to battle?

I've counted the steps to my office hundreds of times, but I still forget how many there are. Up thirteen, turn, up five more. Through the doorway, over to the mailboxes. Grab a few envelopes, memos, bills. Over to the next stairway, up twelve, turn, then up five more again. Thirty-five steps.

Turn on the computer and the desk lamp. Into the chair. Adjust the cushion for lower-back support. The gladiator has put on his armor. It's time to bang a few heads.

I open the calendar, check the list of things that didn't get done yesterday, and survey the piles on my desk. The daily triage begins. Which of the various

projects that belong to me are in such desperate condition that they will die without immediate attention?

Exhibit signage must be ready in two weeks, and no word yet from the designer. There's a phone call or two. Money has to be raised for an exhibition catalog. Thirty letters to well-heeled art lovers must go out by the end of the week, which means a half day at the computer, not to mention addressing and stuffing the envelopes. Six paintings stored in the vaults of six institutions need to be borrowed for a show next year: six phone calls followed by six letters. Contracts must be sent out. Transparencies must be FedExed. Copy must be proofread. E-mails must be answered. Meetings must be scheduled.

A friend and I once traded notes about the life of the museum curator, and we decided that our patron saint should be Sisyphus. Instead of pushing a rock up a hill every day, we balance budgets and write memos.

By midmorning, if I'm lucky, I'm able to close my calendar, take a deep breath, and head downstairs to grab some coffee. On my way back with cup in hand, one or two people commandeer me for impromptu meetings. As I settle into my chair again, I often remind myself that I'm very lucky to have this job, that it sure beats most of the other things I've done over the years to stay alive. Remembering this doesn't change the fact that it's not even lunchtime yet and the inside of my head feels like Mount St. Helens right before it blew up and leveled half of Oregon and Washington.

Fortunately my office has windows, three big ones in a row along one wall. I'm on the third floor, so I get a good view of what's going on outside, though I rarely notice. But I do remember what I saw one autumn afternoon as I sat at my desk. A storm that had blackened the sky all morning was just starting to break up. The dark clouds gradually lightened, and a warm glow slowly suffused the room. Finally the sun broke through, and the rectangular, window-shaped patches of light on the floor looked as if they were going to etch their way into the carpet like celestial hydrochloric acid.

I pushed back my chair and stared out the windows. The clear light of October poured down through the rolling clouds, and I saw the beauty of it all . . . the silent, fleeting, impossible, eternal beauty. A voice inside asked, "If you had to leave now, would you be ready?" I had no easy answer. Yes and no, I guess. Much work left to be done. But also, at that moment, content with where I have been and where I want to go.

The phone rang. I picked it up and reentered the fray. By the time I had trudged back down the thirty-five steps, signed out, said good-bye to my friend at the front desk, and climbed into my car to drive home, I had forgotten what I saw that afternoon. But later, just before going to sleep, I lay in bed, remembering.

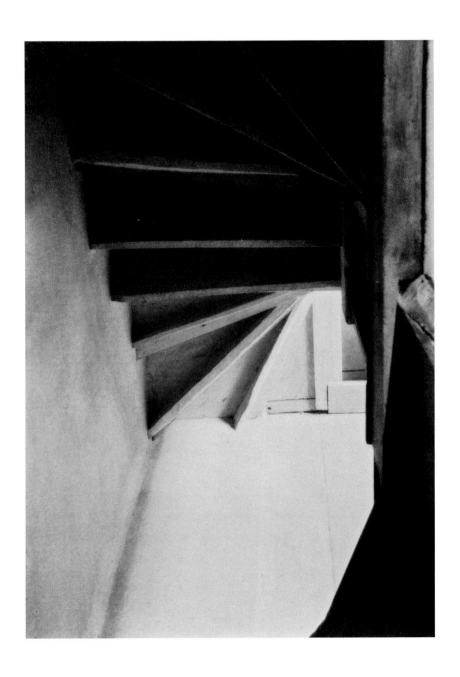

. . .

Charles Sheeler (1883–1965), *Doylestown House—Stairs from Below*, 1917. Gelatin silver print on paper, 8¼ × 5¹⁵⁄₁₆ inches. Metropolitan Museum of Art, Alfred Stieglitz Collection, 1933 (33.43.343). © The Lane Collection

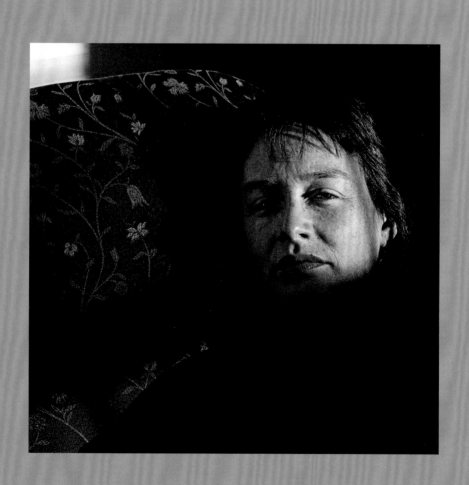

HELEN'S JOURNEY

I woke up with a jolt that morning. Why didn't the alarm go off? Oh Jesus—it's a quarter to eight. I sat up in bed and started to swing my legs over the side, a picture of the next forty-five minutes forming in my mind. Shower, get dressed, let the dog out, eat breakfast, pick up my shoulder bag, sprint out the door at eight-thirty.

Wait a minute, you idiot, it's Saturday.

I took a deep breath, exhaled, and fell back on my pillow. Even though it was late May, the night had been cool, so I pulled the covers up over my shoulders. I turned on my side to look at Helen, and the warm sheets slid smoothly over my bare feet. Gently, surreptitiously, I moved my right leg forward, tunneling through the little mountain of blankets she had gathered around her, until my foot finally touched the soft bottoms of her upturned toes.

Only her head and neck were visible. Her mouth was open, her skin was pale. She'd been sleeping all night but she still looked tired. I could see a neat row of one-inch strips of translucent surgical tape about halfway down her neck. Her skin was turning yellow, the first indication of the bruises to come. Underneath the tape a perfectly curved purple gash ran from one side of her neck to the other.

I counted back—let's see, it was four, no, five days earlier—we'd been sitting in the surgical prep room at seven in the morning. There was nothing else to do while we waited, so we tried to add up how many times we'd gone through this together in our ten years of marriage. We decided this was number six: two hernias for me; a breast lump, fibroids, and a thoracotomy for her. Tho-ra-*cot*-o-my—that strange five-syllable word, for us at least, consisted of cutting open Helen's back, prying apart a couple of ribs, then removing a piece of lung—a big piece if they found lung cancer, a small piece if they didn't. It was a small piece. Both the radiologist and the high-powered surgeon had told us it was almost certainly going to be cancer. Actually it was some weird fungus she'd inhaled, probably from bird shit. We avoided pigeons religiously after that.

. . .

BHP: *Helen Mirkil*, 2000

"You'd think we'd be used to this by now," Helen said with a rather weak smile. We weren't.

I wondered if you ever get used to the idea of having your body, or the body of someone you love, being opened up, exposed, wounded, sharp metal through muscle and flesh. When surgery becomes routine—that would be one way of knowing you're in trouble. I remembered a conversation I had right after the thoracotomy with a guy in the elevator at the hospital. "I haven't seen you before," he said.

"Well, my wife just had surgery," I replied, and gave him a few details as the door closed and the elevator started to move. He listened attentively, then asked, "Do you like this place?"

It had never occurred to me that you could actually *like* a cancer center. "Uh, sure, they seem to do a pretty good job."

"I think it's great," he exclaimed. "I've had all my surgeries here!"

This time it wasn't cancer the doctors were worried about, thankfully. It was one of Helen's parathyroid glands. I had become an armchair expert on the parathyroid, just as in the past I had been an authority on lung cancer, hernias, fibroids, and breast lumps. There are four parathyroids embedded in the larger thyroid gland, and they make a hormone that regulates calcium metabolism in the bones. Occasionally one of the parathyroids malfunctions, gets bigger, and sends out too much of the hormone. Then the bones don't absorb enough calcium, and you get osteoporosis. The solution is to cut the bad one out—then hopefully the other three will take up the slack.

Naturally we wondered if surgery was really necessary. The endocrine doctor gave us all sorts of up-to-date statistics and rationales, but what really got our attention was a story he told about a woman who refused the operation. Ten years later she got out of bed one morning, stepped onto the floor, and fell over with a broken hip. The surgeon who tried and failed to repair it described the lady's bones as "mush."

So there we were, in a different surgical prep room this time, but with the same cold fluorescent lights and nearly blank walls painted a sickly shade of institutional green. An aesthetically minded nurse had taped up a row of faded Renoir reproductions around the room, and we entertained ourselves with speculations about Renoir's ethereal women.

"I bet this one has a Ph.D. in economics," Helen said, while staring at a picture of a pale young woman in a frilly dress with an especially vapid look on her face.

"Yeah, well, that one's name is Doris and she moonlights as a waitress," I countered, pointing to an elegant middle-aged matron standing in a rose

garden at twilight. But I had to describe the painting to Helen. It was behind her bed, and she couldn't turn around because of the IV needle that a nurse was sticking into her hand.

The operation was going to take at least two or three hours, depending on how long it took them to find the surplus gland. I gave the surgeon my phone number, then drove home and fell asleep on the couch, the phone placed strategically by my ear. I was already awake by the time it rang, and I grabbed the handset so violently that I almost knocked the phone off the coffee table. Everything had gone well, the doctor told me. They had finally found the gland they were looking for, tucked up behind the thyroid, and snipped it out. But I could hear the nervousness in his voice.

"There's just one problem," he said, "the gland felt funny—a little hard." Then he uttered the dreaded c-word. "She's probably okay, but we won't know for sure until we get the pathology report in a couple days."

"So, I guess we'll have to sweat this one out," I said, expecting him to laugh the whole thing off.

"Yes," he replied.

I got to know the two attendants at the hospital parking lot pretty well. The morning guy was a bummed-out, long-haired dude wearing headphones who never looked at me. The other attendant was an elderly black man who always leaned forward and said hello when I drove up. Once I even heard him singing softly to himself, which cheered me up considerably.

It only took a day or so for Helen to learn the life stories of half the nurses on the floor. She worried about one nurse whose boyfriend had destroyed his own car with a crowbar because he was mad about something. Another nurse was a frustrated painter, so Helen told her where to find some good art classes. Helen's roommate was a lady named Christine, whose body was covered with bruises from a fall. Helen gave Christine a drawing of the view outside their window, a little landscape with a church steeple and trees, done quickly on a yellow legal pad. Before she left for the nursing home I asked Christine if I could see the drawing. She pulled it out of her tote bag with a huge smile.

Helen responds to a crisis by summoning up a fierce and fearless generosity. She probably got this from her father, who gracefully nursed both a wife and a girlfriend through terminal cancer. A week before he died, I heard him apologize to a nervous young nurse who had to poke him several times before she could find a vein in his arm.

Helen also can be grumpy when she's frightened and in pain. Who wouldn't be? And there are few things in life more scary and painful than surgery. After the anesthesia had worn off and her neck started to throb, she got irritated with

a nurse who had just disconnected the IV line, thus depriving Helen of her steady morphine injections. She explained, vigorously, that she was not ready to switch to pain pills. After the nurse left the room, Helen turned to me with tears in her eyes and said, "I'm just not the same as my dad."

Unlike my wife, I respond to a crisis by completely shutting down. My main goal is to get through it, survive. I'll pick up the pieces when it's over. Usually there are plenty of pieces to pick up. Helen told me later that when I came into her hospital room, my face was always pinched and frozen, and often I was unable to make eye contact. This explained why she kept asking me how I was doing, even though she was the one with the drainage tube coming out of her neck.

By her second day in the hospital she was feeling a little better. "I want to show you something," she said, and slowly led me down the elevator, through some long corridors, and into the chapel. It was a small, dimly lit room with a beautiful stained-glass picture of a tree in the front. A giant Bible on the altar was open to the Twenty-third Psalm, with a spotlight shining down on it. I glanced at the familiar text and felt a vague sense of comfort in the idea that there was a shepherd taking care of me and therefore I should fear no evil, even though at that moment I didn't believe a word of it.

We sat for a few minutes in one of the little pews, not saying much, holding hands. Before we left, Helen turned to me and said, "No matter what happens, I think we'll be okay."

We got the pathology report later that afternoon, and we *were* okay, although the surgeon still wanted to bring her in for a scan every six months just to make sure. I drove her home the next day, and the first thing she said when we walked through the door was, "Let's take a walk."

"Are you crazy? You just had surgery."

"I don't care, I feel fine."

So walk we did, on our usual route through the neighborhood. I managed to convince her to turn around after a few minutes. She had said what she needed to say to the universe. Helen was back.

But something had changed. She was more silent and reflective than she'd been before. Maybe the experience of surgery is different after you turn fifty. I asked her several times over the next few days how she was feeling about what she'd been through, and she just shrugged her shoulders and said, "I don't know."

Watching my wife wake up is one of the great pleasures of marriage for me, though it doesn't happen often because she's a morning person. Once the sun comes up, she can't go back to sleep. Her mind starts to churn as she thinks about all the pictures she wants to make, and all the stuff she wants to get done.

But that Saturday morning she was still worn out from the operation, so I got to see her as she stirred, stretched, yawned, opened her eyes, and finally rolled over in my direction. Her voice was warm and slow as she said, "I just woke up from an incredible journey."

"Really—where did you go?"

"I wanted to get to the church at my old boarding school. You were waiting for me there. But I had to go through this little town first, and I got lost. Only it didn't matter because I got to visit all these people, regular people like my friends from the Y, and I saw how beautiful they are, how much God is in their faces, and I went in their houses and saw all the wonderful things on their walls, and the light shining through their windows. Then I went outside and was in an ancient city in a canyon, and I saw these old walls, solid, that had been around for hundreds of years. There were so many beautiful things that I wouldn't have seen if I'd known where I was going!"

When one of us has a dream like that we usually lie in bed for a while and talk about it. We tried, but for some reason words seemed to spoil this one. We knew it had to do with what she'd experienced in the last week—the pain and uncertainty, but also something else—something new, that wouldn't have happened *without* the pain and uncertainty. We couldn't exactly figure it all out, and somehow it didn't matter. So we got up, took our showers, and headed downstairs for breakfast.

Helen rested most of the day but eventually began to feel fidgety. After dinner she couldn't decide what she wanted to do—spend the evening at home or go to her studio and paint. "This may sound strange," she said with a grin, "but I think I want to stay here with you."

So we did the dishes, and for the next hour or so we worked in the backyard. Helen grabbed the clippers and trimmed a few of the bushes. I dragged a bag of fertilizer out of the shed and fed the trees. We didn't say much—just a few words about how nice the light from the setting sun looked as it filtered through the leaves. Sometimes we worked near each other, sometimes we were on opposite sides of the yard. But we knew we were together.

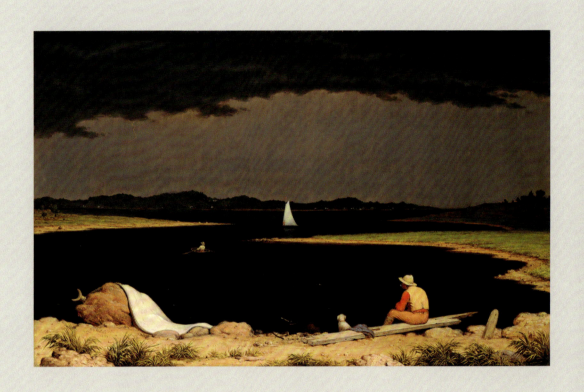

THUNDERSTORM IN THE WILDERNESS

I have no idea why I decided to stop. Maybe I enjoyed how the light was falling on the old stump, or the grass in the shady place might have looked especially thick. Maybe I was simply tired of walking. There was a barely visible path off the main path, so I wouldn't have to push my way through any bushes. All in all, it looked like a decent spot for a nest. I walked down to the rocky creek and planted myself in a sheltered area near several large cedar trees. I could see all the way down the valley, the stream flowing into the horizon.

I spread out my beat-up orange poncho and unpacked my backpack. Camera, light meter, film, tripod, books, journal, pen, water bottle, lunch, bug spray—soon all were scattered around randomly, but within easy reach.

For the next few hours this place was the center of the universe. As the mood struck me, I got up, made a few pictures, sat down again, read, wrote in my journal, slept, made a few more pictures. Patches of light and shadow slowly moved across the dusty ground. Giant wood ants crawled onto the poncho following an unknown scent, then crawled off. Flies buzzed here and there, sometimes landing on my blue jeans for a few seconds, then taking off again—just in time—as my hand struck with a loud thwack.

About halfway through the afternoon I started to hear thunder in the distance. I had to make a decision. The clouds were rolling up the valley, but I could still see a bright spot where the creek met the sky. So instead of retreating to the car, I decided to stay and ride out the storm. The first drops began to trickle through the trees overhead. I threw on my wrinkled yellow raincoat, pulled the poncho over my knees, and jammed all my stuff under this makeshift tent.

There was nothing to do then but wait. The smooth plastic in front of me gradually filled up with tiny raindrops, each landing with a sharp pop. Soon I could see a whole village of isolated droplets on my lap. Almost as if they

. . .

Martin Johnson Heade (1819–1904), *Approaching Thunder Storm,* 1859. Oil on canvas, 28 × 44 inches. Metropolitan Museum of Art. Gift of Erving Wolf Foundation and Mr. and Mrs. Erving Wolf, in memory of Diane R. Wolf, 1975 (1975.160)

sensed each other's presence, two of the villagers began to move. A stir, a wiggle—stop. A barely noticeable twitch, then—a steady, millimeter-long crawl—and the other drop came into view. Pause. They moved again, and suddenly the delicate, invisible skin shattered. Now—one, where there had been two.

This newly formed organism had some heft to it, and it inched forward with more conviction. It was not yet prepared to dribble. But creep—yes, a creep was well within its powers, and creep it did, occasionally absorbing a smaller neighbor on its slow march downward. Then a full stop, quivering, as if sniffing the air. Which way will gravity lead? But the hard surface resisted. The journey was over.

Another drop appeared—pop—then another, and another. Each drop added something to the collective effort. Now it flowed! Now it converged! Onward liquid soldiers! Move, move—find your way—come together!

A thousand specks of moisture, each an entity unto itself, needing each other for movement to begin. Soon they were joined in a miniature lake of merged souls, perched precariously on the brink of the known universe. With godlike calm, I reached under the plastic and strategically poked with my index finger, sending the little pool over the precipice into the rivulet that was starting to plow its way through the dirt beside me.

Who knows what happened after that? I suppose my little friends eventually ended up where all solitary droplets go, the ocean. But I no longer cared. The storm was over and I was hungry again. I packed up my things, took one last look at the dark surface of the stream, and said a silent good-bye as I made my way back to the trail.

ALL THE LOVELY THINGS

"You have to visit the market." When I told people I was going to Seattle, that's what I heard from almost everyone. I didn't plan on taking their advice. I knew I would be busy (it was work, not a vacation). Besides, who cares about an oversize strip mall filled with trinkets and tourist traps?

Downtown Seattle was like every other American metropolis I'd seen—row after row of buildings that look like upturned boxcars, with plenty of concrete parking garages, and jammed with smelly buses and cars that crept along at the speed of a geriatric pedestrian. After a day or two of being cooped up indoors looking at color proofs for a book, I was desperate for an adventure. So I changed my mind and walked down to the market one afternoon, figuring I could nab a T-shirt and maybe a pair of earrings for Helen.

I could tell right away that this place was no suburban mini-mall. It was more like crafts fair meets Kmart meets three-ring circus, with a few jugglers and fishmongers thrown in too. Imagine a narrow wooden building, two or three blocks long, packed with assorted booths and shops on three levels. Several adjoining streets and alleys were also lined with stores, and there were interior walkways filled with even more places to empty your wallet.

The nice folks who had built the market provided a big color-coded map near the entrance. After staring at it for several minutes I realized that someone had swiped the "You Are Here" arrow. The idea of a map didn't fit in with the spirit of this place anyway, so I decided not to worry about where I was going and just let my eyes guide my feet.

Fish. Hundreds of them, all in neat little piles. A squid, barely dead, laid out end to end on a white display table. Well, seafood makes sense in Seattle. But Mexican ceramics?

A row of leather belts, neatly folded over a four-foot dowel: a dozen rich shades of black and brown. A basket full of peaches next to a crate full of tomatoes next to a box full of potatoes: orange, red, then more brown. The label on the box says "Famous Idaho Spuds," with a picture of a happy farmer poking a big shovel into the ground.

Earrings, maybe fifty pairs, all the same style, but all different. Handmade blouses on hangers, dozens of them, each with its own delicate floral pattern. A whole shop full of glass sculpture: birds, flowers, abstract designs. A whole shop full of chocolates. Old coins. Postcards. Pastries. Posters. Roses. Cookies.

Your average Wal-Mart has a thousand times more stuff than this market. But here, the people who made the stuff, who bought the stuff, who know everything there is to know about the stuff—they're standing right in front of you, hoping you'll like what you see.

The fish guy: broad shouldered, with huge leathery hands, wearing a tattered white apron flecked with spots of blood and gray matter. He grabs a two-foot-long salmon, glances at the crowd of onlookers, tosses the fish to his friend by the scale, and shouts, "Weigh it up!"

The T-shirt guy: middle-aged with gray hair, a round face on a rounder body. "Time to go to the facility," he says to his neighbor, a woman selling flowers. She leans toward him and replies, "Okay, I'll keep an eye on things." I can see that they like each other. He spots me rummaging through the many piles of shirts, neatly arranged according to size. "Uh-oh, I may have a sale," he whispers conspiratorially to his friend and moves in my direction.

"Where are you from?" His voice is warm, his posture open.

"Philadelphia," I reply.

"I was there once—in the airport."

"Well, that's a start." We both smile.

I lift up a dark-colored shirt that says "Pike Place Market," decorated with a big fish in profile, presumably a pike. "Do you have this one in extra large?"

"Nope—but they're preshrunk."

"Okay, I'll take it."

"They're only five dollars. Sure you don't want two or three?"

I'm tempted, but I'm also hungry, so I hand him my five bucks and stroll over to the nearby lunch counter where I meet the sandwich lady: fifty-ish, plump, with ruddy cheeks, wearing the obligatory apron and hairnet. I watch her as she trades jokes with her regular customers while her left hand reaches over to a foot-high stack of bread, grabs a piece, and lays it down in front of her. At the same moment her right hand maneuvers a slab of roast beef onto the slice of bread, which has already been slathered with mayonnaise. Every movement is graceful, unconscious. She is the Zen master of the cutting board.

. . .

Louis Bosa (1905–1981), *Fish Market*, n.d. Oil on canvas, 30 × 40 inches. Collection of Lee and Barbara Maimon

"I'll have a BLT," I say when my turn comes. "What kind of bagels do you have?" Without bothering to glance at her inventory she replies, "Sesame, poppy, pumpernickel, plain."

"Do you have 'everything' bagels?"

"Not anymore."

She waits for this to register, notes my puzzled look, and says, "You're getting the last one." Our eyes meet, and we start to laugh at the same time.

A timer goes off nearby, a series of short, clear, bell-like sounds. Someone else's sandwich is ready in the toaster. "Your phone's ringing," I tell her.

"Must be for somebody else."

Meanwhile my sandwich grows beneath her busy hands. "Mayo? Pickle on the side? Toasted?" Yes. Yes. Yes.

After a couple hours of absorbing this busy, chaotic marketplace, my brain feels like a big shopping bag that's filled to the top with—what? With things. Every booth, every shop is both a question: "Do you need things?" And an answer: "We have things!" Things to eat, things to wear, things to look at. I'm worn out but exhilarated with all the looking and all the deciding. What does that thing feel like? What does this thing smell like? Will that other thing look good on my wife, and will the thing right next to it look good on my refrigerator?

When I pick something up, hold it, examine it, there's a question in the back of my mind: "I wonder why I like *this* thing, but not *that* thing?" Every object has its nature—hard, sweet, old, funny, green, smooth. I guess I have a "nature" too, and the trick is to match the nature of the thing with the nature of me. But there's a problem: the Wal-Marts of the world have given things a bad name. Who wants to buy a thing, or *be* a thing for that matter, if there are a million other things that are exactly the same?

Maybe that's why I like this market. It reminds me that I'm a thing too, and there's nothing wrong with being a thing. Fish or fowl, man or beast, animal, vegetable, mineral—we're all part of the endless creativity of the universe. Each of us has a nature, a name. Each of us has a tale to tell. That elderly tourist wearing a fishing hat, for example, who is walking slowly in front of me and blocking the sidewalk—he's a thing. So is the wobbly woman with a cane crossing the cobblestoned street, who grins at me and says, "Well, I'll get there." So are the teenagers on bicycles, with spiky blue hair and skintight black clothes, who weave through the crowd like Olympic skiers.

The two young mothers pushing their sleeping babies down the sidewalk, chattering rapid-fire while pausing to squeeze a few melons—they are things too, as are their babies, the melons, the strollers, the bricks in the sidewalk. The singer with the raspy voice is most certainly a thing, as are the songs she sings,

the guitar she plays, and the crude sign in her open guitar case that says, "Thank you for your kindness."

There was one thing I was especially glad I had that day: my sunglasses. Because while walking back to the hotel, to my surprise I found myself fighting back tears.

I don't know who or what God is, or sometimes even *if* God is. But at that moment I felt God in all the things of the world, all the created things: old and young, sacred and banal, wounded and whole, living and dead.

Don't ask me to explain this. Thinking back on the experience, I can remember what it felt like, but it no longer makes any sense. How could "God" be present in more or less equal amounts in everything? In the man with no legs who was sitting in a wheelchair by the bus stop and shaking a tin cup with a few quarters inside. In the woman next to him with long black hair who was wearing a red dress and shiny new tennis shoes and eating a tuna sandwich.

All I know is that right then, for a minute or two, both the disfigured young man and the shapely young woman were things, lovely things with names and faces, with stories that needed to be heard, and somehow, despite the young man's suffering and the young woman's indifference, they were both going to be okay, as was I. We were three random people whose lives intersected for a few seconds. We could not have been more different. But we were on the same journey, and we were beautiful. All three of us. Beautiful. My logical and ethical problems with this idea had melted away, and what remained was love. Love for everyone and everything.

It was the market that made me feel this way—that love is in the world, and the world is in love. Maybe that's all we need to know about this thing called God.

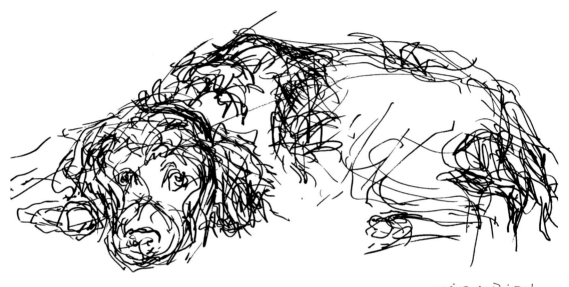

CLIMBING MOUNT SPARKY

1.

Helen's studio is in an old apartment on the second story of a barn, and she knows the names of all the horses who live there. Usually she takes along a few carrots to bribe the cranky ones. The gentle ones get a lusty scratch behind the ears. On some days they stick their noses over the fence by the barn door, and as Helen walks by she gives each of them a few quick strokes on the sides of their dark, massive heads.

Often we see a cat sleeping in the tack room, stretched out in his blanket-lined basket. But we had never seen a dog in the barn until that fateful Sunday afternoon when we were escorting a couple of friends inside to see Helen's paintings. Someone had tied a beagle to a long leash and left him there, by himself. He almost blocked our path as we walked past the stables to the studio door.

Most dogs would have reacted to being alone in a strange place by making every living thing within earshot miserable. But this little guy just sat there calmly, looking at us with bright, curious eyes. He was perfectly happy to let us rough up his fur and stroke his head, and he expressed his pleasure as only a dog can: the dreamy look, the barely audible grunts, the generous application of tongue to moving fingers.

This beagle had been tied up and abandoned in a poorly lit room full of foreign sounds and smells, but any place he found himself, it seemed, was a pretty good place to be. Which made us think that he was not a stray, that he had probably been part of someone's family since he first sprouted those deadly puppy teeth and his mother kicked him out of the nest.

The next day I came home from work and, as usual, collapsed on the couch in front of the tube. Soon the familiar reflection flashed across the window as Helen's car turned into the driveway, and I heard the telltale crunch as she set the emergency brake on her old Volvo. She strolled in, sat down across from me, looked me in the eye, and with an odd, determined smile on her face said, "I got us a dog today."

. . .

Helen Mirkil (b. 1952), *Sparks,* 2004. Ink on paper, 11 × 14 inches. Collection of the artist

My wife loves beagles about as much as she loves her two sons. She loves their clumsy, irregular gait, their lumpy, muscular bodies, and the silly way they flop their ears and stick their tongues out the sides of their mouths.

There's a cone-shaped wooden sculpture in our living room, maybe two-and-a-half feet high, that Helen made many years ago. The sculpture has contoured sides, a rounded top, and a tiny circular depression right in the middle—almost like an eye staring at the ceiling. I looked at this thing every day for years before I finally got around to telling her what a fascinating, semiabstract, obscurely symbolic objet d'art it is. She informed me coolly that what I thought was an eye is actually a mouth, and that all along I'd been looking at one of the dogs she used to own: a beagle who has just heard a far-off train whistle. His nose is pointed at the sky, and he's baying and barking the way only a beagle can.

No one had claimed the beagle at her studio, so both Helen and her landlord concluded that he needed a home. On impulse, without discussing it with me, my usually rational wife decided that *our* home was where he belonged. Fortunately, the dog's distraught owner claimed him the next day, so my life was spared—temporarily. But the seed had been planted. One way or another, my wife was going to bring a dog into our lives.

I knew I had no hope of winning that battle. But all I could think of was poop. Mountains of it. I saw myself walking around the neighborhood with a plastic bag in hand, day after day, staring hopefully at a dog's rear end. Second on the list, after poop, was hair. Everywhere—on clothes, the furniture, the carpet. After that came the smell: the faint odor of old piss that clings to every surface of a dog-infested house.

And how are you supposed to communicate with the brainless beast? There's not much in the way of common language, yet somehow you have to convince it not to pee inside or attack the mailman. If you don't give it enough attention, you pay the price in chewed-up wallpaper and shredded newspapers.

The dog wants to go out. It wants to come in. Out again. In again. Once outside, it must roll in every pile of turds it can find. And I, the so-called master, exist only to satisfy its every need.

I know what it's like to have a dog—we had two very nice ones when I was a kid—and lovable as they are, the cost-benefit ratio is heavily weighted in the cost direction. Or so I told myself. And told Helen every time she brought up the subject. Which was often. We own an illustrated encyclopedia of dog breeds, and the massive tome began to appear in strategic locations around the house, opened to a particularly enticing picture. She found ways of working the subject into almost every conversation.

Eventually an uncomfortable truth dawned on me. Something other than a coldly logical assessment was making me grumpy about getting a dog. What

better way to find out what was bugging me than to give in? Besides, I could see how badly Helen wanted one, and she had certainly put up with plenty of grief from me over the years. So we agreed to get a puppy. Her preference was for short-haired dogs, mine was for the long-haired variety, so we compromised on a Brittany spaniel, a breed with medium-length hair. We'd never even seen a Brittany—we just liked the picture in the dog book.

The preparations began: we bought numerous doggie toys, a crate, two beds, two collars (puppy and adult), three leashes of differing lengths and styles, and three kinds of food (canned, dry, and of course those tasty treats). We topped it all off with an invisible fence. Never in my life have I felt like such a Yuppie! Helen and I began to chatter endlessly about the details of training, feeding, and disciplining a puppy—even though we didn't have one yet. During these conversations I often found myself staring into space, my sentences trailing away half finished. The more we talked about adding a puppy to our "family," the more I was overwhelmed by the knowledge of what I hadn't done and will never do—and the consequences.

That whole tabula rasa, blank-slate thing has always struck me as the intellectual equivalent of a pile of fresh, steaming doggie doo. Like every human being, I came into this world not as an empty vessel but overflowing with possible lives I could have lived. I grew up in a family of scientists and easily could have been one myself, a pretty good one too. There are all kinds of other people I might have become. A composer. A piano player. A singer. A shrink, perhaps. A minister. Even a monk. I could have been a Ping-Pong player if I'd set my mind to it—I used to have the reflexes.

Sometimes I imagine the inside of my head as a nest full of baby birds with their mouths wide open. I have a limited supply of worms, which means that most of the babies will not survive. I choose two or three birds that are the biggest and strongest, and they're the ones that get fed day after day. Later, after the well-fed birds have grown up and learned to fly, I look at the nest again and see that it's full of starving babies, some almost wasted away, some a bit stronger, but every last one of them angry and looking for revenge. Their sharp little beaks and claws occasionally jab at me and dig into my skin.

The biggest hungry bird, with the sharpest beak and claws, is the part of me that wants to be a father.

I work near a library, and nearly every day I see a mom or a dad with a couple of bright-eyed kids who are carrying about ten books each because they couldn't decide what they really want. I go to church and observe all those cherubs in their choir robes, poking each other, fidgeting, whispering, grinning, while their parents look at them with a strange mixture of pride and dread. Or I see a father

kneel behind his son in the locker room at the Y, enfolding the boy in his arms while tying those tiny shoes, quietly answering some silly question or murmuring a gentle reprimand because the kid is squirming too much.

Probably a thousand times a year I'm with people who start to talk about their children or grandchildren. I usually just stand there quietly while my friends haul out their snapshots and discuss some shared experience, from the finer points of infantile bowel movements to the relative merits of Harvard versus Yale.

It doesn't take a genius to see that if a person like me decides not to have children—or lives his life in such a way that children inevitably don't happen—there probably will be consequences. The urge to be an artist took over my life when I was a teenager and has only gotten stronger. Almost every important decision I've made was meant to help me feed this hunger: schools, where I live, jobs, even the women I married, both of whom are as nutty as I am about being creative. Which made them much less likely to have my babies.

In my twenties I just assumed that someday I would have children. I had even picked out a few favorite names. I told myself that I wanted to experience life, all of it. Having a family is a big part of that, so how could there be any doubt that eventually I would become a father? But I continued to live my life as though I would not.

Now, in my late forties, when in many ways I'm living the creative life I dreamed of as a teenager, I look back at every one of those big decisions and know that I would make the same choices all over again. I'm doing what I'm cut out to do, and thus no regrets, right? But my wife and I decide to get a dog, and suddenly (to use a doggie metaphor) my nose is rubbed in the price I pay for those choices: a deep and lasting and inconsolable ache about what might have been.

I learned about the hot stove when I was a kid, and learned just as quickly to avoid emotional pain too. And why not? Isn't that the whole point of pain—to avoid it? But maybe running away from pain is a bad idea. Most pains of the soul are just hungry birds that need to be fed. The prospect of getting a puppy was stirring up something very painful. But the need to be a father is part of me, and its voice must be heard. Our new puppy was going to teach me to listen.

So Helen and I brought an eight-week-old dog into our home. We called him Sparky. Within hours we had fallen hopelessly in love with him. His every trait and habit became the subject of endless conversations. Even the poop wasn't so bad, though I let him lick my hands, not my face.

A few weeks after we got Sparky, I was standing in line at a bookstore buying Christmas presents. A young woman right behind me was struggling with

a cranky two-year-old boy. She had a big pile of books under one arm and was desperately trying to hold on to her son with the other arm. He proceeded to grab things on nearby shelves. When she pulled him away, he rolled around on the floor, yelling at the top of his lungs, his face a contorted mask of wild anger. The poor woman seemed nice enough, but she was in over her head. The rest of us looked on sympathetically. I wasn't in a hurry, so when my turn came I invited her to go ahead of me.

She looked at me like she had just seen God. Uttering profuse thank-yous, she lurched up to the counter, where buying her books became another comedy of errors. She had to let go of junior for a second while she signed the credit card slip, and he gleefully took off for the door. She grabbed her books, ran him down, nabbed the little felon, said another quick thank-you in my direction, and disappeared.

I was smiling quietly to myself as I walked up to the counter, and the cashier must have thought that dealing with angry little boys was nothing new to me. In a way, she was right. The first thing she said was, "Been there done that, eh?" I was surprised to hear myself reply, "Yeah, sort of."

2.

I should have known what we were in for when he attacked my shoelaces. But it seemed so lovable at the time. We had just driven two hours to the breeder's house and worked our way through her eighteen excited Brittany spaniels, finally arriving at the room near the kitchen where she kept the puppies. We watched them sniff and play and explore for a while, until one clumsy boy-dog ambled up to Helen, crawled into her lap, looked her right in the eyes and, in a minute or so, fell asleep. How could we resist? He was everything you would expect a puppy to be: all cuddly and sweet, with a round face, soft brown fur, and a tiny white patch on the end of his nose.

On the way out to the car he followed along behind me, nipping at my feet, eventually untying one of my shoes. "A feisty devil," I thought, and the image of a spark plug popped into my head. Different images entered Helen's mind, because he managed to puke on her three times in the car. I grabbed my camera when we finally got home and recorded the moment: Helen, standing in our backyard, looking a bit misty-eyed, holding the new baby in her arms. Our adorable canine spark plug had arrived—Sparky.

There wasn't a particular moment when we knew we were in trouble, just a gradually dawning awareness. A creature that was only seven or eight inches high couldn't do too much damage—to us, at least. Chair legs, wallpaper,

baseboards—these things quickly got moved, covered up, or destroyed. But our clumsy fur ball couldn't even climb the three steps to our back door, so how could those playful nips and growls ever be a problem?

It only took a few weeks for seven or eight inches to turn into a couple feet and for those cute baby teeth to grow into terrible needles of mayhem and destruction. The problem was not so much the weapons themselves, but the mind that operated them. I don't remember whether he first drew blood with Helen or me. But soon our pant legs were full of holes, and our arms and legs were covered with bruises and scabs. Any interaction with Sparky quickly broke down into open warfare.

We could barely get near him ourselves, much less invite anybody else over to our house to see him. Introducing the dog to our neighbors' children was a disaster; the look of terror in their eyes as he growled and snapped at their outstretched hands was obvious, and after that we kept him away from them at all costs. We had no choice but to lock him up in his doggie crate for a good part of the day, periodically letting him out for a couple hours of supervised play in our heavily barricaded kitchen or on a long chain in the backyard.

At first we tried to be Chamberlain to Sparky's Hitler—you know, appeasement. If we're kind to him, he'll see that we're not a threat, right? But the friendlier we were, the meaner he got. We bought books on dog behavior, and talked to almost everybody we knew about the problem. Some people said we didn't need to worry, that all puppies were crazy, and eventually he would grow out of it. Other people got a dark, ominous look in their eyes and said, "If they're violent when they're young, they will never really change."

One person told us we should lick the dog's treats before he eats them, so they have our smell on them as they go down. Helen actually tried this. We were desperate!

We talked to the friendly lady at the post office down the street who breeds dogs. Her solution? A baseball bat. She had a point. As anybody who's ever owned a dog knows, you have to show them you're the boss. We took the lady's advice when she offered a less drastic solution: tackle Sparky and hold him down by his throat, almost as if we were going to throttle him. The idea was to give him a nonlethal demonstration of absolute power. But when we were lucky enough to actually force him to the ground, he got such an intense look of fear in his eyes that it broke our hearts, so we just let him go.

Helen suffered terribly. She couldn't believe that he wasn't the cuddly ball of fluff she had held in her arms that first day. We considered the unthinkable: taking him back to the breeder. Maybe he'd be better off as a hunting dog, which is what he was bred to be.

We signed up for an obedience class as soon as he was old enough, and at first he was so distracted by the other dogs that he forgot about us. We told the trainer about our problems, but all he could offer were a few platitudes about "alpha dogs" and the "pack mind." Finally one evening Sparky did his usual routine with Helen—attacked her while she was trying to teach him to lie down on command. He drew blood from a nip on her arm. The trainer looked thoughtful and left the room for a minute. When he came back he had a Band-Aid and a muzzle.

Helen and I quickly became unashamed disciples of B. F. Skinner—the guy who put his daughter in a box and made pigeons perform ridiculous tricks by giving them electric shocks. As soon as Sparky got aggressive, on went the muzzle. He hated it, which is why it worked. By the end of the class he was voted Most Improved Dog by the parents of his classmates and was awarded a giant green octopus toy with squeakers in every tentacle. He loved that octopus— loved it to death. Within a couple weeks he had torn it to shreds, and for months afterward we found chewed-up pieces of green cloth all over the house.

I'm embarrassed to admit how much I enjoyed jamming that muzzle over snapping jaws when Sparky came after me. But it was the closest thing to

. . .

Helen Mirkil (b. 1952), *Couch Pup*, 2007. Ink on paper, 5½ × 8½ inches. Collection of the artist

revenge I would allow myself. This adorable puppy of ours would have happily torn me apart if he could. Once when he was attacking me, a weighty thought occurred: "Gee, our dog is not a Christian!" All those civilized traits that had been bred into me since before I could remember—love, mercy, forgiveness, respect for the other's point of view—well, our beloved little spark plug lived in a different universe. He was a vicious carnivore, or so it seemed: a descendant of wolves, a wild animal born to hunt and kill. He only understood one thing: either he was stronger than me, or I was stronger than him.

It turned out that the more optimistic dog-advisors were right. Sometime between his fourth and fifth months he calmed down, partly because he simply started to grow up, and partly because we worked on the aggression problem every day. Finally we were able to play with him without being bloodied and bruised. And the more I got to know him, the more I began to wonder if Sparky and I were really so different after all.

If you've never had a boy-puppy, then you may not know that the traditional wisdom about the importance of fire hydrants is incorrect. Early on, at least, the boys relieve themselves like girls, in the squat position. One day when Sparky was about four months old I took him for a walk in a local park. As usual he was sniffing every blade of grass and wrenching my back with his nonstop yanks on the leash. At one point he walked up to a tree, stopped, snuffled a bit, turned around, turned back around. Slowly—with quick, involuntary jerks—his right rear leg began to elevate, and he stared at me with eyebrows raised. His body was behaving strangely and he couldn't stop it! Soon a little pee dribbled out, missing its target completely. As we resumed our walk, his satisfied prance seemed to say, "Look out, world, Sparky is here." When we got home I announced to Helen, "Our boy became a man today!"

This leg-lifting fire-hydrant routine is the subject of endless jokes and *New Yorker* cartoons. But maybe we find this funny because it hits so close to home. Watching Sparky relieve himself on the tree, I had to admit that I'm also very territorial, and I also have ways of marking that territory. Not with my urine, fortunately. I do it with things. Helen and I have an ongoing, friendly battle about this. Often without noticing it, each of us claims certain areas of the house: part of a kitchen cabinet, perhaps, or an unused bed in the guest room. As days and weeks go by, more and more of our stuff accumulates in these places. Eventually we figured out what was going on and had a good laugh about it. We'd each been "peeing" on those spots, just like a dog.

Sparky's main territory is the kitchen. On workdays he's locked up there because he might wreck the house when we're not around. He always hears

me walking up the steps to the back porch at the end of the day, and when I finally put my key in the door he's scratching the glass frantically, peering out from between his paws, eyes opened wide in a manic, crazed look. When the door opens, he forces his way outside, twists his body into an S-curve, then vibrates so wildly that he looks like Chubby Checker on speed. His doggie butt twists back and forth violently, and he emits a desperate, high-pitched whine. The little stub of a tail wags so rapidly that it almost looks like a propeller, and I imagine him leaping into the air and flying away, eventually reaching escape velocity and going into orbit.

This is his way of saying, "I'm glad to see you."

He's not so friendly when someone else comes near his territory. Sparky runs to the edge of the property, hops back and forth like a psychotic cheerleader, and barks violently—at a jogger, or maybe the neighbor's cat. If the invader is another dog, sometimes those elaborate canine greeting rituals take over: they eye each other for a minute, sniff eagerly from nose to tail, run around, sniff some more, then go their separate ways.

It's easy to laugh at Sparky when he goes crazy over a jogger or is suspicious of a strange dog. But I behave the same way. I may not bark at a salesman who rings my doorbell, or sniff his rear end (that would be an interesting way to get rid of him). But I *will* look him over pretty carefully, observing the details of clothing and gesture, then engage in a ritualistic dance of greeting that includes cautious eye contact and casual conversation—all of which are designed to let us size each other up.

When Sparky growls at another dog who comes too near his yard, it's not that different from two office workers who write nasty memos back and forth because they threaten each other's turf, or two politicians who exchange angry words because one guy's submarines got a bit too close to the other guy's coastline.

While Sparky is an expert on defending his territory, he wouldn't last too long if he had to kill things for his dinner. Still, what goes on in the backyard is serious business for him. As soon as he's out the door, he sticks his nose about an inch above the ground and trots around slowly, making jerky, back-and-forth movements. It's obvious what he's thinking: "I can't see it yet, but I know something exciting was here!" Then he finds the scent and trots forward rapidly, occasionally bumping into a tree.

I once saw him stiffen just as he was standing up. His body had an awkward twist, but he stayed that way for at least ten minutes. He had spotted a rabbit over his shoulder.

Front foot forward, freeze. Back foot forward, freeze. Inch by inch, the predator stalked his prey. Meanwhile, the rabbit nibbled absentmindedly on a leaf.

Suddenly the angry wolf-dog sprang from the shadows, and the rabbit simply hopped once or twice to safety underneath a nearby bush.

Sparky and I both know what it's like to want something badly—to get the scent of it and pursue it with all our energy and skill. For me it might be an idea that turns into one of these essays. For him it's a rabbit. The experience probably feels basically the same for both of us.

When Sparky is indoors there are no varmints to pursue, but there are lots of perfectly fine stuffed animals and old bones, not to mention those more expensive toys that let out an enticing squeak when he chomps on them. If he sees one of these things and I'm anywhere nearby, pretty soon it's time for "Let's Play a Game." First he pounces on a tennis ball and chews on it furiously, thus claiming it as his own. But where's the sport in that? So the next step is to tempt me with the prize. He rushes up, sticks it in my face, and bites down hard a few times. Most of the time I can't resist. When I lunge at it, try to claim it as my own, the fun begins, as we wrestle each other with mock violence. Sometimes this devolves into the "Chase Game," as he races around the room with me in hot pursuit. When he gets tired of this, he will suddenly change the rules and run toward me, rushing through my legs, or he'll zip into the bathroom and peek around the door, daring me to come after him.

Sparky's doggie games seem simple-minded and frivolous to us big-brained humans, right? So let's talk about football. A bunch of guys pound each other senseless for three hours—but there are all these complex rules they have to follow. Despite the basic violence of the game, no one is supposed to get hurt. The main idea is to move the ball around, but to whom does it belong? Sometimes my team has it, sometimes the other team. You win the game by attacking the other guy's territory and defending your own. There's a hierarchy— an all-important leader (the quarterback) who tells everyone what to do, the grunts in the trenches (the linemen), and a bunch of players in between. But they all have to cooperate.

Sparky would do pretty well on a football field. Like us, he is violent. He loves to fight. But he knows how dangerous fighting can be, so he makes up rituals and games that allow him to vent his violent energy safely. Sometimes the squeaky toy is his and sometimes it's mine, and battling over who owns it can be a lot of fun. But it is a mock battle. He'll roll on the floor with me for hours without once biting me. He understands that I'm the boss, but we also have to work together to create an enjoyable game.

Sparky needs to have a boss. He wants to be part of a social order, a pack. It gives him a sense of structure. The truth is, people need to be part of a pack too, though we don't like to see ourselves that way. I observe this every day at my job. Because I work in an art museum, you might think we're all a bunch of

intellectuals who've evolved beyond this primitive hierarchy stuff. Nope—we're dogs. At the top of the heap is the most important dog, the director. There are several of us who are not top dogs, but still are pretty big dogs who often are allowed to tell others what to do. Then come lots of smaller dogs who do important things but rarely get to boss anybody around. Below them are one or two other layers: secretaries and various assistants, and finally all the dogs who do important stuff but don't get paid.

Unlike the top dog in Sparky's hypothetical pack, my boss doesn't require that I lie down on my back and expose myself every time he walks into the room so that he knows I'm no threat to his alpha credentials. But there are plenty of subtle signals that pass between us, such as it's okay for him to walk into my office without an appointment, but not vice versa. I do the same thing to the people who work for me. In fact, everybody knows exactly how this structure works, and we reinforce it in an infinite variety of ways. We even have a chain-of-command chart that lays the whole thing out on a single piece of paper!

Sparky would fit right in, not only in a museum's social structure but in the military and just about every other human organization. His biggest problem in *our* world would be his directness. He doesn't have a large enough brain to bring much guile to the playing field. And once he figures out where he stands in the scheme of things, he's happy. Not so with us. We're always dissatisfied and restless, and our ploys, feints, and manipulations are so devious that half the time we have no idea what's going on ourselves in social situations. Thankfully we have novelists like Kafka and Dostoyevsky to help us figure out the subtleties.

I don't want to ignore the many differences between dogs and people. I will never understand what it's like to communicate with whines and barks instead of words, or run around on four legs instead of two, or smell the world with Sparky's incredible nose. Yet I have a pretty good idea what it feels like to be a dog.

I need companionship and I need to play. Sparky does too. We both know what it's like to be curious, to explore, to be bored, to miss people when they're gone, to be glad at the start of a new day. We both become angry if we're denied the basic freedom to be who we are.

Both Sparky and I have tantrums when we've been ignored, or when we're forced to sit too long with nothing to do. I may not tear up all the magazines in my doctor's office and chew on the legs of his sofa—but wouldn't it be fun if I could?

It's almost as if I have a doggie brain folded into my people brain, with similar desires and similar programming. Sparky doesn't have those fancy

cognitive powers that come from our oversize frontal lobes. But that doesn't stop the two of us from sharing the raw pleasure of being alive. He often reminds me about the importance of the simple things—excitement, fear, attachment, pain—and he does it unfiltered by all that heavy thinking, which usually just gets in the way.

If I have this much in common with a dog, I wonder what I also have in common with a mollusk, or an amoeba, or a pine tree. I've spent a fair amount of time with pine trees, and no one could ever convince me that the seed isn't feeling something akin to excitement when it sends that little shoot into the air and senses light for the first time, or that the three-hundred-year-old Ponderosa doesn't know it's going to die.

We have a sand mound in our yard: a small hill about twenty feet across and three or four feet high, installed by the previous owner when the township decided the septic system wasn't working right. At first we thought we'd get rid of it because it's no longer functional, but after a while we got used to it and even began to like the way it breaks up the uniformity of the lawn. Our dog decided that the sand mound is his favorite place to be when he's outside, so we dubbed it Mount Sparky.

On a warm summer day, Sparky loves to climb his mountain and sit with head erect, hind legs folded underneath, and front paws stretched straight out in front of him. Often he chews absentmindedly on a stick or a ball. Occasionally a gentle breeze ruffles the fur behind his ears, and he sticks his nose in the air to see what delicious odors he can pick up. A crow flies overhead, squawking loudly. The dog glances up for a few seconds, watches the bird disappear over the top of the nearby trees, then looks down again, staring at the horizon. A squirrel scampers between a couple of trees in our neighbor's ancient orchard, but the little Buddha on the hill is unperturbed. I've seen him sit there for a half hour, an hour, even more—alert, but dreaming.

Sometimes I'm tempted to join him on his mountain, but I never do. Still, as I watch him, I can almost feel the warmth of the sun on my own back, and I remember what it's like to be *here*, in this beautiful place, with my eyes and ears open.

STRANGE GIFTS

Dave was a gravelly voiced chain smoker in his mid-sixties, a volunteer at the museum where I work. He would never have been mistaken for a diplomat. There was always a vague air of impatience in his voice, as if he knew he'd seen more of life than the rest of us. No doubt he had. He was a retired newspaper man, and I liked to imagine him as a world-weary reporter in an old movie, working a beat—say, the courthouse or the police station—interviewing cops, browbeating suspects, flirting with secretaries. When his day was done and his story was filed, he would head for the taproom where, with drink in hand and cigarette dangling from lower lip, he proceeded to entertain the barflies with stories about mobsters and ax murderers.

I never found out how he ended up at the museum. Maybe he liked the innocence of the art world after spending so many years writing about criminals and crooked politicians. Maybe he just wanted to feel useful again. Retirement didn't suit this guy. He was restless. He briefly tried his hand at organizing a small exhibition but didn't get much encouragement from us, and it never got off the ground. We were busy, and Dave wasn't an easy person to help. When the exhibit didn't work out, he became a guard. Once in a while I walked by him in the galleries and we managed a few pleasantries, but that was it.

I didn't notice when he started showing up less frequently, or when he stopped smoking. The truth is, I barely noticed him at all, until one day I strolled into our busy little temple of art and found out that he was dead. His obituary said he had known for some months that he had terminal cancer. He chose to keep it to himself, going about his business as if nothing unusual were happening. When the final illness set in, he went quickly. Later, reflecting on my conversations with Dave, I remembered a quiet intensity in his eyes, a certain loving wistfulness in his voice. He was saying good-bye, in his own way, and I had missed it.

I began to wonder what thoughts went through his head those last few months. What did he see that he hadn't seen before? Did he take special pleasure in putting his pants on in the morning, knowing that his days of wearing them were almost over? When he took a breath, did he expand his chest slowly, then relax and let the warm air rush out through his nostrils, just to remind

himself of what it's like to have lungs? When he walked into the museum, did he run his hand along the stair rail and enjoy the texture of the polished wood on his fingers? Did he listen to the musical rise and fall of voices in the galleries, and watch the school kids' faces as they gathered around a painting?

I wondered if he watched busy and important people like me walk by, thinking our busy and important thoughts, and said to himself, "It's so easy to miss what really matters."

When Helen and I were getting to know each other, I also got to know her neighbor Anne. Sometimes Anne and I had long conversations over the back fence, and I soon learned that her husband, John, had inoperable cancer in his spine. He had decided to spend his last days in their house, and as the disease progressed he became paralyzed from the waist down and completely bedridden. Anne took good care of him, but she needed to work. Sometimes John was alone. The thought of him over there by himself bothered me, so I visited him once in a while.

. . .

Susan S. Bank (b. 1938), *El Médico and Chengo*, from *Campo Adentro Series*, 2005. Toned gelatin silver print, 11 × 14 inches. Collection of the artist

His bed was on the second floor, and I always took a good look at the photographs in the stairwell, just to remind myself that the broken-down person I was about to spend an hour with was not the man he'd always been. I don't remember much of what we talked about. He reminisced about his experiences during the war; I told him what it was like to grow up in the West (he'd never been there). Mostly we said what people say who don't know each other very well and who don't have a lot in common.

The last time I saw him, I think he knew he was nearing the end. As I got up to leave, John suddenly reached out, grabbed the round metal bar over his head that was attached to his bed, raised himself up with one hand, and took hold of my arm with the other hand. His fingers felt cold on my bare skin, but his grip was fierce. He looked at me, waited until our eyes met, then said, "Thank you, Brian! Thank you for coming!"

I had never heard a man speak with such conviction. There was no distance between what he was feeling and the words that came out of his mouth. For days afterward I was filled with the experience, and when he died I said a few quiet thank-yous of my own.

Later, I wondered if John, like Dave, was more alive when he was dying than he'd ever been before. Death was a gift for both of them—a strange and terrible gift that woke them up and opened their eyes to the reality of the world they were leaving.

Though our paths crossed only briefly, their deaths were also a gift to me. Now I try to pay attention to what the water feels like on my bare flesh during my morning shower, and what the light looks like as it falls on the bathroom tiles. When I'm brushing my teeth at night and staring at my aging face in the mirror, sometimes I ask myself, "Well, how did I do today? Did I miss anything?"

SAYING GOOD-BYE

When I'm lying on my deathbed, I'm going to remember this place.

Maybe the little things will mean the most to me then. The green plastic watering can, on its side, barely visible in the tall, scraggly grass by the back door. The stone wall near the patio, covered with orange-colored lichens and puffs of black moss. The wrinkled old hat—the kind you can roll up and stick in your pocket—resting on a chair in the breakfast room.

Yes—the hat—how many times have I seen it on my father's head while we walked up a trail? How many silly grins on his face while he wore that hat, holding up a string of fish for the camera, or a saucepan full of just-picked huckleberries? Some men might wear an expensive cowboy hat, or one of those stylish straw hats with a colorful cloth band around the top. Dad's hat says to the world, "You'll never find anything fancy on *my* head."

I will probably remember the sound of the poplar trees behind the house—the low, rustling murmur of leaf on leaf, rising and falling in the afternoon breeze. And the spruce tree that was nine or ten feet tall when we moved in—now I have to tilt my neck way back to see the neat rows of cones at the top. The woodpile—the huge one that Dad made a few years ago after a late snowstorm knocked half the branches off his apricot trees—all the biggest logs were on the right, and there was a perfect, orderly progression down to the smallest twigs and sticks on the left.

Every year, on the first day of my annual visit, I have a nighttime ritual that I've never told anyone about. Before going to bed I walk out to the backyard, lie down in the grass, and look up. Usually the air is clear in August, and there are stars, thousands and thousands of stars, clean and bright against the cold black sky. In the city I can usually see a few dim dots at best, barely visible in the muggy haze. Here the stars are a blazing, silent roar in the heavens. I always forget how much I've missed them. Soon the mosquitoes locate me, and I rouse

. . .

Helen Mirkil (b. 1952), *Missoula Bird House*, 1994. Oil pastel and conté crayon, 11½ × 9 inches. Collection of the artist

myself and go inside. But before I do, I stand up, raise my arms, and spin around as fast as I can, the stars becoming a happy, whirling blur.

A house starts with a piece of earth—in this case, two small, rectangular lots along a busy street near the edge of town in Missoula, Montana. A house is a hole in the ground, a foundation, walls, a roof, maybe a lawn and a few trees. You also need a mailbox with a number on the side. But none of this stuff has anything to do with what gives a house its character, its "houseness."

At the far end of the backyard, a twelve-foot wooden pole sticks out of the ground between two poplar trees. On top of the pole is a homemade birdhouse, with a pointed red roof and twelve little holes (six on each side) leading to twelve coffee cans. The whole contraption dangles precariously from the pole at a 45-degree angle. Each year the angle is a little steeper, and the surfaces look a little more weathered. The swallows it was meant for have never used it. Even the sparrows prefer the tiny outhouse hanging from the tree by the clothesline.

I used to tease Dad about this crazy birdhouse: "Why the heck do you keep that beat-up old thing? I haven't seen a bird come near it in years!" He always gave me a sheepish grin, but the idea of taking the birdhouse down never entered his mind. Nowadays I can't imagine their place without it. Once when Dad and I were sitting on the back porch, he said, "Do you remember right after we moved in, how the two of us drove into the mountains and found the dead pine tree that we used for the birdhouse pole?" Actually I'd forgotten, but when he reminded me it all came back. Any day that I went to the woods with my dad was a good day.

If I hadn't grown up in my parents' house, I would never have learned that every possible problem can be solved with some combination of string, coffee cans, and tape. Take the apricot problem: a big tree with lots of ripe fruit growing near the top. It's inconceivable that a single precious apricot would not be harvested, and if one falls to the ground it might be bruised or nabbed by an evil squirrel. The solution? Nail a coffee can to the end of a long stick, then poke the can up into the tree. The dislodged fruit falls neatly inside. When the apricots won't budge, tie a piece of string to one side of the can, run the string through a groove on the other side, and grab the end with your free hand to keep it taut while you jiggle the can. Even the most stubborn apricots soon end up in the bucket beneath the tree.

If it's August and you need to find Dad, the first place to look is in the yard. I've seen him stand on the upper rungs of a ladder for hours, sweating and grunting while he jams that stick into the highest branches, twisting and turning his body like an octogenarian ballet dancer.

61

My father lives by a very simple philosophy: Why should I buy something that I can make? Why should I replace something that I can fix?

Dad hates deer almost as much as he hates squirrels, because the deer jump into the yard at night and destroy his garden. He solved this problem by running a piece of wire around the yard, a couple feet above the fence. But then the deer went after the tomatoes he always plants on the side of the house. He located the gap in his defenses and made a barrier out of some boards, a decorative wagon wheel, and an old lawn mower. Every time we wanted to walk around the house, we had to drag the lawn mower out of the way, then move it back. Finally he built a gate, with red-painted boards and a simple hook-and-eye latch. Soon the gate began to sag, and the hook no longer fit into the little round eye. Now there's a second eye, a few inches below the first one. If my parents still live in the house next year, I'll expect to see yet another eye, and all three will be lined up in a nice neat row.

The soul of a house is the *things*—inside and outside, significant and inconsequential, ordinary and strange—and the stories told by the things. But a house is also the gatherings, the rituals—the hellos and good-byes—all the beautiful and banal moments that add up to a feeling of history in a place.

. . .

BHP: *Missoula, Greenhouse Gate*, 2004

I call up my mother one Sunday afternoon, and I tell her I can barely hear her because of a strange, rhythmic hissing sound in the background. "Sorry for the noise," she says. "We're making applesauce."

"Oh, that's what I'm hearing!" I exclaim. "The little bobbing thing on the pressure cooker that lets the steam out." Then all the memories return: Mom and Dad in the kitchen, making jam, canning apricots, sorting and washing huckleberries. "I bet you're using apples from the trees out back," I tell her.

"Yup," she replies.

I don't need to be there to know what's going on, because I've seen them do this so many times. There are giant heaps of green apples everywhere—in pots on the counter, in bags on the floor, even piled up in the dish drainer. Dad is cutting and peeling, filling an endless stream of plastic bags with mushy apple cores destined for the compost pit. Mom is cooking the apples, grinding them into a thick paste, adding spices and not too much sugar, pouring the mixture into mason jars, and finally sealing the jars in huge pots of boiling water. Both of them know exactly what to do and when to do it, without saying much to each other except an occasional "Here's a few more" or "We're almost out of cinnamon."

In some houses people gather in the living room, in others the family room in front of the TV. In my parents' house, the place where most conversations happen is the back porch. Every summer, on days that aren't too hot, we eat both lunch and dinner there, in a spot that's sheltered from the sun by a massive wall of honeysuckle vines. We clear off the table completely after every meal, which means that the next time we have to start the ritual from the beginning. Round cloth goes on round table; chairs are arranged according to how many people are eating; salt, pepper, and napkins are brought out from the breakfast room. Food is carried from the kitchen in stages, and if someone forgets to close the screen door, Dad quickly jumps up and slides it shut. "Gotta keep the flies out."

Sometimes a pair of robins is raising a few babies in the old nest in the honeysuckle. We always stop talking when one of the birds flies up with a worm in its mouth. Most of the time the conversation is routine: people we know, places we went. For better or worse, my family is not the sort that conducts seminars or therapy sessions at the dinner table. But in the last few years, knowing that my parents are aging, I've sometimes tried to shift the flow of words toward the old days.

"You know, Dad, I just don't remember your father too well. I think I was, what—five years old the last time I saw him?"

A question like that usually gets the ball rolling. "Yeah, I guess it would have been the time when we went to California, maybe '58 or '59," he replies. "I still

remember what he said to me right before he died. He had colon cancer, and they operated on him, took out half his guts. I went to see him in the hospital, and he said, 'Jim, look what they did to me.' Then he pulled back the blanket and showed me the bottle they'd attached to his side. Hey, there's the robin."

Sure enough, the mother bird has shown up, and the babies squirm and chatter as they fight each other for their meal.

"Anyway, Granddad"—that's what we called his father—"after they lost the farm in the Depression and he and Mom split up, he worked the rest of his life in factories. Never had any money. Did anything just to survive. By the time he got old he was deaf—we had to pass him notes because he couldn't hear a thing. Well, when he finally stopped working he started going to libraries all the time. He read everything he could get his hands on. He was excited about it. One day he was telling me about a book he was reading, and he turned to me and said, 'I feel cheated.'"

I already know most of this, but I don't mind hearing the story again. It reminds me of how hard it was for *my* father to get his education—how he had put himself through college while working full-time as a butcher. It wasn't any easier for my mother. Her mother wanted Mom to learn how to type, so she went to business school and helped support the family by doing secretarial jobs. Finally she did go to college, where she promptly met Dad, got married during the war, and eventually had three kids. But she still went back to school and finished her degree. She wanted to work, which was not a popular thing for a woman to do in the fifties. Mom used to quote the old Betty Crocker advertising slogan with a dark, angry look on her face: "Nothin' says lovin' like something from the oven."

After a while Dad winds down, and it's her turn. I decide to take a stab at a more touchy subject.

"What was it like when your mother got depressed?" I ask her.

"Well, she mostly just sat around the house and cried."

"Any idea what caused it?"

"She had a miscarriage once—twins—but actually that was a little later. I guess we never really knew. My father, though—he was great. Always kind to her. Must have been tough for him, because it was the Depression and he was losing his business. He and his dad had three or four butcher shops there on the north side of Chicago. I remember one time my mother was sitting on a bed at home, weeping, and she called me over and said, 'Gladys, what's wrong with me?' I said to her, 'You don't smile enough.' I was thirteen years old."

"Your mom always seemed pretty happy when I knew her—how did she pull herself out of it?"

"She got a job. For some reason that's what she needed."

One important detail in the story is new to me. "Twins—I haven't heard anything about that before."

"It wasn't talked about much. I didn't even know she was pregnant."

"How did you find out?"

"Well, one day Mom and I were going somewhere in a streetcar. She wasn't looking too good. Suddenly she said, 'We have to get off.' She ran into a store, called a cab, and I spent the night at her sister's house. All I knew was that she went to the hospital. The next day my aunt told me, 'Your mom had twins last night, but they died.'"

Year after year of living in a house—gradually it fills up with things, until eventually every square inch of the place says something about the people who live there.

At some point during every visit, I like to sneak into Dad's basement office when he's not around. I stand in the middle of the room and take the whole thing in—this glorious mess, full of filing cabinets, bookshelves, bulletin boards, and paper. Mountains of paper. Maps, letters, and journals are strewn all over his desk, piled in heaps on his worktable. We actually used to play Ping-Pong on that table, but for many years it's been the nerve center of his professional life.

With most men Dad's age, you would use the past tense when speaking about their careers. This room still looks lived in, though I know he's more or less retired now. Dad is a geologist, and much of what geologists do is make maps—or at least they did before computers took over. So the Ping-Pong table is covered with boxes of colored pencils, rulers of various sizes, and a T square or two, as well as a flexible lamp with a big round magnifying glass built in. The walls are filled with pictures: a poster of the Grand Canyon, a huge image of the earth from outer space, and a long vertical sign that illustrates all the geological eras (with the words "The Tower of Time" at the top).

Hanging over Dad's desk—among the calendars, memos, and aerial views of geological formations—is a large black-and-white photograph that I gave him many years ago. The two of us are sitting on a rock in a canyon in Utah, looking directly at the camera, our bodies tilted slightly toward each other. What he doesn't know, because it's never occurred to me to tell him, is that I have the same picture pinned to a bulletin board above my desk.

Mom has always been uneasy about Dad's office, and all you have to do is look at the rest of the house to see why. The laundry room, where she spends quite a bit of time, has a shelf over the washer and dryer. Every box and bottle has its place: bleach here, detergent there, fabric softener over there. The kitchen is the same way. A line of large copper-colored jars sits on the counter

by the stove, with the largest jar (cookies) on the left and the smallest jar (tea) on the right. Most surfaces are bare except when bags full of food are being unloaded or meals are being fixed. The magnets on the side of the refrigerator are laid out in rows.

Mom is a retired schoolteacher, and her office still has the feel of a class-room, with brightly colored organizers, stacks of magazines arranged by sub-ject, and wire baskets with little piles of paper inside. I half expect to see lesson plans and grade books on her desk, but nowadays it's stuff from the AARP or the retired-teachers association.

Even if I didn't know my parents so well, all it would take is a quick glance around their home and I would have to ask: How have these two people man-aged to stay married for almost sixty years and live together in this house for nearly forty? The answer is, sometimes not so well. Usually their fights are minor squabbles, as when they disagreed about where in southern Colorado Dad won a prize for one of his paintings (he was also a serious amateur painter in the early sixties).

"I'm pretty sure it was Ouray," says Mom.

"Well, I don't think so, it was Telluride," says Dad.

"No, it was Ouray."

"Huh-uh. Telluride."

"Ouray!"

"Telluride!"

Everyone else at the table freezes, forks in midair, while the two of them glare at each other. "There's the robin again," someone says, and the tension is broken.

Once in a while when I was growing up their arguments got more serious. The worst fights happened when I was in high school, after my brother and sister had gone to college. Mom and Dad didn't speak to each other for a week after one particularly nasty shouting match, which ended with Mom hurling an insult and Dad picking up a table and dumping the remains of dinner on the floor.

It would be easy to be judgmental about such things. But I've since found out myself what it's like when a husband and wife get angry with each other. It happens. People survive—usually. Marriages often don't survive, of course. My parents' marriage did—not because they're better at it than anyone else, but simply because the glue that holds them together is stronger than the anger that drives them apart.

Where that glue comes from is a mystery. Generally it's invisible. But I've learned to sense its presence in the mundane back-and-forth of two people living out their lives under the same roof.

They're reading the paper over their bowls of oatmeal in the morning, and Mom says, "Hey, look at this headline: 'Pit Bull Bites Suspected Burglar's Backside.'" Dad looks up, grins, and says, "I guess he got what he deserved."

That's a spot of invisible glue.

Or they've both been sick, and as they pass each other in the kitchen Dad brushes her arm and says, "How's that bug treating you?" "Oh, okay," she replies. "Still a bit stuffed up." Another spot of glue.

I'm not sure I've ever heard my parents say "I love you" to each other. Or to their children, for that matter. This used to bother me, especially when I got married and learned how much the "l-word" is used in other families. But I finally figured out that for my family the word itself is redundant. There's so much love gluing us together that talking about it just breaks up the flow. So we find other ways of telling each other how we feel.

As Dad and I are pulling into their driveway after a day in the mountains, he turns to me and says, "Thanks for the trip." He makes a point of looking me right in the eyes, and when he says those four ordinary words I feel a warmth, a brightness in the air that I can almost touch.

An envelope arrives in my mailbox from Mom. Inside are a note, a couple articles from the local paper, and a stack of random family snapshots. I quickly flip through the images of smiling nieces and nephews. At the bottom of the pile I'm surprised to see a photo of my favorite chair in their house, a chaise longue on the back porch. I love to sit in that chair in the late afternoon, reading and writing, while the shadows creep through the grass and the sun slowly disappears behind the hills. She had made the picture around that same time of day: the chair is bathed in sunlight, and a spider has built a web in one of the arms. On the back Mom has written, "Brian's chair."

Every summer when I walk in the door of their house, I try to notice something they've changed so that I can tease them about it. "What happened to that old laundry basket—we had that thing since I was a kid!" Or "You painted the kitchen—what was wrong with the old color?"

This year, as I'm lugging my suitcase through the garage, I notice that all of Dad's file boxes that had been stacked along the walls are gone. These boxes held the endless raw material and records of his life's work. The garage seems empty without them. This is not something I want to tease him about. In fact, I feel a few silent tears welling up. But I don't want to make a big deal out of it, so I just glance over at him and say, "I see you got rid of some stuff." "Yeah," he replies. "I gave most of it to the geology department at the university. Those boxes were just sitting there gathering dust anyway."

As I gradually make my way upstairs, I see that a few other objects are missing. Nothing major—some books, a couple of filing cabinets. Dad is eighty-eight, Mom is eighty. They're still healthy. But they've begun to say good-bye to their house, and I realize that it's time for me to start saying good-bye too. I need to love this place, pay attention to all its details, then let go. I have my own life, my own house—my own death. That's where my anchor is.

The day before I leave, I take my usual stroll up the hill behind their back-yard, where I used to walk our dog. The path I had worn in the weeds and grass is long gone, but I have no trouble finding the spot where I like to sit and look down at the street where I grew up. Most of the homes have neat, fenced-in lots. I can see swing sets, doghouses, and picnic tables in almost every yard. My parents' place is a rectangular blob of green, with trees and thick bushes enveloping the entire property. I can barely see the house, much less the patio and yard.

As I take in the view I think of Dad, putting in all those trees, caring for them over the years, watching them grow. He's made his own little island, a place where he can plant his garden and pick his apricots. Nine years earlier, when Helen and I had just moved into our house, Dad had carefully dug up an apricot seedling, wrapped it in newspaper and ice, and sent it home with me in my suitcase. That tiny tree is now more than ten feet tall, and I smile when I remember that earlier this year it bloomed for the first time.

... Honesty ...

HONESTY

Mrs. Bader was my first piano teacher. Her house was past the high school and down the big hill—way too far to walk—so Mom would drive me there, then come back to get me an hour or so later. I was afraid of Mrs. Bader. Not because she was unkind, but because she was so focused. On me. When she watched me stumble through my scales or butcher a watered-down Bach minuet, I felt like a bug on a window who knew the flyswatter was coming but didn't know when. "Remember, Brian, it's the treble clef—the spaces are F-A-C-E, like a face—the lines are E-G-B-D-F—Every Good Boy Does Fine." I wanted to learn it, I really did, but I *didn't* want to be a good boy who did fine. I was actually thinking about catching lizards in the desert or tossing a football with Mrs. Bader's son while I waited for Mom.

I was twelve when we moved from New Mexico to Missoula, Montana, where we found another piano teacher, Mrs. Clark. Her house was handy because I could walk there once a week after school was over. She mainly taught me that "handy" is not a good reason to pick a teacher. To her, piano playing was a problem to be solved. She gave me exercises, she pushed me to improve my technique, but it was never clear why anyone should care about the music I was playing or how I played it. Something was missing. I didn't know what; I didn't even know that I wanted more than she could give. But I did.

The university orchestra had concerts several times a year, and sometimes I tagged along with my parents. Like most teenagers I had the attention span of a fruit fly, and I was usually squirming in my seat halfway through the evening. A few days after one of these concerts, I spotted an ad for private piano lessons in the newspaper. I cut the ad out, showed it to my parents, and told them that this was the person I wanted to study with. He was the second-best viola player in the symphony—that's all I knew. I'd never met him. But I had seen him at the concert, cracking jokes with the principal violist as they walked on stage. Something about these two men had caught my eye.

. . .

Lee Nye (1926–1999), *Eugene Weigel*, 1957. Gelatin silver print, 8 × 6 inches. By permission of the Estate of Lee Nye and Nye Imagery, Ltd.

Maybe I paid more attention to them because I had started to play viola too, and I was more aware of the subtleties. I had begun to see that the personality of the players was expressed in how they played.

All musicians move when they play, but the two violists were fluid and graceful. There was plenty of eye contact between them—they enjoyed playing together—but their styles were very different. The older one, Weigel, was hunched over, compact, his shoulders and arms wrapped around the instrument like a coiled-up spring, his long black hair bouncing wildly around his ears. The younger one, Mader (the man who had placed the ad), leaned back in his chair and held his viola higher. He had the arms of a construction worker but moved like a dancer, his bow caressing the strings in light, delicate strokes.

I'm no longer sure what my teenage eyes were seeing, but I think I saw two people who were good at being themselves. It was the way they lived in their bodies. There was something solid about them, something real, that started on the inside and radiated outward into every gesture and every word.

Why is it so important that things be what they really are?

Think of Orwell, *1984*—the most terrifying aspect of Big Brother is not his ability to control behavior but his manipulation of our minds through a cynical abuse of words (war is peace, freedom is slavery) and his power to decide what's real and what isn't. When words lose their meaning, when what we see with our own eyes is no longer true, where are we? A more recent example: the *Matrix* movies, in which the horror of the machine-controlled universe is mainly that it's an illusion. The citizens of Matrix-land think they're leading ordinary, happy lives. In fact they are glorified cows hooked up to vast milking machines and need to be rescued from their unconscious bliss even if reality is worn out, painful, and dangerous.

Then there's the famous sentence uttered by Galileo following his conviction for the heresy of believing that the earth revolves around the sun: *Eppur si muove* ("And yet it moves"). Actually he never said it, but that doesn't matter. The phrase has survived the centuries because it speaks to our need for truth and our fear of truth. Those four simple words (three, if you prefer Italian) say that there are forces in the world that want to control us, and one way they do is by creating something false and telling us it's true. These forces may win many battles but will eventually lose the war, because there will always be a heroic individual who says NO. "I will hold fast to what I know is real," those four words say. No judge, no priest, no dictator, no torturer can ever turn a lie into the truth.

There is a deep desire in the human soul to see clearly, to have our feet on the ground, to know what really is. This desire can be corrupted, repressed,

ignored, forgotten. But it will win out in the end. We need to believe this. Otherwise everything we are, everything we'll ever be, is built on sand and blows away in the first gust of wind.

But how do we know what really is? Is anything ever certain, or is reality always a search, an approximation, a struggle?

The arguments over this question have gone on for millennia. Some people live in a world of absolutes and are comfortable only within a rigid structure held up by unshakeable pillars of truth. Others say that truth exists but is always just beyond our grasp. We can feel its presence, even catch a glimpse here and there, but if we try to grab it and hold on, it slips out of our hands. Still others believe that we create our own worlds—what we collectively agree on is all we will ever know about reality. A smile says "happy" because that's what we've decided it means. The sky is blue because as children we learned the word for blue and attached it to the sensory input from a particular wavelength of light. We all agree that the name of this wavelength is blue, but in fact there's no such thing as blue. What we call a color is just one tiny fragment of all the electromagnetic energy that's flowing through the cosmos, and the puny word "blue" only has meaning within our own self-created universe.

It's fun to speculate about what's real and what isn't, and how we know the difference. There's a whole branch of philosophy devoted to this subject— epistemology. Epistemologists are very smart people who figure out lots of important stuff (though they spend most of their time fighting with each other).

I don't know whether reality is eternal and absolute, or a butterfly that I can never quite catch, or something we invent just to keep ourselves busy, or some conglomeration of these things—or maybe something that would knock even the most well-heeled epistemologists on their speculative rear ends.

Here's what I do know. When I'm pulling weeds in my garden on a warm Saturday afternoon in August, I pause once in a while to wipe the sweat off my eyebrows. As I stretch my arms and glance upward, I see the sky and it's blue. The clouds are white. The smell of the dirt fills my lungs as I take a long, slow breath, the mud is caked on my fingers, and my lower back is sore. All that epistemological conjecturing about what's real and not real never enters my mind. I know what's real. What I see and touch and smell is real. The whole universe is real, and I'm real because I'm part of it.

My body is designed to take in and process information about what's going on around me. I need that information to avoid being hit by a truck, just as my ancestors needed it to avoid being eaten by a saber-toothed tiger. I'm comfortable with accepting and even enjoying what my body tells me is real, even if I know there's a lot going on out there that I'm missing. Which reminds me of

William Blake's contribution to epistemology: "How do you know but ev'ry Bird that cuts the airy way, / Is an immense world of delight, clos'd by your senses five?"

Our senses are limited, as is our ability to imagine what might lie beyond them. But within the world they create for us, those five input channels work pretty well. For the *outside* world, that is.

No one can ever convince me that the sky is green—not even Big Brother. Fine. But what happens when I turn myself around and survey the inner landscape? Is the sky always blue there? Is the ground always firm? How do I find what's real on the inside? How do I discover, or become, who I am?

I moved into adulthood as a confused mass of contradictory impulses, traits, desires. It's not that I was living in teenager hell, completely out of touch with myself. I knew I had yearnings and predilections. I knew I had abilities. But my brain and body didn't know how to have a conversation. Everything was out of whack. I had thoughts, I had feelings, but they always got in the way of each other. My soul was like two magnets that were facing the wrong way and repelled rather than attracted. I was parts and pieces and fragments, with no idea how the pieces might connect, how the parts could become a whole.

Something was wrong, but I had no idea how to fix it. How do I weld something together when nothing seems to fit? How do I sort through all the voices and characters in my interior house and discover which ones should be living there?

Is being myself something I can figure out? Is it an accumulation of knowledge? Maybe it happens on its own—but I can't just sit back and wait for the seed to turn into a tree. What choice do I have but to dive into life and trust what excites me? Keep what works, jettison what doesn't. Hopefully clarity will emerge out of chaos.

But all the self-knowledge in the world won't make the pieces fit together. There's something else going on—a process of sorting things out, yes, but at the same time, a congealing, a coalescing. Clarity emerges because self emerges, and self is more than an accumulation of information. Self is a structure, a being-ness. A lovely, graceful vessel that grows out of the clay.

Clay isn't empty, lifeless; it has qualities, tendencies, possibilities. Clay is capable of becoming something, but it needs the hands of the potter, the turning of the wheel. The potter doesn't impose a mathematical formula or pick a shape at random. She listens to what she's feeling that day, senses the texture and flow of the clay in her fingers. The two, together—potter and clay—have a conversation, and a form slowly rises. The vessel is not just the contour, the color, the size of the handles, the smoothness of the surface. The vessel is a

thing unto itself. Try to understand it solely in terms of its details, and you miss its completeness, its essence.

Self grows out of a dialogue, a dance, between the clay and the potter. But here the clay metaphor breaks down. I create myself. I am persistent, attentive, engaged. Nothing happens unless I make it happen.

And yet—I also stand aside and let myself be made.

I observe, take chances, make mistakes, and gradually acquire the skills I need to tend my own garden. But I do not cause the plants to grow. I do not control the creation of self, the becoming of me. That happens somewhere else, in the vast dark realm that lies just beyond the circle of light where I make my home, the place where word and image are conceived and patiently wait to be born.

I couldn't have been more than thirteen or fourteen years old, squirming in my seat while the symphony played some long-forgotten piano concerto. Looking back after more than forty years, knowing the importance of that moment in my life, I'd like to think that whatever it was in me that wanted to grow was starting to wake up. The seed of selfhood recognized itself in the two violists and said, "Where those men are is where I want to be."

This was the crucial moment when the needle on my compass stopped twirling aimlessly and turned toward true north. I studied viola, piano, theory, and composition with both men in subsequent years, and I learned that music is serious and demanding and doesn't come easily. But mainly I learned what it felt like to be an artist. Following the creative path had made these guys into the kind of people they were, so that was the path I was going to follow.

What excited me was not the idea of performing on a big stage, or even making some heroic work of art that would save people's souls. My soul turned toward art when I realized that as an artist, the real work of my life is myself. To make art that's real, I have to find what's real in myself.

But it's not a matter of finding, it's a matter of being. To make the honest sonata, sonnet, or symphony, you have to be working out of a condition of honesty. Your words have to ring true.

For me, this was the ultimate adventure. The journey of selfhood. Other people may want to climb mountains, or build buildings, or search for the more concrete truths that science offers. This was not my path. The truth I wanted to find was inside, not outside. The raw material of the artist *is* the artist.

Eventually I became a good enough violist to play in the symphony myself. I was never in the same league as Weigel and Mader, but at least I got to sit behind them and hear all their wisecracks and jokes. Once after the viola section had finished rehearsing in Weigel's music department office, the old musician

decided to unwind by sitting down at the piano and playing the first movement of Bach's C-minor French Suite. I had struggled with that movement myself for years, never quite mastering the intricate, rocking rhythms. When he played it, I finally *heard* the piece, for the first time, what it was meant to be.

Bach in Weigel's hands was steady and thoughtful, but relaxed, playful—never weighty, never ponderous. It sounded like Bach—but it also sounded like Weigel. Every musical gesture, every emotional nuance was perfectly realized—yet it was nothing more than a simple song, sung by a simple man.

This was also why I wanted to be an artist. To find myself—yes—but even more, I wanted to sing that same simple song. I wanted to be alive the way Weigel was alive.

If I'd tackled the problem of selfhood logically, I would have quickly given up, because the way it happens doesn't make any sense. If you want to sing the simple song that everyone sings, then isn't all this heroic self-cultivation the last thing you should do? Doesn't the path of self-realization inevitably lead to narcissism—the lonely ego in touch with only itself?

But I saw where this path leads when I heard Gene Weigel play that day. If I wanted to be alive the way Gene was alive, I had to make the solitary journey that all true artists make, toward the singular, the particular. If I could reach the center and move through it, on the other side would be that simple song—my own song, but also a song that was bigger, deeper, truer. That was a life worth living.

Hearing Weigel play Bach, I knew that I *already* was that lonely ego in touch with only myself. I was isolated and broken. I needed to join. I needed to be healed. Weigel once said to me, "Brian, you can eat, you can sleep, you can make love—why can't you write music?" He was trying to tell me that being an artist is as simple as breathing, as simple as living in your body. But he didn't know that I was floating above the earth, wounded, in some ways barely alive.

The journey I needed to make, no one could make for me. No one could teach me how to be an artist. Art that can be taught is not the authentic art, just as self that can be taught is not the authentic self.

Self is the deep honesty out of which true words are spoken, true connections are formed, true things are made. What it is, where it comes from, no one can say. Yet we all are telling its story, and that story is making and remaking us every hour of every day.

RANDALL EXON: A QUIET LIGHT

My business card says "curator," but most of the time the more accurate title would be middle manager. Basically, I'm a glorified paper pusher who sits in his office all day managing projects and people, making sure the pictures are on the walls when they're supposed to be. Once in a while I break free from my chores and visit an artist's studio, which gives me a chance to get acquainted with some genuine true-blue bona fide art, as well as the human being who made it.

People say that dog owners look like their dogs. Sometimes I entertain myself during these visits with a related question (unspoken, of course): do the artists look like their work? Often I have a hard time believing that *this* person made *those* pictures. The most energetic, noisy canvases are sometimes made by painters who mumble and avoid eye contact. I've seen artists with a highly developed sense of balance and rhythm in their work who regularly stumble over their own feet. This is not the case with Randall Exon. I've never seen him stumble—which is a good thing, because to get from his house to his studio you have to walk down some rather circuitous outdoor stairs.

Some artists are very businesslike: here are the paintings, pick the ones you want, see you later. Exon likes to talk things over. He doesn't tap-dance from one subject to another, never planting his feet on solid ground. He loves to chew on ideas slowly, methodically, finding all the sustenance he can before moving on. There's no need to hurry and no need to fill up the silence with unnecessary chitchat. When he talks there's an odd feeling of space around the words. As the afternoon slips by and the conversation unfolds, you have all the time in the world to get where you need to go.

Exon is awake and aware—when you talk with him, it's obvious that he's taking things in, observing what's going on around him. But he also has one ear turned inward. He has cultivated a sense of quiet in himself, because if you're not quiet, how can you listen? And that's what he seems to be doing all the time: listening. It's as though the space around his words comes from the wide-open spaces in his interior ecosystem—a hidden landscape where shadows creep across the grassy prairies and the sun lights up the edges of the slow-moving clouds. Exon grew up in the Great Plains, after all, and maybe

some of those never-ending spaces seeped into his soul. Could it be that he's listening to the wind blow across these inland plains, so he can hear the sound of the next painting that wants to be born?

The picture has the haphazard look of a real place. A run-of-the-mill house with green, weather-beaten siding sits on a sandy beach. A rickety old fence—barely able to support its own weight—extends from the corner of the house to the edge of the image. A single strip of wood, somehow separated from the sagging fence, leans precariously against the house. Off in the distance, rising up from the dull brown sand, another house—pure white—glows in the morning light. This building is framed by a thin strip of clouds on the horizon, and a delicate, hazy halo surrounds its simple A-frame roof.

The green house and fence in the foreground are part of the everyday, transient universe—victims (as we all are) of wind, weather, and time. The white house lives on the same beach but in a different world. It's there, but also not there—tangible, corporeal, yet luminous and ethereal, like a distant temple or the embodiment of a dream.

Randall Exon is in love with things—plain, ordinary things. In *Autumn Equinox* it's the fence, the house in the foreground, the weathered siding. In another painting it might be a dark green garden hose coiled loosely around a hook, or an old aluminum coffeepot resting on a rusty gas stove, or two straight-backed chairs perched on a bare hardwood floor near a round, three-legged kitchen table. These objects are painted with precision and detail, making their plainness all the more tangible. You can touch them, feel the texture of their surfaces, know them as real things in a real world.

Surrounding and interpenetrating this everyday stuff is a universe of intense light and endless space. Giant windows look out across a vast ocean vista to a distant cloudbank. Chairs and tables, hoses and swing sets are highlighted by a soft luminosity that plays lovingly across their rhythmic contours. Otherwise-nondescript buildings are bathed in a warm afternoon light that gives their weather-beaten boards an otherworldly glow.

Everything Exon sees and paints somehow manages to be both momentary and eternal. His images appear to describe specific places, specific times of day, specific weather conditions. But these transitory events look as though they haven't changed in a thousand years. Every object is surrounded by infinite space, and every moment is a small slice of eternity.

The best word to describe what Exon is wrestling with in these canvases is *transcendentalism*—which, according to *Webster's,* means being grounded in the perception of a "supernatural element in experience." Ralph Waldo Emerson, the prime mover of American transcendentalism in the nineteenth

century, placed the movement in a more or less religious context in his essay *Nature:* "A spiritual life has been imparted to nature; the solid seeming block of matter has been pervaded and dissolved by a thought." Emerson sums up the idea with a sentence that is so innocent and so bold that today it sounds downright shocking, a sentence that very few contemporary artists and thinkers about art would dare to think much less say: "I am the lover of uncontained and immortal beauty."

Randall Exon is a quiet man who doesn't wear his spiritual life on his studio apron, and he would probably be uncomfortable with Emerson's unrestrained enthusiasm. Yet Exon's work is, more than anything, a meditation on the complex, paradoxical nature of the beautiful and the sublime.

Exon spent a great deal of time as a boy on his grandparents' farm in South Dakota, near the Missouri River. "Looking back on it now," he says, "it seemed a place out of time. Theirs was a way of life that was much more about the nineteenth than the twentieth century. When I make a painting today, I'm often drawing upon my memories of their farm and the landscape of the upper Midwest."

It's hard to say what specific memories Exon is drawing on, but it's obvious that the endless spaces of the South Dakota plains still inhabit his dreams. Some painters use space mainly as a way of filling up the gaps between events. But Exon doesn't think of space as empty. Even his interiors feel roomy, partly because he keeps them simple and uncluttered, but also because they usually

. . .

Randall Exon (b. 1956), *Autumn Equinox,* 2004. Oil on canvas, 24 × 46 inches. Private collection. Image courtesy of Hirschl & Adler Modern, New York City

contain a window or door that faces the horizon or the open sky. In his land-scapes, space often becomes the main character on the stage. It's as though Exon is always telling the houses and fences and trees to move over and make room for that broad, sandy beach or grassy field. Space is a living thing in these paintings—a tangible yet timeless presence.

For all their vast stretches of space and time, Exon's canvases would be cold and lifeless without the light. His light is not the blazing intensity of noon but the calmer, softer radiance of morning and late afternoon when the shadows are longer. Exon loves light that rakes across surfaces, emphasizing texture and highlights, separating one thing from another. A set of curtains, a dish on a windowsill, a radiator, a sink—each object is full and distinct, yet living comfort-ably in its environment. And the light makes them beautiful and alive, some-times radiating a mysterious energy, as if they're illuminated from the inside.

This immersion in the transcendental makes Exon's work something of an anomaly nowadays. The artists who typically get the most attention are very much "in the trenches"—using their work as a political and cultural weapon, employing heavy-handed and confrontational strategies that are worlds apart

. . .

Randall Exon (b. 1956), *Beach House Kitchen*, 2004. Oil on canvas, 32 × 46 inches. Courtesy of Hirschl & Adler Modern, New York City

from Exon's quiet inferences and delicate suggestions. If these artists are warriors trying to change the world with their art, then Exon is more of a shy philosopher or, better yet, a monk who withdraws from the battle and contemplates both himself and the universe, struggling with spiritual problems that have preoccupied people since the Neanderthals walked the earth.

While Exon is an oddity today, he would have fit in much better in nineteenth-century America, when transcendentalism was one of the dominant creative currents of the age. The idea was folded into our young country's obsession with westward expansion and the frontier. The natural world to the Puritan pioneers of the seventeenth century was often seen as threatening and dangerous, inhabited by inhuman beasts and demonic forces. By the nineteenth century, nature had become as much a place where God resides as any cathedral. Some painters depicted this concept metaphorically; Thomas Cole and Jasper Cropsey, for example, scattered temples and other classical monuments throughout their idealized landscapes.

Artists such as Frederic Church and Sanford Gifford found less obvious (but arguably more intense) ways of filling their canvases with a transcendental aura. Both Church and Gifford painted broad, expansive valleys and mountain ranges, dotted with glassy lakes and placid streams, with a barely visible sun shining through misty clouds and bathing the landscape in a divine luminosity. Many of these artists were associated with a movement known as luminism, a loosely defined style in which light and space predominate and both the human and natural worlds are supernaturally serene. Other artists who were not necessarily luminists were swimming in similar transcendental currents, including one of Exon's favorite painters, George Inness. When Inness painted a tree bathed in cool twilight shadows whose bark seems to burn with light from the setting sun, the tree is as much a part of heaven as of earth.

Like Emerson, most of these painters believed that God is equally present in nature and the soul of man, and that each of us is capable of experiencing a transcendent union with the divine. There's an ecstatic quality in Emerson's passages on this subject, as in this famous passage from *Nature:* "Standing on the bare ground—my head bathed in the blithe air, and uplifted into infinite space—all mean egotism vanishes. I become a transparent eyeball; I am nothing; I see all; the currents of the Universal Being circulate through me; I am part or particle of God."

While Exon's vision is less fiery and more inward looking, he breathes the same air and drinks from the same cup as Emerson and the luminists. Yet Exon has found his own way of bringing these experiences to life. He paints with an intense, almost photographic realism, and many of his canvases have the feel of places that one might see during a walk in the woods or a stroll on the beach.

According to the artist, most people believe these places are indeed real and are visibly disappointed when told that they're not.

In fact, Exon is in the process of constructing, painting by painting, a real world that is also an imaginary world. The kitchen and dining room in one painting are meant to be part of the interior of a beach house in another painting, for example—and while bits and pieces of things may have actually been seen and recorded, the universe they inhabit was born in the artist's mind. "I go to certain places to get glimpses of them," he says, "but the paintings are more fictional places than anything real. William Faulkner described himself as 'sole owner and proprietor' of the fictional county of Yoknapatawpha, and I suppose I desire a similar ownership of a place."

Why does Exon create this tension in his images? If his goal is to express Emerson-like experiences of the transcendental, why doesn't he just cut loose and create a purely transcendent, mystical world of light and space? Why, in the words of the artist, is he so "desperate to keep it real"? The answer is, he wants his work to be rooted in the spiritual contradictions and tensions inherent in the human condition.

We are beings of this earth. What we're able to see and know is limited by the capabilities of our bodies and by the way our bodies have this unavoidable habit of ceasing to exist. "For dust thou art, and unto dust shalt thou return," was how God broke the bad news to Adam, right after the notorious apple incident.

Yet the Book of Genesis also says that God "created man in his own image." We have intimations and intuitions of some other, higher reality. We open our eyes to Emerson's "blithe air" and "infinite space" and ask ourselves, "What does it say about the world that it is so intensely beautiful?" We have thoughts and dreams that enter our minds unbidden, as if from another place and from another consciousness that sees farther and knows more. We're moved to dance and sing, to worship and create, for no other reason than to celebrate the mystery of our existence.

We are both ordinary and divine, and our ordinariness and divinity are not separate, opposing forces, but woven together, both present in every moment.

This is our predicament, and it's the central obsession of Randall Exon's paintings. Exquisitely grounded in the ordinary, they're filled with yearning for a more beautiful place—a place we can see, off in the distance, like the white house in *Autumn Equinox*—that we know is there but lies just beyond our grasp. This yearning is at the core of what it means to be human, and it has often been the preoccupation of poets, misfits, and spiritual seekers of various kinds. In *Mythologies,* for example, William Butler Yeats had this spiritual tension in mind when he described humanity as "a moment shuddering at eternity," or

Randall Exon (b. 1956), *Beach House*, 2002. Oil on canvas, 36 × 36 inches. James A. Michener Art Museum. Museum purchase with funds provided by the Janus Society

when, after listing all the ways a person could know love in his life, Yeats said that "unveiled Love he never knows."

Even Emerson acknowledged this tension, this predicament. For all his ecstatic confidence in our ability to merge with the divine, he also said that "souls never touch their objects. An unnavigable sea washes between us and the things we aim at and converse with." In an essay called *Circles,* Emerson arrives at a surprising insight that appears to be at odds with his "transparent eyeball" experience, in which there was no separation between himself and God: "Our life is an apprenticeship to the truth. . . . [The circle] symbolizes the moral facts of the Unattainable, the flying Perfect, around which the hands of man can never meet."

Saint Paul, who could be depressingly earthbound at times, was feeling this same yearning for the "Unattainable" when he wrote what are arguably the most famous lines on the subject in his eloquent meditation on love in I Corinthians: "Now we see but a poor reflection as in a mirror; then we shall see face to face. Now I know in part; then I shall know fully, even as I am fully known." Paul never told us exactly what he meant by "then." Perhaps, like Emerson, he believed that as mortal beings the door of the divine temple is closed, but at peak moments we can merge with the eternal, becoming "part or particle of God." More likely Paul, as a Christian, felt that such a sacred and complete union could only occur at the point of death, but until that moment our knowledge is clouded, incomplete.

Whatever context one chooses to understand this problem—philosophical, religious, artistic—the yearning we feel is real, and it would be a mistake to conclude that only poets, painters, and saints are struggling to understand this tension between the "dust" we come from and our innate divinity. At one time or another, each one of us must confront our mortality and ask ourselves if there is something more to our existence.

Randall Exon's paintings say yes, there is something more. There's something out there in the universe, and inside the human heart, something that we can feel but not touch, something that has had many names throughout our history, that might be described as spiritual, that some would even call God. Whatever one calls this "something," it's the key to understanding what's going on with this Exon fellow, both the man who likes to talk all afternoon in his studio and the intense, otherworldly pictures he makes.

The fields and shorelines Exon paints are more than geographical phenomena —they are sanctified, alive. The light in his paintings does more than just define forms—it's a quiet light that comes from someplace other than the sun.

FREDERICK EVANS AND THE CATHEDRALS OF LIGHT

Ansel Adams had Yosemite. Eugène Atget had Paris. Walker Evans had rural Alabama. Lewis Hine had Ellis Island. Dorothea Lange had the Great Depression. Edward Weston had Carmel, California—not to mention naked ladies and naked peppers. Eugene Smith had World War II, Pittsburgh, Japan, Spain, Africa, and the view from his New York City window. . . .

It's hard to imagine anything more inconsequential than a photograph. Paper clips, maybe? Grains of sand on a beach? It's even harder to imagine using a camera to explore your relationship with something you love, as Adams did, and Atget, and Evans, and countless other photographers both living and dead. Photographs are so easy to make nowadays that it's hard to take them seriously. Did you ever wonder how many pictures we make in a year? Trillions? With all those bytes and pixels flowing through the world, the number is probably a trillion or so a day.

Actually, from the beginning people have been suspicious of photography's ability to do anything other than glorified mimicry. It's probably the aura of technology that seems so antithetical to the poets: Baudelaire said the camera was nothing more than a scientific instrument and a memory jog; Yeats called it "banal mechanism."

It's true that most photographers are obsessed with the mechanical minutiae. In the old days it was the fine points of lenses (mine is longer than yours) and the arcane details of film, paper, and darkroom. Now the technology is even more complicated—the camera is a sensor surrounded by sophisticated software, and the darkroom has become the great god Photoshop, which, like the ancient deity of the Bible, can be both angry and merciful, and no mortal soul has any hope of truly understanding.

A glance at the shelfful of Photoshop books at your local bookstore quickly confirms the fact that photography tends to attract people who've been mesmerized by the "mechanism" and can't see very far beyond it—people whose images often look like desiccated Magritte ("Wow—I can put a naked lady inside a rock!") or souped-up Ansel Adams on acid ("Why make a tree green when it could be orange?").

There's nothing inherently wrong with taking pleasure in the mechanistic side of photography. Just as painters enjoy the texture of the canvas and the viscosity of oil paint, photographers become photographers in part because they feel comfortable with the tools and materials of the medium, both analog and digital. But with the best workers—photographers whose images continue to nourish people well beyond the artist's lifetime—the camera becomes a conduit for some great passion.

Ansel Adams made his first picture of the Yosemite Valley with a Kodak Brownie at age sixteen. While he photographed countless other places throughout the West, Yosemite was his first love, and like any true love, Yosemite to Adams represented an intense connection with something *outside* himself that led to a deeper understanding of what was going on *inside*. It was no accident that Adams's soul was stirred by Yosemite; its beauty was, in essence, a religious experience for him, and in some nonverbal, instinctive way he used his photographs of Yosemite to explore his spiritual connection with the natural world.

This inner/outer dialogue is common to almost all memorable photography. You could go so far as to say that a great photographer is also a great lover. Not literally, of course (though a few of them had some noteworthy exploits in that arena)—but in the sense that they fall in love with something outside themselves that focuses their lives and energizes their work. In the process they discover what they really care about and become who they really are.

Frederick Evans (1853–1943) was the last person you would think of as a great lover. His friend George Bernard Shaw's first impression of Evans was "as a man of fragile health, to whom an exciting performance of a Beethoven Symphony was as disastrous as a railway collision to an ordinary Philistine." If Evans was a lover of anything, perhaps it was old books. He began his adult life as the owner of a bookstore, a place that Shaw referred to as "a genuine bookshop and nothing else, in the heart of the ancient city of London. . . . It was jam full of books. The window was completely blocked up with them, so that the interior was dark; you could see nothing for the first second or so after you went in, though you could feel the stands of books you were tumbling over."

Evans began to make photographs seriously in his thirties—mostly portraits and close-ups of natural forms. By his mid-forties he had sold the bookstore so that he could concentrate on photographing the Gothic cathedrals of England and France. There are no surviving stories of a teenage Evans visiting Chartres or Notre Dame with camera in hand (as Adams did with Yosemite). But Evans had a great interest in art, literature, and philosophy, and as a young man he developed a particular taste for the spiritual writings of the German mystic Jacob Boehme as well as the Swedish scientist and theologian Emanuel Swedenborg.

These early spiritual interests eventually led Evans to fall in love with those Gothic wonders that loom over the ancient cities of England and France. While he was not an orthodox religious man, it's clear from his images that his connection with these buildings was real and intense. More than any other photographer before or since, Frederick Evans understood the otherworldly vision that motivated the medieval architects and priests who built them.

There is no shortage of cathedral photographs in the world—from nineteenth-century tourist photographs and *cartes de visites* to architecturally oriented pictures that document the buildings' geometrical complexities, to glossy, romanticized photos of stained-glass windows and gargoyles. While Evans was obsessed with the cathedrals, he had little or no interest in simply documenting what they looked like, in all their grandeur. The closest he came to a "documentary" exterior view is the magnificent photograph *Lincoln Cathedral: From the*

· · ·

Frederick H. Evans (1853–1943), *Provins, France,* ca. 1906–07. Platinum print on paper, 4^{1}/$_{16}$ × 5¼ inches. Philadelphia Museum of Art: Purchased with funds contributed by Dorothy Norman and with the Director's Discretionary Fund, 1968

Castle, which is actually a visual metaphor for the heavenly and earthly planes: the cathedral is a dreamlike, ethereal vision of divine perfection that rises above the jumbled, earthbound rooftops of nearby houses.

Some of his best photographs are small-scale, interior views of anonymous-looking doorways and stairwells. These images live in a universe of powerful light and deep shadows. Often the shadowy areas predominate: dark corners and hidden recesses, silhouetted pillars and barely visible passageways. But the darkness in Evans's photographs is never harsh, never cold. There are no demons and monsters lurking behind his stately columns. In part this is because you can always see into his shadows—the surface of the intricately carved rock, the delicate curve of an archway—so the dark areas are always softened, warm, full of possibility. His darkness is never truly dark because it's always and everywhere a counterpoint to the light.

Light is a constant presence in these pictures. It illuminates every interior; it penetrates into every corner. It comes in brilliant shafts that pour down from windows or appears as a steady, luminous glow that permeates the very molecules of air and stone. As the eye is lifted upward, from shadow to brightness, the light causes the inert cathedral walls to shine, to transform. The walls are no longer made of rock but are almost translucent. If you touch them, will they still be solid?

This is more than light as a physical, material thing, divorced from poetry and spirit. This is light as an embodiment or reflection of the divine: the light of the first epistle of John in the Christian gospels, which simply says, "God is light."

Almost nine centuries separate us from the planning and early reconstruction of the first Gothic cathedral, which was conceived and built by Abbot Suger of Saint-Denis, a northern suburb of Paris whose cathedral had long been the burial place of France's kings. Those nine centuries do not even begin to measure the distance that the Western mind has traveled since the cathedrals were built, a distance so great that it's almost impossible for us to imagine the aesthetic universe that Suger and his priestly colleagues inhabited.

The whole concept of aesthetics as we understand it would be foreign to the medieval mind, which could not conceive of beauty and art as anything but expressions of a religious experience. Even the word "expression" is

. . .

Frederick H. Evans (1853–1943), *Westminster Abbey: Across the Transepts,* 1911. Platinum print on paper, $9^{13}/_{32} \times 6^{21}/_{32}$ inches. The Metropolitan Museum of Art, Alfred Stieglitz Collection, 1949 (49.55.236). Copy Photograph © The Metropolitan Museum of Art

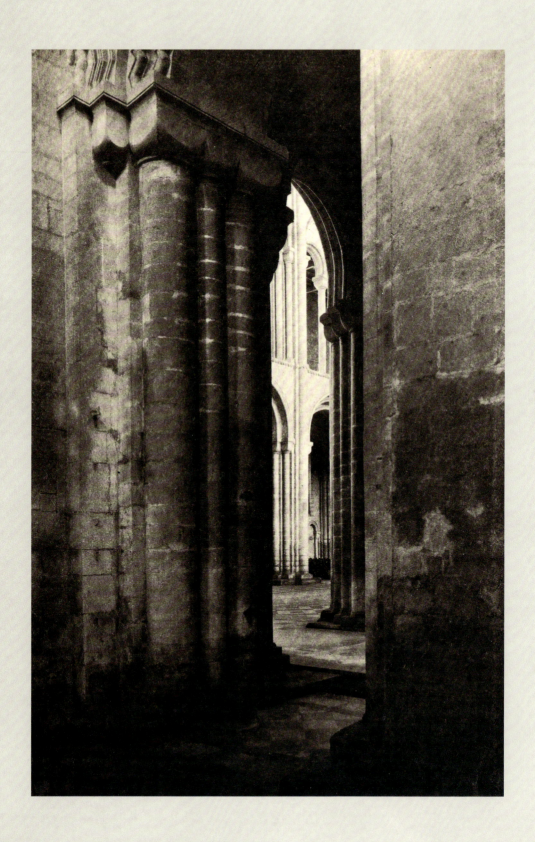

misleading, because it implies an aesthetic gap between the experience of the observer and its artistic utterance. "Mirroring" would perhaps say it better. As the architectural historian Otto von Simson said, "The Middle Ages perceived beauty as the 'splendor veritatis,' the radiance of truth; they perceived the [artistic] image not as illusion but revelation."

So the Gothic cathedral is not a "work of art" in any modern or postmodern sense. While these buildings seem to share many qualities with more recent artistic creations of various kinds, it would be a mistake to look at the cathedrals as we do a cubist drawing or even a cathedral painting by Monet, which to some degree are attempts to work out purely intellectual ideas and passions. As von Simson puts it, "The church is, mystically and liturgically, an image of heaven." And heaven, to the medieval mind, was more than anything a place of light. Actually—and this is an even stranger concept to us—the earth was too. The French historian Georges Duby describes this concept beautifully in his book *The Age of the Cathedrals:*

> *Every creature stems from that initial, uncreated, creative light. Every creature receives and transmits the divine illumination according to its capacity. . . . The universe, born of an irradiance, was a downward-spilling burst of luminosity, and the light emanating from the primal Being established every created being in its immutable place. But it united all beings, linking them with love, irrigating the entire world, establishing order and coherence within it.*

This theology of light was not the only metaphysical principle that the cathedral builders embodied in their designs. They also felt a profound sense of wonder—again, completely foreign to the modern mind—in the area of mathematics. We tend to think of math as theoretical and cerebral, something generally practiced by eggheads. To the medieval mind the science of numbers was a direct link with the mind of God and expressed the great secrets of the divine principles that ordered the cosmos. Grounded in this deeply felt numerical mysticism, the medieval architects created a sacred structural geometry, infusing their buildings with ratios and proportions that to them were expressions of the angelic harmonies that blessed souls heard when they entered the heavenly realm.

. . .

Frederick H. Evans (1853–1943), *Ely Cathedral, Southwest Transept to Nave (A Memory of the Normans),* 1897. Photogravure print, 7²⁹⁄₃₂ × 5⁵⁄₃₂ inches. Courtesy of George Eastman House, International Museum of Photography and Film

While the use of geometry and proportion was the more or less invisible foundation of medieval design, the metaphysics of light became the most highly visible architectural element—the true raison d'être of the cathedrals. As every art history student learns, Abbot Suger, in his prototypical structure at Saint-Denis, introduced a series of alterations to the previous Romanesque style, adding numerous windows, replacing interior walls with columns, and opening up the series of chapels surrounding the central core of the building, all of which were designed to allow more light into the interior. From front to back and top to bottom, the light streamed into the inner recesses of the church, turning the entire building into a living symbol of divine creativity.

Frederick Evans wasn't an overtly pious man, and his writings take a cautious and measured approach to the theological grounding of his work. When he explained the title of his picture *'In Sure and Certain Hope,' York Minster,* for example, he carefully danced around traditional Christian ideas about the afterlife. The title of this photograph comes from a passage in the Burial of the Dead service in the Anglican Book of Common Prayer: "In sure and certain hope of the Resurrection unto eternal life." The image depicts a cathedral interior, apparently a crypt, with a recumbent figure staring upward, hands folded. "As I was studying [the scene], the sun burst across it, flooding it with radiance," Evans said. "There is my picture: 'Hope' awaiting, an expectancy with a certitude of answer; and the title seemed defensible, if a little ambitious." No grand claims, no flowery language in those words! Instead Evans seems cautious, as if he might have to defend his "ambitious" title in a scholarly debate or perhaps to an imaginary inquisitor.

As with most serious artists, Evans felt much more freedom to give voice to his feelings in his work rather than his explications. While his words are circumspect, his photographs at times border on the ecstatic. In *Provins, France* the camera stands in the shadows of what is apparently a basement area of the cathedral, pointing toward a stairwell. A shaft of light from an unseen window or door pours down the stairs, creating a pool of illumination on the floor that flows into the darkest areas of the room. Evans's interpretation of this place is not harsh or melodramatic but delicate, uplifting. The nondescript room has a magical glow; as George Bernard Shaw said about Evans's handling of light and shadow, "the obscurest detail in the corners seems as delicately penciled by the darkness as the flood of sunshine through window or open door is penciled by the light."

Evans was famous for "stalking" his photographs over a period of weeks or months, returning with his camera at the precise moment when the light was where he wanted it to be, and even demanding that chairs and other objects be removed so his view would be unobstructed. So this staircase of light is a

carefully calculated depiction of a real place at a specific time. But the image also has the emotional intensity of a dream or vision. Where does the light really come from? A door or a window, yes, but there's a metaphorical layer at work here as well.

The drama of this picture lies in its movement from darkness to light. The stairs go somewhere—to a place shrouded in mystery yet intensely desirable. If you were to climb them, what would you find? They seem abnormally steep, so the ascent would not be easy, but where would you be if you were to reach the top? The phrase "stairway to heaven" is, of course, a cliché, but it's not hard to imagine Beatrice leading Dante up such a staircase to the highest reaches of Paradise.

This photograph is the embodiment of what von Simson tells us is the very goal and essence of the medieval notion of reality: "to ascend from a world of mere shadows and images to the contemplation of the Divine Light itself." But that explanation, being verbal and theological, doesn't do justice to this picture, which has the excitement of something newly discovered—as if this archetypal image of the spiritual desire to know and join with the Creator, which is at the heart of our culture's religious tradition, is revealed here for the first time.

In other words, it's not enough to say that Evans understood the medieval mind. He felt it. He knew it in his ligaments and corpuscles. Perhaps he loved these buildings in a manner that even Abbot Suger might have recognized. Evans would have been cautious about the ambition of such claims and would never have used the grand theological language of the medieval priests. But the photographs speak for themselves.

Frederick Evans was an unashamedly spiritual artist: an artist who was committed to conveying something of the ecstatic, transforming, transcendent nature of the genuine religious experience. He did not do this because he was some sort of proselytizing Christian soldier who added a notch to his belt with each converted soul. His motives were simpler and more honest. He was excited to his marrow by what he saw in these places. The cathedrals—and the spiritual world they inhabit—were his great love. Just as Ansel Adams did with Yosemite, in pursuing that love through his photographs Evans was also living out his own spiritual journey. He was learning about, and becoming, himself.

There's something refreshing about Evans's innocent expressions of spirituality, which seem so far removed from the endless arguments about science and religion that have plagued us since Darwin spotted his first finch on the Galapagos Islands. So often the defenders of the faith—both scientific and religious—take up extreme positions as they do battle with each other. Religion in its most radical forms has become an oppressive force in our culture and is sometimes used as a weapon to repress art and most other forms of individual

expression. When we hear religious leaders talk about God as they advocate assassination and bigotry, religion appears to be nothing more than a form of neurotic zealotry whose only purpose is a mindless conformity that denies the healthy diversity of human experience.

People on the other side of the argument focus on the excesses of religion, rejecting it entirely in favor of a rational universe governed solely by chance and physical law. But these people also fall into extreme positions and even zealotry, brutally devaluing and debunking the whole spectrum of religious experience. They argue passionately that life and consciousness could only have been made by completely random processes, but in doing so they create an empty universe that is stripped of beauty, wonder, and meaning.

Evans's cathedral photographs reject this conflict, or more accurately, *ignore* it. These pictures are beyond politics and ultimately even beyond theology. Evans uses the mechanism of photography to create images that express a single human being's experience of that which is transcendent in our lives. As such, they are far more powerful than any philosophical argument for or against the existence of God. They are Frederick Evans saying to anyone who cares to listen, "I saw this. I felt this." They stake no claim on absolute truth, yet they have the unassailable reality of lived experience.

For those who have had similar experiences, these photographs are an affirmation. For those who see the world differently, Evans's work is a gentle reminder that there is more to life than what we can quantify and measure, that beauty and wonder are real, and that it's good to be excited about such things and to follow them wherever they happen to lead us.

. . .

Frederick H. Evans (1853–1943), *'In Sure and Certain Hope,' York Minster,* 1902. Platinum print on paper, 7⅞ × 5²⁷⁄₃₂ inches. The Metropolitan Museum of Art, Gilman Collection, Purchase, Alfred Stieglitz Society Gifts, 2005 (2005.100.906). Copy Photograph © The Metropolitan Museum of Art

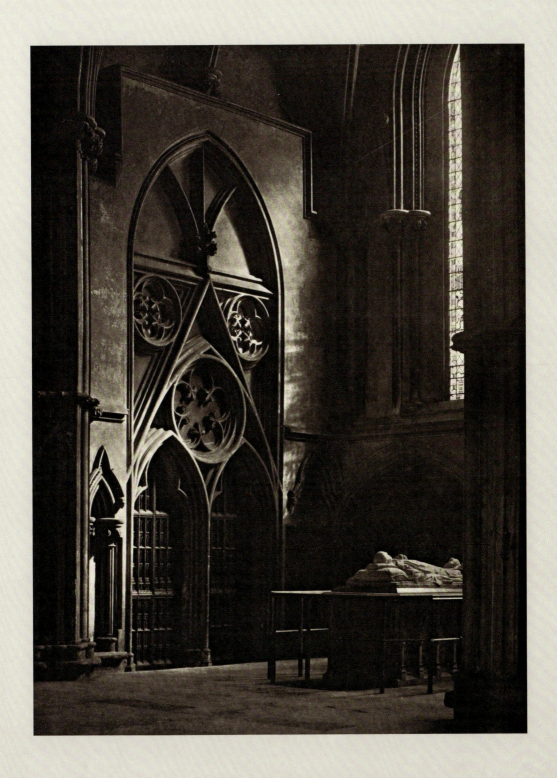

THE UPSIDE-DOWN WORLD OF BARRY SNYDER

A place for everything, and everything in its place.
—Mom

If you're curious about the difference between children and adults, all you have to do is walk into a child's bedroom on an average day. What will you see? Toys, half-opened books, dirty clothes, assorted unfinished projects, and random precious objects—all left in the exact positions they occupied when their owner's fluid attention was drawn somewhere else. In other words, it's a mess.

Mom and Dad try to introduce their kid to the concept of order, and the room becomes the battleground for the advance and retreat of civilization. Parental armies periodically invade, leaving behind a visible floor, simplicity, and structure (this goes here, that goes there). But then the counterattack begins. The forces of chaos quickly reappear and spread to every corner as the child's rebellious will reasserts itself.

When childhood ends, and we take the unavoidable next step to mortgages, rush-hour traffic, and time clocks, most people (thankfully) opt for order. In the process we learn about the nature and logic of *things*. A pen, for example, is for writing, but a book is for reading. A stone is hard and belongs on the ground. A car moves and is bigger than an apple, which one eats. Fresh, clean, and new objects are useful and good; old, decayed, and dirty objects are useless and bad. Everything has a name, predictable qualities, and a function. The sum total of these classifications and associations becomes something we call "reality," which we assimilate so thoroughly that we can no longer conceive of the world in any other way.

When we were kids we saw things differently. It's impossible for us to recapture how a young child experiences the world—when the universe is new, nothing has a name, and everything is equally exciting. A dirt clod, a clump of dust, or a dead bug—each must be thoroughly examined, often (to the chagrin of the horrified parents) by placing the item in question into the adorable youngster's

. . .

BHP: *Barry Snyder,* 1999

gaping mouth. Touching it is not enough—to really know something, you have to chew on it, taste it, consume it.

The ultimate victory of order over chaos is inevitable and necessary. Just imagine the world organized the way a child's room is! We need to know how to tell one thing from another and how it all fits together. How else could we speak the same language? How else could we get anything done? But we pay a heavy price for our grown-up reality. As an adult it's easy to lose touch with the creativity and innocence we were born with. Our lives can become predictable and empty of meaning. Perhaps this is what Thoreau was talking about in his famous line from *Walden:* "The mass of men lead lives of quiet desperation."

Barry Snyder is a smallish man in his mid-sixties, with a quiet, self-effacing manner and overflowing white hair that often frames a day or two's worth of gray stubble. Underneath this unlikely exterior beats the heart of a child.

Now retired from an active career as a businessman and gallery director, he journeys every day to his cluttered studio (his "room") where he plays and dreams, making art out of the most unlikely subject matter. Somehow this

. . .

Barry Snyder (1929–2008), *Mask of the Sower,* 1987. Wood, metal, crayon, fabric, 67 × 33½ × 3 inches. Courtesy of the Snyder Family

aging scavenger has rediscovered the ability to see an object as if no one before him had seen it. When he isolates something from its customary surroundings, or combines it with something else, a strange and wonderful transformation occurs. Suddenly a beat-up old stool becomes a fragile, newborn colt sucking hungrily at its mother's nipple. A clump of dried vegetation is a human brain. An old broomstick becomes a wild African war mask. A twisted branch and a rusty piece of metal are now a serene meditation on space and movement reminiscent of an elegant Japanese garden.

Snyder works the way a child plays, creating battles, heroes, and great cities out of whatever stuff is available. Except he is not a child. He is a thoughtful, mature artist engaged in a deeply serious attempt to communicate his particular slant on things—his discoveries, his passions, his way of seeing the great, universal drama of life. Beneath the playfulness and the humor, he's trying to tell us something about ourselves:

What grief we should feel at our loss of innocence! What joy there is in searching for it! How it would change us if we could find it again!

There is much that we—the descendants of conquerors and colonizers—need to learn from other cultures, especially the fierce and fearless mask makers of Africa and South America and the mysterious, egoless grace and delight of the Zen masters.

Finally, Snyder wants us to pay attention to that moment of transformation when the world is turned upside down—when the low becomes the high and the ugly becomes the beautiful—when the simple is profound and something ordinary turns into something new—when the only thing that matters is our imagination—when all peoples and traditions are equally rich, anything is possible, and the universe is alive with energy and meaning. In that moment, if we're lucky, we may catch a fleeting glimpse of the wisdom of the spirit that the great Spanish poet Federico García Lorca was also trying to find:

My heart of silk
is filled with lights,
with lost bells,
with lilies, and with bees,
and I will go very far,
farther than those hills,
farther than the seas,
close to the stars,
to ask Christ the Lord
to give me back
my ancient soul of a child.

THE SECRET WORLD OF CELIA REISMAN

Suburban landscapes—now there's an oxymoron!

Say the word "landscape," and what images come to mind? Perhaps the wild and pristine panoramas of New York's Hudson River Valley. Or the highly romanticized renditions of the Rocky Mountains, with storms hovering over jagged peaks that look like the Matterhorn married to Mount Everest. Or transcendental visions of New England's coastline, complete with four-masted schooners sailing through smooth, luminous waters. Or cheerful views of Connecticut's countryside, or California's, or Pennsylvania's, or Indiana's, or wherever the impressionists happened to plant their easels. No place is safe from the gaze of these artists; even the gritty and brooding canyons of Manhattan have sometimes caught the eye of America's landscape painters.

No place is safe—except the suburbs.

You would think that the only way to be taken seriously as a landscape painter is to find and record the most exotic sunset ever seen or to preserve on canvas the most charming forest or seashore ever imagined. The last place a painter would think of going is to the home of strip malls and billboards, traffic jams and sprawl—the breeding ground of Kmart and Wal-Mart and a thousand other Marts—where historic farmland is gobbled up by hungry developers and the name of every new subdivision says that only the crème de la crème of English aristocrats are allowed to live there.

Why would anyone want to make art out of the suburbs? One reason might be that an awful lot of folks live perfectly happy lives there (confession: I'm one of them). Celia Reisman lives there too. And Reisman, unlike so many of her landscape-minded colleagues, decided early on in her creative life that she wanted to keep her toes firmly planted in the soil of her home turf.

It's almost a cliché that young *writers* are encouraged to stay at home, to begin and end with where they live and what they know. Landscape painters, on the other hand, have often been seduced by the spectacular and the picturesque.

. . .

Celia Reisman (b. 1950), *Angel Awning,* 2000. Oil on canvas, 40 × 50 inches. James A. Michener Art Museum. Museum purchase

They have headed out into the world like some great Oklahoma land rush of canvas and brush, competing with each other to stake their claim on the biggest waterfall, the highest mountain, or the prettiest little girl in the prettiest little garden.

So this is where our journey into Reisman's universe begins: she is an artist who finds beauty and mystery where others find only banality and boredom. It's as though she says to herself, "I could spend my life searching for exciting stuff to paint, and I would only end up right back where I started. The most exciting place is the place I know best." The simple wisdom of this decision is grounded in a fundamental faith in the richness of her own interior life. In other words, even for a landscape painter, what's going on *inside* the artist's head is more important than what's going on *outside*. The most common, ordinary subject matter can become a vessel for the painter's fantasies, perceptions, speculations, and dreams.

There are no malls in Reisman's suburban universe, no gas stations, no convenience stores, no clusters of cookie-cutter houses. Her canvases *are* filled with houses (though they don't all look the same), along with sidewalks, trees, bushes, lawns, and garages. But Reisman is not overly concerned with describing the exact appearance of these things. There's a simplicity in what she sees—a lack of detail—and a subtle sense of rhythm that's created by paring down both man-made and natural forms to their essential geometry. When the poet e. e. cummings said, "I am abnormally fond of that precision which creates movement," he might have been talking about Reisman, who finds her own precision, her own movement, in the lines, planes, and angles of the suburban environment.

Reisman enjoys extracting these geometrical abstractions from her subjects, but abstraction for its own sake is not the holy grail for this artist. The soft, muted colors, deep shadows, and subtle shadings slowly coalesce into a different reality, and a brooding, mysterious atmosphere settles on the sidewalks and cul-de-sacs. Something in her connects with these places. She sees things that most of us miss—not just tangible things, but moods, auras.

Reisman makes the suburbs seem beautiful, in a quiet sort of way. And there's an intimacy in her paintings that's surprising, even shocking. It takes an odd kind of genius to find such personality in these places. No grand vistas here, but plenty of enclosed, intimate spaces, protected from the world in an almost womblike way. Sometimes there are barriers too—a strategically placed concrete wall, or a bush that blocks the view. She loves these private, hidden enclaves, and when you see one, you can't help but wonder—what's *in* there? What's *behind* there? Is something unexpected about to pop into view?

Sometimes her colors are shaded a bit darker, and a subtle but palpable sense of foreboding descends on the suburban terrain. But then the intense

luminosity of late afternoon takes over. Buildings glow. Trees and bushes burn with an otherworldly light.

The more you look, the more you see that Reisman's paintings are about Reisman, not the suburbs. Admittedly, the places she depicts seem real enough. But reality has been transmuted and transmogrified. The ordinary stuff of the world has somehow been inhabited by the artist's clandestine inner life.

I don't know who Celia Reisman's ancestors were. But I'm willing to bet that somewhere in her family tree you would find a few of those ancient, mystical, Druidic types who worshiped both places and things—trees, earth, stones, vessels, even buildings. And maybe, just maybe, these forgotten people have been covertly looking out through Reisman's eyes, magically transforming the suburbs into a modern-day Stonehenge, a sacred territory where every fence post is alive, every garage is pregnant with possibilities and portents. This is as good an explanation as any for the strange vitality of her work, though if one wanted to resort to "artspeak" there would be plenty of more conventional ways to talk about what she does.

Who's to say what's really going on beneath the surface of those supposedly banal suburbs? Dig down a bit and you might find all sorts of mysterious, wonderful substrata to explore. That's what Reisman did. What she found was a secret world that is also *her* world. What she found was herself.

. . .

Celia Reisman (b. 1950), *Big Dipper*, 2006–07. Oil on canvas, 28 × 34 inches. Courtesy of Gross McCleaf Gallery

THE WISE SILENCE OF DANIEL GARBER

I am a very happy man. I am enthusiastic about my painting; I have few theories about it. . . . I've had a wonderful life.
—Daniel Garber

Daniel Garber was in his seventies when he made this offhand comment to a journalist. He'd already had a heart attack a decade or so earlier, had retired from teaching, and was no longer putting in long hours every day with palette and brush. To arrive at this moment of reflection and self-appraisal and not only be happy but "very happy"—to look back on your life and describe it as "wonderful"—what more can anyone ask from this troubled world? Each of us can only hope that when we're approaching our final hours, we can honestly feel the same way despite the accumulated wounds and lamentations we all experience.

We may respect, and even envy, people who apparently manage to lead such meaningful and contented lives—but do we really admire *artists* who so enthusiastically describe themselves as happy? Happiness, or the pursuit thereof, is an unalienable, God-given right—it says so in the first few lines of the Declaration of Independence. There's no footnote or codicil in the famous preamble that denies this right to artists. But aren't we just a tiny bit suspicious of artists who call themselves happy? Isn't there a voice inside that whispers, "Thomas Kinkade—now there's a happy artist . . ."? In other words, when a painter like Garber is described as cheerful and sunny (as he often was in his lifetime and still is today), there's usually an implicit "wink and a nudge" going on, as if to say, "Well, a good painter to be sure, but in the end, a lightweight."

There's something about good old-fashioned Sturm und Drang that gives weight and credibility to an artist's work and helps to raise his or her life to mythic dimensions. We admire Beethoven, who managed to write most of his symphonies despite being deaf, or van Gogh, who battled mental illness and a world that ignored his genius. If an artist's life ends tragically, the work is

. . .

Daniel Garber (1880–1958), *The Quarry, Evening,* 1913. Oil on canvas, 50 × 60 inches. Philadelphia Museum of Art: Purchased with the W. P. Wilstach Fund, 1921

often treated with greater reverence—as if suicide is the ultimate form of "street cred" for a creative person. Given our obsession with the idea of the suffering artist, you can't help but wonder if the ultimate career move for a contemporary painter or poet might be to jump off a bridge—but not before producing an ambiguous and vaguely troubled body of work that gives critics and curators plenty to talk about.

This is not to say that the old chestnut about the artist suffering for humanity doesn't have a grain or two of truth in it. From African American spirituals to Picasso's *Guernica,* some of the most powerful art ever made has grown out of terrible and tragic circumstances. Composer Olivier Méssiaen wrote his *Quartet for the End of Time* in a Nazi prison camp. Solzhenitsyn's greatest work was born in the horrors of the Soviet gulag. For other artists, the suffering is more personal and internal, but no less real. Käthe Kollwitz comes to mind, a gifted artist who turned her grief over the deaths of a son and grandson in war into haunting expressions of pain and loss—or Frida Kahlo, whose troubled marriage and terrible physical suffering became the raw material for her intensely autobiographical paintings.

Artists who follow this path are living out a kind of crucifixion/redemption archetype: artist suffers; artist makes work that expresses suffering; humanity shares in the suffering and is both educated and uplifted by the experience. While this archetype works reasonably well for some artists, Daniel Garber presents a very different model for a creative life. On the surface Garber's life unfolded smoothly, from his birth and childhood in rural Indiana, to his student years at the Art Academy of Cincinnati and the Pennsylvania Academy of the Fine Arts, to a period of travel and study in Europe, to his employment as a teacher at the Pennsylvania Academy—all before his thirtieth birthday. His thirties and forties were a period of fabulous success, with an unending stream of prestigious awards, exhibitions, and collections added to his résumé. He reached the upper echelons of American painting at a relatively young age, and he maintained this status to some degree for the rest of his life, though like all landscape painters he was increasingly seen as outdated and irrelevant as modernism and its many offspring gradually took over the art world.

The orderly unfolding of Garber's career was accompanied by a similarly stable domestic life. He met his wife, Mary, in art school, and despite the stereotype (often accurate) of successful artists dallying with models and students, he was faithfully married to her for more than fifty-five years. If his paintings are any indication, his family life was tranquil and loving; he often used his wife, children, and grandchildren as subjects for his large-scale figure work, and the mood of these canvases is nearly always bright. His Bucks County home, Cuttalossa, where he lived more or less full-time from the 1920s until his death, was

an almost Disney-esque, farmlike environment, with picturesque outbuildings and sheep pens, a creek that he dammed to make a pond, and a beautiful, sunlit studio that became the subject of some of his most famous paintings.

It's always risky to assume that artists' personal lives are mirrored in their work, but in Garber's case there appears to be just such a connection between the content of his imagery and the stability of his domestic and professional life. If you had to choose a single word to describe Garber's work, it might be *warmth*. He must have accumulated a large bill at his local art supply store for yellows and browns! Garber loved the lush yellows of the afternoon sun as it fell on the trees and hills that lined the Delaware River, and the warm light that streamed through the windows of his house, illuminating its shadowy interior. His design habits were typically very simple, especially in the landscapes,

. . .

Daniel Garber (1880–1958), *South Room, Green Street,* 1920. Oil on canvas, 51 × 42 inches. Corcoran Gallery of Art, Washington, D.C. Museum Purchase, Gallery Fund

which are usually laid out in repeated horizontal layers that extend from the foreground to the horizon. He often broke up the inherent stability of these stacked horizontals with a graceful, sinuous tree—a practice that his family enjoyed teasing him about, noting that sometimes the foreground trees in these paintings look remarkably similar.

With all this warmth and stability in Garber's paintings, it's not surprising that his work has so often been described as "sunny." But calling Garber sunny

. . .

Daniel Garber (1880–1958), *Mother and Son*, 1933. Oil on canvas, 80⅛ × 70 ¼ inches. Courtesy of the Pennsylvania Academy of the Fine Arts, Philadelphia. Gift of the Artist

is like saying a mountain is tall: true as far as it goes, but somehow missing the mark.

While he's probably best known for his landscapes, the intellectual and spiritual underpinnings of his work are most powerfully expressed in his figure paintings. *Mother and Son,* for example, was painted in his Cuttalossa studio, and the image depicts both a real and imaginary domestic scene: real because the protagonists are the artist's wife and son, imaginary because it's unlikely that Garber would have allowed them to play a game of chess in his sacred workspace.

For better or worse, Garber is often associated with American impressionism, a movement that almost always presents domestic life in a highly idealized and romanticized vein: elegant society ladies in frilly dresses, tea parties on terraces, perfect little children frolicking in flower gardens. What's striking about Garber's figures is their plainness, their lack of pretense. Both son and mother are wearing everyday clothes that look well worn and comfortable. The young man leans on the open studio door, hands in pockets, sleeves rolled up, as if he's momentarily stretching his legs while contemplating the next move. His mother leans forward, her head gently cradled on two fingers, right hand resting lightly on her casually crossed legs. The mood is silent, inward, meditative.

Time passes slowly . . . yet it passes. Garber's son will eventually grow tired of leaning on the door, pull up a chair, and sit down. His mother will raise her hand to the chessboard, make her move, then lean back and uncross her legs. Soon the game will be over, the sun will go down, and the studio doors will close.

On one level this painting depicts a single, fluid moment in the flow of time, a moment that exists briefly in just this configuration, never to appear again. Yet this fleeting moment is enfolded in a more expansive universe—a universe of brilliant light and infinite space. Warm sunlight streams through the studio doors, highlighting every fold and wrinkle in the young man's clothing and making the windows glow. The chess players are alone in their world of light, the doors stretching high above them; the intimate interior of the studio opens out to a wide, sunlit lawn, with the sky just visible over the tops of the luminous trees.

Garber loved the surfaces of things—the texture of his son's pants, the smooth and shiny patina of his wife's white apron. The painter's attentive eye lingers on the contours of the delicate curtains; every thread is lit up as the sunlight passes through. Garber was rooted in the particularity of the world— in what you can see and touch and taste. But what a dreamer he was! A dreamer in the best sense of the word: a man who had one foot in the here and now, one foot in the eternal.

Lance Humphries, the author of Garber's recently released catalogue rai-sonné, calls the studio in *Mother and Son* the artist's "secular chapel," with the interlocking arches in the studio doors reminiscent of a Gothic cathedral and the glowing windows resembling stained glass. These religious associations are more covert than overt. Garber did not have an obvious spiritual agenda that he was trying to force on his viewers. Nevertheless, a deeply felt spiritual-ity flows through his work, a spirituality that is no less intense because it's also quiet.

There's an ancient and very simple question at the heart of a painting like *Mother and Son:* What is this phenomenon that we call "reality"? What is it in our lives that is truly real? Certainly *things* are real—the things of the world—that which we can hold in our hand, the hand itself that holds. Garber painted the infinite variety of the physical universe in loving detail: the opulent folds of his wife's sleeve, the morning light shining through his daughter's golden hair. His work reminds us that we're surrounded by things, and we ourselves are things. Like the two chess players, our lives are made up of a succession of moments that are here and gone. We are mutable, temporary: we move, we change, we grow, we die.

Yet in Garber's universe there's much more to reality than what we can see and touch. Every ordinary thing, every fleeting moment, is infused with the transcendent. We're creatures of the earth who dream of heaven and who even catch an occasional glimpse of it here. To Garber, "heaven" was not somewhere else, a distant, unreachable goal. Heaven is *real,* right now, in this ordinary yet eternal moment. In fact, the entire distinction we make between the ordinary and the eternal may, in the end, be false. Garber's chess players, while very much of this earth, are not separate from the light and space that surround them. The studio doors open out to the infinite. The ordinary and the eternal are one.

Garber was born into a traditional Baptist family and became an Episcopa-lian; while he was serious about his spiritual life, he didn't talk about it much, and he was never known to quote Emerson or Thoreau. But the seamless inter-weaving of the temporal and the timeless in his work is reminiscent of some of the core ideas of American transcendentalism, which was rooted in a simple appreciation of the particulars of nature—as in Thoreau's wry comment that a true huckleberry never reaches Boston because only the person who picks a fruit tastes its full flavor—as well as an intense awareness of the presence of the eternal in our everyday lives.

Emerson might have been speaking of *Mother and Son* when he said, "Light is the first of painters. There is no object so foul that intense light will not make it beautiful." And Emerson, like Garber, felt the presence of the divine in the touch and feel of things:

We live in succession, in division, in parts, in particles. Meantime within man is the soul of the whole; the wise silence; the universal beauty, to which every part and particle is equally related; the eternal ONE. *And this deep power in which we exist, and whose beatitude is all accessible to us, is not only self-sufficing and perfect in every hour, but the act of seeing, and the thing seen, the seer and the spectacle, the subject and the object, are one.*

Given the ecstatic nature of much of his writing, it's not hard to imagine Emerson in his seventies echoing what Garber said in his final decade of life: "I am a very happy man." Yet Emerson's exuberant prose grew out of a life of almost unimaginable tragedy: the death in his childhood of both father and sister, the loss of his first wife and two brothers from tuberculosis, and the death of his five-year-old son from scarlet fever. So Emerson's transcendental theology did not come from ignorance or denial of suffering but was grounded

. . .

Daniel Garber (1880–1958), *The Orchard Window*, 1918. Oil on canvas, 56 × 52 inches. Philadelphia Museum of Art: Centennial Gift of the family of Daniel Garber, 1976

in the certain knowledge of how terrible life can be. That knowledge lurks behind every ecstatic word, giving strength and substance to his idealism.

Garber never knew the kind of extreme turmoil and grief that Emerson experienced. But even though Garber declared himself a happy man, it must be pointed out that while his rural home, Cuttalossa, may indeed have been Disney-esque, he did not lead a fairy-tale existence there.

Garber had his own full measure of troubles in his life. His wife was known to be moody, even depressive, and her emotional condition was sometimes a matter of concern for her family. There was serious and ongoing tension between Mary and her daughter, and as the years went by the emotional connection between the artist and his wife became increasingly reserved and formal. Garber suffered major financial losses in the stock market crash of 1929 and experienced the typical "empty nest" loneliness when his son left for college around the same time.

Garber also lived through what was arguably the most violent and horrific half century in human history. As an educated man he was certainly aware of this wholesale suffering, and while his own difficulties never reached such cataclysmic proportions, he was a human being like the rest of us and in no way led a pain-free life. Why, then, did he always keep his work "on the sunny side of life," as the old Doc Watson song puts it? Why the otherworldly tranquility, the idealized beauty?

The best answer to this question is also the most obvious: it just wasn't in Garber's nature to focus on what the same song describes as the "clouds and storm." The temperament of some artists calls them to be in the trenches, battling the brutality and injustice of the world. Other artists are like birds who perch on a tree above the battlefield and sing about how beautiful life is. Mozart was such an artist. So was Vermeer—in fact, Vermeer, with his mysterious integration of everyday life and timeless beauty, may have been Garber's true ancestor.

Perhaps Garber was well aware of the clouds and storm, but he decided to show us what life could be, even what it *ought* to be. If this were his only motivation, then his work would be little more than a sun-drenched fantasy, a retreat from life's terrors by someone who did not possess the moral courage to face them. He would, indeed, have been what some of his critics have implied: a lightweight. But Garber was not a utopian. His goal was not to paint some idyllic but unreachable vision of the world as it should be. Like Emerson, he was trying to show us the world as it is, if only we could find the eyes to see it.

THE SMILE AT THE HEART OF THINGS:
EMMET GOWIN'S SPIRITUAL JOURNEY

*"There is something predatory in the act of taking a picture. To photograph people is to violate them."**

The baby rests on his mother's arm, back toward me, his tiny, bald head framed by the just-visible sky in the background. His fleshy arm stretches loosely across her bare collarbone, gently enfolding her neck, while locks of dark hair fall casually over the graceful curve where the bodies join. The woman's chin is nestled on his shoulder, her lips just brushing the soft skin above his neck. The two forms fit together like pieces of a puzzle. Though I can barely see her face, her expression hints at an almost religious intensity of feeling. These two beings—the woman, the child she brought into the world—were once joined together, and perhaps their bodies still remember.

Move back a step or two and another person comes into view. This is a photograph—someone had to make it. Someone who must be almost as close with these two people as they are with each other. Moments like this one rarely happen in the presence of an outsider, especially one with a camera in his hand.

This picture is about love. The image exudes it from every molecule of silver deposited in the developer tray. I don't mean just the obvious physical and emotional connection between the two protagonists. The fact that the image even exists is evidence of a three-way union, a family. The energy between mother and child reaches outward, like an invisible electromagnetic field, joining them with the person behind the camera, the father.

There's someone else at this family get-together: Me. Normally I would say something like "the viewer" to maintain the proper critical distance. But it's closer to the spirit of this picture to keep things in the first person. When I'm looking at it, the photograph speaks not to some impersonal audience but to me, and it lives or dies on its ability to stir me up, to connect.

A moment of intimacy occurs between a father, a mother, and their infant child when all the doors are open to the love they feel for each other. One of

. . .

* All italicized quotes in this essay taken from *On Photography,* by Susan Sontag (Picador, 2001).

the people involved has a camera and records the light bouncing off the other two. Why? Most of us take pictures of our families simply to preserve the occasion for ourselves, with little or no awareness of how much information a photograph can convey. But this picture is elegantly designed, with a certain careful spontaneity that reveals a highly cultivated intelligence at work. And it was made at a peak moment when the nature of the bond between the participants is fully revealed. In other words, the photograph was skillfully observed, selected, and printed strictly for its power to communicate.

It's a gift, from the person who made it to me, and to you. We've been invited to share in something that, as strangers, we have no right to see. Nakedness is usually reserved for the closest of friends, and these people are astonishingly, beautifully naked. There's generosity at work here, and courage too. Not many people would choose to be so unguarded in front of a camera, to let their most private and intimate feelings flow so openly through the lens, into the image, to us.

"Between photographer and subject, there has to be distance."

I once read about a cameraman filming a movie scene from a helicopter who leaned out farther and farther to get just the right angle, eventually falling to his death. The story provides an appropriate metaphor for the dangers to body and soul that the camera can represent to the unwary. When you hold an imposing, ugly-looking machine in front of your face, how can you expect to have any real contact with your surroundings? And if you look through the viewfinder long enough, what you see in that little window starts to seem less real, as if the world was put there for your observation and amusement.

Even the language of photography is hostile and acquisitive. You take a picture—take what, from whom? Or you "capture" the moment—but why stop with capturing that innocent little flower of a moment? You might as well rough it up a bit just to show the world who's in charge.

Anyone who has spent a few minutes smiling politely while looking at someone's snapshots knows that a photograph doesn't necessarily communicate anything important. Most of the time the pictures we make do nothing but remind us of what we've already seen and already know, and they have no intrinsic content whatsoever.

But there's another side to the story, and his name is Emmet Gowin.

. . .

Emmet Gowin (b. 1941), *Edith and Isaac, Newtown, Pennsylvania*, 1974. Gelatin silver print on paper, 6⅝ × 6⅛ inches. James A. Michener Art Museum. Museum Purchase. © Emmet and Edith Gowin, Courtesy Pace/MacGill Gallery, New York

There are endless ways that the camera can alienate people from themselves and each other. But Gowin uses his camera to make connections: with his family, with the people who look at his pictures, and with some of the simple questions that human beings have asked since we were eating mangoes in the treetops. While we make uncounted billions of meaningless pictures, and the photograph is a symbol of empty-headed banality, Gowin turns each image into a vessel of living energy, a poem that contains a fragment of his insights, his values, and the particular way he sees the world.

"Strictly speaking, one never understands anything from a photograph."

Born in 1941 in Danville, Virginia, the son and grandson of ministers, Emmet Gowin made his first picture at age sixteen when he was deeply moved by an Ansel Adams photograph of grass sprouting from a burnt tree stump. He went to business school for two years after graduating from high school, but he soon realized that the world of Kmarts and commerce was not right for him. He began studying photography seriously in a college graphic arts program in his early twenties, and he was initially attracted to the kind of humanistic portraiture and street photography found in MoMA's famous 1955 exhibition *The Family of Man*. But by the time he reached graduate school, he discovered that, like all young artists who are truly called to the task, he had a problem: What fragment of the endless assortment of earthly phenomena was he going to call his own?

Neophytes tend to bounce around from one big idea to the next—usually someone else's. But ideally these little "affairs" will blossom into a real relationship, in which the photographer literally falls in love with something and every image says, "This is what I care about. This is who I am." Artists can flounder for years before reaching that blessed moment when their work has the urgency of a newly sprouted seedling desperate for the light.

Many thoughtful artists have struggled to describe this hunger, as well as the emptiness they feel when, for whatever reason, it goes away. Perhaps, as the poet and Biblical scholar David Rosenberg has pointed out, the craving that artists feel for contact with this interior voice is not that different from the Psalmists' search for an ever more intense relationship with the divine. Wherever such ideas come from, artists live and die for them. But many young artists never develop the skill and patience needed to separate the weeds from the flowers. So their art never deepens. Rainer Maria Rilke may have been talking about this problem in *Letters to a Young Poet* when he said, "A work of art is good if it has arisen out of necessity."

When Emmet Gowin first planted his flag and claimed his territory, he made a peculiar choice, a choice that should have condemned him to obscurity.

Instead of opting for whatever the New York galleries happened to be showing, or flying off to Nepal in search of the last great truth about art and life, young Emmet chose to stay at home. In his mid-twenties he had a moment of insight that was so simple and so beautiful that it had to come from a genius or an idiot. As he worded it, "I was wandering about in the world looking for an interesting place to be, when I realized that where I was was already interesting."

So where was he? No place special, really—not a war zone, or a ghetto, or Yosemite Park, or any other place where serious photographers have typically found their voices. Just a young man with a young family, living in Dayton, Ohio, of all places, and working at his first teaching job out of graduate school. You can imagine some well-meaning friend taking him aside and saying, "Come on, Emmet, what's so interesting about that?"

There were several character traits that guided Gowin on his photographic journey. The one that motivated this decision was *innocence*.

. . .

Emmet Gowin (b. 1941), *Nancy, Danville, Virginia,* 1969. Gelatin silver print on paper, 5½ × 7 inches. James A. Michener Art Museum. Museum purchase. © Emmet and Edith Gowin, Courtesy Pace/MacGill Gallery, New York

As children we live like no one has ever lived before, stumbling into things as if we're the first person who ever tripped over them. The problem is, as we get older, all the bumps and rough edges get worn down, and the world gradually settles into a comfortable sameness. Most of us have no idea what we've lost, until a child or an artist comes along who makes the familiar seem unfamiliar and reawakens, however briefly, the sense of wonder that is our birthright.

What could be more familiar than Gowin's subject of choice, the family? There must be a couple billion of them in the world. Even worse, as a symbol the family has been so abused by right-wing ideologues that even hearing the word can induce a noticeable wince. But it's here, at home, a place most of us take for granted, that Gowin's innocent genius began to flower.

The family is so universal, so basic to who we are that it seems unnecessary and unnatural to even think about it. Emmet Gowin thought about it.

Fertility—the union of male and female creating new life. Happens in the family. Growth—the nurturing and shaping of life, the imparting of knowledge, culture. Happens in the family. Almost all the great moments and rituals revolve around the family—birth, coming of age, marriage, death—as do the archetypal relationships that define how we interact with people: all the permutations and combinations of mother, father, husband, wife, son, daughter, sister, brother, aunt, uncle, cousin. The family is rootedness—where we learn how to live and be in this world, where the seed of selfhood starts to grow. Families are how we join, with place, home, community.

Finally, there's the most fundamental element of the family, DNA. That primal corporeal "stuff," which evolutionary biologists now claim is the one and only reason we have for living—to make sure the next generation is blessed with a few strands of our very own deoxyribonucleic acid. Through DNA we literally share our bodies with both our ancestors and descendants. So when we get together for all those family reunions and picnics, if we listen carefully between bites of greasy chicken, we just might hear our DNA whispering that Uncle Fred really is part of the family despite his tantrums and bad jokes.

Maybe it isn't so surprising that Gowin turned to the family as the "prima materia" of his art. But what *is* surprising is the way he did it. He could have made some epic, *Life* magazine photo essay that revealed the ultimate truth about the subject. I can see the headline: "The American Family: From the Barrio to the Breakfast Nook." For a young artist fresh out of graduate school with a wife and kids to support, there is tremendous pressure to produce a body of work that will make a splash, that will lead to high-profile exhibitions and a twenty-page résumé. Your job and your career depend on it.

Instead, Gowin decided to photograph *his own family,* and he did it in a way that was militantly personal and "subjective." To really understand why this was so significant, you have to think of the risks. In the late sixties there was an established tradition of mythic photojournalism, personified by the great master of the field, W. Eugene Smith. Gowin himself was highly influenced in his student years by Robert Frank's groundbreaking documentary project *The Americans,* and Gowin did his first serious work photographing civil rights demonstrations and African American churches in Virginia and North Carolina. It would have been easy for him to slide into the journalistic mode, and had he done so he would have found a support system of jobs and publications readily available.

But a serious photographer making a lengthy and intimate study of his own extended family was essentially virgin territory. So Gowin turned away from the safe, conventional path toward the unknown, and in the process he ran the very real risk of having his pictures mistaken for that most commonplace and reviled photographic genre, the family snapshot.

. . .

Emmet Gowin (b. 1941), *Edith and Elijah, Danville, Virginia,* 1968. Gelatin silver print on paper, 8 × 10 inches. © Emmet and Edith Gowin, Courtesy Pace/MacGill Gallery, New York

It took innocence for Gowin to see that he could stay home and still make pictures. It also took *conviction*. I'm talking about the kind of conviction that artists feel when practicing their art is also a spiritual journey, when images start to arise spontaneously, magically, almost as if they were meant to happen and someone else is making them. It didn't matter that he was breaking new ground, taking risks, dancing on the edge of snapshot territory. The man could no more have turned away from this idea than water could flow uphill.

"There is an aggression implicit in every use of the camera."

So Mr. Gowin began to photograph the people he knew best: his wife, his two young sons, and his wife's family living in Danville, Virginia. At first glance they are unassuming little pictures, informal and apparently artless. There's number-one son Elijah as a baby, frolicking in a little plastic pool with the "girl next door." Niece Nancy lies on the grass surrounded by her dolls. His wife, Edith, stands in the midst of a chaotic heap of wrapping paper after a very busy Christmas morning. Throw in a few travel shots, a backyard swing set and garden, and a sunset or two, and we'll have a typical family album.

But something else is growing in Emmet's garden. You don't find too much genuine emotion in a snapshot, but in Gowin's work it's everywhere.

Young Nancy stands by herself and faces the camera, with her arms twisted together in front of her like some preadolescent contortionist. She's holding a perfectly shaped egg in each hand with an impossibly delicate grip, and her upturned face radiates joy bordering on rapture.

Family portraits make a point of hiding the reality of family life behind vacuous grins and stiffly posed bodies lined up with military precision. But there is fierce and gentle honesty in Gowin's pictures. The photo of Elijah in the swimming pool, for instance—both he and the girl are naked, and in the process of reaching out to grab something she has placed her tiny derriere within inches of the boy's face, exposing her bare genitalia both to him and the camera. Shocking. But this is the way kids are! Not only are they not ashamed of their bodies, they're morbidly curious, and this photographer isn't afraid to show us what they're really like.

Gowin has a simple rule: If it's real, it's worth paying attention to. Sex is real, and like it or not, children are obsessed with it. So he gives us a picture of Nancy at age ten or so, on her back in freshly mowed grass, with her legs spread wide and a shirtless boy on top of her. Shocking. But the content of this picture could not be more pure and beautiful. The girl is holding her mock lover in a passionate grip, her fingernails digging into his neck, with a look of breathless excitement on her face that seems to say, "So this is what it feels like! How wonderful!"

Photographers who use a view camera are obsessed with the technical minu-tiae. They're trained to make images that are sharp and evenly illuminated from corner to corner. Early in his career, due to either ignorance or poverty, Gowin put the wrong lens on his view camera, and his pictures became neat little circles in the center of the frame instead of the normal rectangles.

This is the photographic equivalent of emitting a loud fart in church. No self-respecting art photographer would even dream of showing such an image in public for fear of being dismissed as a rank amateur. Photography, like almost every other human activity, is full of rules and conventions, and there are plenty of people who happily will tell us what we can and can't do. Once we learn the rules, it's very difficult to avoid being controlled by them.

Looking at the circle in the middle of the frame, Gowin could easily have said, "I'm not allowed to do that" and returned to making pictures in the con-ventional way. Instead, he took to the idea like a convert at a revival meeting. He didn't do this just to be rebellious, though I suspect that he took a certain pleasure in thumbing his nose at the rules. He did it because it worked.

Somehow he managed to free himself from all the "shoulds" and "supposed to's" and looked at the phenomenon like he had never seen a photograph

. . .

before. He saw that the circle makes the images feel as though you're peering through a peephole into another world, a world that's somehow different, magical. The circle surrounds the images with darkness. All the energy, warmth, and light of human connection gradually disappears into a rich, inky blackness, creating a sense of mystery vaguely reminiscent of Rembrandt's chiaroscuro style.

Woven throughout Gowin's exploration of family and community is the strong, sober presence of his wife, Edith. She is the sine qua non of this work, the center around which all else revolves. We see her paired with her sister and other relatives, lying on her back in a tent, standing calmly naked in front of the camera, and even, in a much-discussed image, silhouetted gracefully in a doorway wearing a delicate white nightshirt and urinating on the floor below. Gowin is fascinated with her gestures, her body, her daily routines. In a number of images she's pregnant, and it's clear that he's drawn to her "otherness," her feminine power to create life.

Emmet loves Edith. He loves her not as an adolescent who sees only himself in everything, but as an adult who wants to know who she is. Mature love is never passive. To love and to know, or at least try to know, are synonymous. And the evidence of these pictures is that this particular lover uses his camera to get to know his wife.

Emmet Gowin is a bloodhound. As a young man he caught the scent of something, and he spent the next decade or so sniffing out that scent in every corner of his life, using a trusty Deardorff view camera as his principal olfactory aid. And what was he looking for? Gowin is a man who believes in, and lives for, connections. You notice this immediately when you talk with him, in the ready eye contact, the warmth of the voice, and in the many moments of quiet self-revelation that seem to ask only for a similar honesty in return.

What Gowin figured out was obvious, so obvious that most of us never see it. Connection—simple, honest connection that is rooted in the body and finds flower in relationship and has its ultimate expression in the bonds of love, friendship, and family—*connection is reality*. You may not be able to build skyscrapers with it or use it to get to the moon, but it's where we really live.

The hardened rationalist would argue that even our most intimate relationships are defined by cultural norms and are thus illusory, that the so-called "wisdom" of the body is just a programmed physiological response, and that building one's life on the ultimate reality of our connections is hopelessly sentimental and even dangerous, because it encourages irrational and unscientific thinking. I can only reply that if you want objective proof, well, you're not going to find it. But search your own experience. When has the world seemed the most

real to you, the most alive? Is it when you connect with something—a person, a place, an idea—and both body and soul are energized, so much so that you're compelled to explore what you love?

You can be rational and objective and detached all you want. You can play the "cogito ergo sum" game until those proverbial cows come home. But you're not going to get much closer to reality, meaning the genuine lived experience of the organism. Emmet Gowin connected—with family, with place, and above all with the experience of connection itself. He made his poetry out of it. And in doing so he made his own life real.

"The camera's rendering of reality must always hide more than it discloses."

There's something I need to say now about Gowin and his pictures, and this last and most important point takes me into an area where I must abandon any pretense of "critical thinking." That area is religion.

Like gravity or the weather, love is an ingredient of life that we think we understand because we're around it all the time but in fact know very little about. I want to peel away some of the layers around this vast subject and talk about love in the context of Gowin's images, as simply the bonds we form with the people, places, and things that make up our individual worlds.

Stop reading for a minute and make a mental list of everything that you're attached to in your life.

Do you find, like me, that there's an assortment of objects? My car, familiar household items, clothes, home. Are there places? Places in nature, places where you've had an intense experience of one kind or another, places that are made larger than life by memory. Is there a community of friends and acquaintances, a gradually narrowing circle of special people, ending up with the most intense bonds with spouse, partner, family?

Stop reading again, and try—really try—to imagine what your life would be like without this vast network of connections. . . .

It's like imagining Wall Street without currency, or a modern city with no electricity. To me, life would be inconceivable. I'm sustained and nurtured by my connections both internal and external. They're a kind of glue that holds things together. Without them, some essential light would disappear from my life, and the world would fade into darkness.

Did you know that the words *religion* and *ligament* are related? They both come from the Latin root *ligare,* which means to bind together or connect. I bring this up because I believe that if you're looking for evidence of the divine in your life, you need look no further than these connections you've made with the world.

Back in the late sixties, when practically every male under age twenty-five was desperately worried about the draft, I met a conscientious objector who had answered his draft board's question about why he opposed the war with three words: "God is love." This ancient phrase has been repeated so often that it has almost lost its meaning. Recovering its meaning is not easy, because you'd have to explain what love is, and explaining the nature and purpose of love would be like a one-celled plankton trying to "explain" the ocean.

I simply want to make the point that every honest connection we make is at heart an act of worship. I'm talking about friendship, of course, but also about those countless little moments of understanding and contact in everyday life, when you connect with a house, or a tree, or a hillside, or a building, and some inner tuning fork starts to involuntarily resonate. Or when you're moved by a book or a picture that stirs some deep sense of recognition. The bonds we make are the bricks and mortar of our lives. Or maybe we're the bricks, and love is the mortar that holds things together.

To understand Gowin's work at the deepest level, you must understand that, to paraphrase Norman Maclean's famous opening line in *A River Runs through It,* in Emmet's house there is no clear line between religion and photography. His decision to make his art out of the people and places he loved was at heart a religious act that arose from the intuitive desire to anchor his life in the spirituality of connectedness.

I suspect that something about his own family life and upbringing left him feeling rootless, uncentered. What drew him to his wife's family was their state of "grace," meaning an innate, natural piety that grew out of their solid contact with the earth and the basic rhythms of the universe. In exploring his connections with them, he was centering his life in the sacred mystery of love. This is what gives these photographs their subtle religious aura and may in part explain why people continue to be fascinated with them so many years after they were first exhibited.

There's something so wonderfully healthy about Gowin's humble affirmation of the magic and poetry of intimacy. Our culture teaches us to stand back and observe instead of trusting the simple and the immediate. We believe only those truths that are measurable and objective. We need statistics, demographics, and surveys to tell us what's real. These one-sided assumptions about the nature of things have worked their way into our very souls, coloring everything we say and do.

. . .

Emmet Gowin (b. 1941), *Barry, Dwayne, and Turkeys, Danville, Virginia,* 1970. Gelatin silver print on paper, 8 × 10 inches. © Emmet and Edith Gowin, Courtesy Pace/MacGill Gallery, New York

We've accomplished a lot with our rational equipment. I have no desire to return to the glorious days of the forty-year life span and the Spanish Inquisition. But the more unbalanced we are in our worship of the god of reason, the less connected we are with ourselves and the universe, and the emptier we feel. What I'm talking about is a great cultural wound that has its roots in the industrial and scientific revolutions of the nineteenth century, eighteenth-century rationalism, Newton and Descartes, the Renaissance, and even, according to some people, certain attitudes of the ancient Sumerians and Greeks.

Emmet Gowin is not some larger-than-life hero who set out to heal the world's wounds. He's just one more creative soul making his way down life's circuitous path, trying to do the one thing that is in his power: heal himself. He uses his camera to make things whole again by centering his life in the simple truths that people have known since there've been people. This is his peculiar genius: to teach us what we already know, and to make us feel that we're learning it for the first time.

. . .

Emmet Gowin (b. 1941), *Edith, Danville, Virginia*, 1970. Gelatin silver print, 8 × 10 inches. © Emmet and Edith Gowin, Courtesy Pace/MacGill Gallery, New York

Gowin takes us by the hand and leads us through his "peephole" into a
secret world, *his* world: a place that is filled, as he says, with "a God of nature—
beneficent, creative, and manifest in love of people for each other." Actually
many artists take us on a journey into their private realities, and often at the
end of this journey we're left holding a few broken shards and trinkets in our
hands. Or else the personal journey leads only to poverty, emptiness, and pain.
With Gowin, as we travel inward to the mysterious universe of one individual
life, a door opens out to the ever-larger spaces of the human heart: to the fam-
ily, the foundation of consciousness, personality, and growth; to love and the
possibility of wholeness; to the immanence of the divine in our lives.

His work embodies the paradox of individuality that was so beautifully
voiced by Walt Whitman in *Song of Myself*: in exploring the life of one individ-
ual, one community, we catch a brief glimpse of the universal and the eternal.

*"Nobody (today) understands how anything, least of all a photograph,
could be transcendent."*

Since the core message of Emmet Gowin's work is to trust and honor the per-
sonal, I'll end this essay with what his pictures mean to me. Despite the frag-
mented nature of our lives; despite the reality of evil, violence, and death;
despite the trials and horrors that life can heap upon our plates; despite all
these things, Gowin's photographs tell me that spiritual and emotional health
is not only possible, it may be as natural as breathing. Gowin's photographs
tell me that God exists, and He/She/It can be found in the simple as well as
the lofty, in the most basic experiences and rituals of life as well as the sym-
phony halls and cathedrals. Gowin's photographs tell me that living life hon-
estly, with a sense of connection to self and community, is actually a sacred
gift, a sacred duty. If we can somehow let our souls become big enough and
innocent enough, we can still find the smile at the heart of things.

. . . Beauty . . .

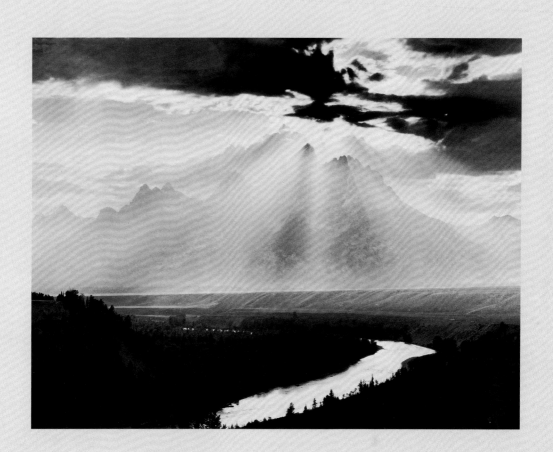

BEAUTY

Beauty. A word we throw around a lot. Sometimes with irony: "Isn't *that* just beautiful!"—meaning, what a rotten thing has happened. Sometimes with enthusiasm: "Ain't she a beauty?"—which could apply to a freshly caught trout or a black eye.

If you pay attention to amateur photography, certain things are always beautiful: sunsets, flowers, turning leaves, puppies, young women with the right bone structure. Stuff that is new, bright, clean, being born, blossoming, or happy is beautiful; stuff that is old, dull, dirty, dying, withering, or sad is not beautiful.

Scientists recently announced that a beautiful face is a beautiful face, and it doesn't matter where that face comes from, or when it's seen, or who's seeing it. So beauty is universal, timeless. But—it's also "in the eye of the beholder." Beauty is just a matter of each person's predilections and fancies. What attracts the eye. Personal. Subjective.

So what is it? What is beauty? The ancient question. When the Neanderthals dug a grave, why did they place flowers and tools there and carefully position the body as if the person were sleeping? Did they think their dead friend was going to a more beautiful place? When the cave painter drew a bison, why did he make the contours of the body so graceful? Did he stand back from the wall after he finished and say, "What a beautiful thing I just made!" Did he even have a word for beauty? If you *are* beauty, do you need to have a word for it?

Is beauty the way things are? Or is it the way something appears—a particular configuration of lines and planes, a quality of light?

Is beauty how the world is put together? Or is it something inside *us* that we tell the world to be?

* * *

. . .

Minor White (1908–1976), *Grand Teton National Park, Wyoming*, 1959. Gelatin silver print, 10½ × 13 inches. Reproduced with permission of the Minor White Archive, Princeton University Art Museum. Copyright © Trustees of Princeton University.

When I was a teenager, I walked home from high school along a road that wound its way up a long, sloping hill. There were few trees, and the hill offered a clear view of the mountains and the sky. Every afternoon I trudged up the road, lost in my own thoughts, going over what had happened in school, wondering what the next day had in store for me. I was so shy, so uncomfortable in my own body, that when a car drove toward me I always turned my head. Looking at the driver made me uneasy.

I was at war with myself—pleasant and polite on the surface, but angry and violent underneath. Life stretched before me, but there was no clear path, no center. Nothing was real. I was a lost soul.

Once in a while I glanced up at the clouds and sky, and what I saw was—clouds and sky. Then something strange happened. One day in the middle of winter, when the sun was low on the horizon, I looked up and saw the afternoon light coming through the clouds, and instead of seeing just clouds and sky, I saw—but words disappear, and only memory remains.

A crack suddenly opened and the world poured in—the world as it really is. I saw it—for a moment, I saw it. This place where we live is not just lifeless objects, not just inert matter. The world is alive! More than alive—the world is beautiful! So beautiful that when you see it you stop breathing and stand there, with your mouth open, and stare.

Then the crack closed, and once again I was trudging up the road. But I was no longer lost. I'd been sleepwalking through life, and now I was awake and hungry.

There is something out there, in here—something in the very molecules we're made of—something that makes a cloud more than a cloud, that makes it beautiful.

What if I could see that beauty all the time, I asked myself, instead of just a glimpse? Where would I have to go, who would I have to become to make that happen?

What is beauty? Beauty awakens.

Beauty lights the fire and stirs the pot. It takes what is hardened and stuck and sets it in motion.

Beauty turns you around and pulls you in. It's a magnet. Once seen, once felt, never forgotten.

Beauty tells a lonely, drifting teenager that it's not enough just to trudge up the hill staring at the ground, never leaving the well-worn path. *I am beauty— follow my path—nothing else matters.*

Beauty says, you gotta sing, you gotta dance, you gotta shake it up and move, move to the music.

Oh, you think you have a choice? If you see beauty, if you hear its call and then turn away—that, my friend, is death. You might eat and sleep and breathe like everyone else, but something inside has dried up and died.

If you're lucky, you might be swallowed by a whale like Jonah, spend some time in the belly of the beast, get chewed up and spit out—and maybe then you'll listen when beauty calls your name.

So goddamn it to hell and screw everything else! I saw it. I gotta have more of it. Beauty is who I am.

Not that it's mine to have. Nobody ever owns it. I can buy a beautiful picture, even buy a beautiful tree or a beautiful mountain, but beauty itself—*it owns me*.

I am possessed. Possessed by beauty.

My family lived on the edge of town, at the mouth of one of the canyons that flowed into the Missoula valley. The road up the canyon was paved as far as the picnic area, maybe four or five miles. We often drove there, especially in the summer. Mom and Dad would pack up the big picnic basket, grab a tablecloth and some silverware, and we would head to our favorite spot. Sometimes we'd light a fire and roast hot dogs, sometimes we took a walk through the pine forest, sometimes we played Frisbee in the grassy meadow by the parking lot.

The road was steep, but we usually saw a few bike riders on the way up, sweating and straining, their feet rotating rapidly because they were using such a low gear. I was twelve or thirteen when we began this picnic ritual, and at that age it was hard to imagine I would ever be strong enough to ride my bike up the canyon, especially on my beat-up three-speed. But my parents bought me a ten-speed in high school, a red one, lean and elegant. Made in France even. How I loved that thing! I rode it all over town, but for a long time I was afraid to take it up the canyon. Afraid of failure, I guess.

It seemed like cheating to put the bike in the back of the car when we drove up for a picnic, but finally I tried riding the bike down the canyon. What a rush! As close to flying as I've ever come—the mountain air blowing my hair back, the asphalt zooming by underneath me, the death-defying angles as I raced around the curves.

After a few months of building up my strength, I was ready to conquer the canyon the other way. Up.

I knew better than to go for the whole thing immediately. It took me several tries, going farther each time, before I finally made it all the way to where the pavement stopped, just above the picnic area. I'd never worked so hard in my life. My heart was thudding, my lungs were raw, my T-shirt was soaked—but I had done it. Victory! It was my "Rocky" moment. If it had been the thing to do in 1970, I would have raised up my arms and punched the sky.

I pedaled over to the picnic tables and stretched out on one, savoring the thought of the downhill ride, which would be even sweeter because, for the first time, I had earned it.

After that I rode up the canyon regularly, at least once a week in the summer. I was especially happy when there were no cars nearby and the only sounds were the bike tires hitting asphalt, the steady clinking of chain on gear, and my breath rushing rhythmically through my lungs. The trees flowed silently by on either side—at least I thought they were silent, until one day I heard it. The sound.

My body was humming along like a long-distance runner at top speed. The last thing I wanted to do was stop. But I couldn't help it. The wind was blowing through the pine trees—I must have heard it a thousand times before. But until that moment I was too focused on myself to *hear* it. The sound came from another world—foreign, yet strangely familiar, as if it had always been there, like an ancient, unknown voice inside me. Rising and falling, sometimes near and sometimes far, a whisper, then a roar that penetrated my skin and flowed through my body, but I had no body, I didn't exist, there was only the wind. This sound was beautiful, but a different kind of beauty, a beauty that squeezed me and wrung me out and shook me until there was nothing left to shake.

I was never the same after that. I had been given a gift, a beautiful and terrifying gift—terrifying because suddenly I knew how small I am, and I knew that what I'm part of is bigger than the biggest thing I could ever imagine. Terrifying because my life wasn't my own anymore. I had heard the sound. There was no turning back.

What is beauty? Beauty transforms.

Rilke wrote a poem about an ancient sculpture of a Greek god, and at the end of the poem the sculpture speaks: "You must change your life." That's the only option when you come in contact with beauty, real beauty. You must change your life—but how? Into what? The god is silent.

But there is a way.

Beauty says, listen to me, follow me, and I will turn you inside out. You must change your life, yes, but you must let your life be changed, let beauty transform you, until you yourself are beautiful and the whole universe is beautiful and beauty is no longer a surprise, an interruption, but is here, now, all the time.

Beauty is a sledgehammer that breaks open a frozen ball of concrete, and inside is a leaf that unfurls and turns toward the light.

Beauty is the crash of a gong echoing through the woods, and suddenly the dust on the dry ground starts to dance and every pebble vibrates and trees burst out of the earth and shoot up toward the sky.

Beauty is—*yes! Yes* to growth. *Yes* to desire.

Carl Sandburg wrote a poem about desire: "If thoughts come and hold you," he said, "if dreams step in and shake your bones, what can you do but take them and make them more your own?" He was thinking about beauty, dreaming about beauty—and it was beauty that shook his bones.

Whatever journey needs to be made, whatever obstacles are in the way, whatever walls need to be broken down—nothing else matters once beauty enters your life. Grab on and hold on and never let go.

A blind man sits by the road, begging. Day after day he goes to the same spot, and each day he receives less and less, and his empty stomach grows emptier. Finally, about to give up, he hears footsteps on the road and says, "Have mercy on me!" But he's just a beggar, and the people walking by say, "Quiet, worm—we're busy." But the blind man is desperate, and he cries out again, louder, "Have mercy on me!" And his neighbors tell him again, "Shut up, you cockroach—we have better things to do." But the blind man is even more desperate, and this time he shouts: "Christ, have mercy on me!"

Then Christ turns to him. "Tell me what you want."

"I want to see."

Suddenly the blind man can see. At first he rubs his eyes, confused. Then he jumps up, stares at the clouds and the sky, and finally says, "My God, it's beautiful! I didn't know it was so beautiful!"

"Your hunger has healed you."

Beauty is—I want to see! I want to live!

I want to turn and burn in the beautiful fire until there's nothing left but an empty vessel waiting to be filled.

But beauty destroys words. It sucks all the language out of my soul and leaves me silent. . . .

Beauty is God, and God is Beauty. That's what it is. You can poke me, whack me upside the head, and kick me in the behind 'til it hurts like hell—but I ain't changin' my story.

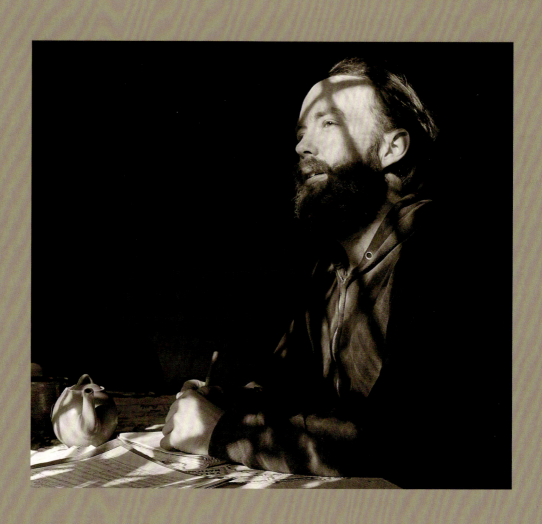

JOURNAL EXCERPTS, 1975–1982

After graduating from high school in Missoula, Montana, I spent two years studying music and philosophy at the University of Montana. In 1974 I transferred to the University of Pennsylvania, which had one of the best composition faculties in the country. I was excited to be studying music in such an intensely creative environment but was having great difficulty with my own creativity. The music that I knew was in me seemed to be buried under layers of concrete and emerged only fitfully and sporadically. Slowly it became clear that my creative difficulties were symptomatic of much deeper problems. I started to read every psychology book that I could get my hands on. I began to pay attention to my dreams, which had become increasingly vivid and powerful.

I thought I was on the right track. I was on the verge of finding what I was looking for. But then came the night of October 19, 1975, the night when the door into darkness opened and the journey began.

September 27, 1975
Just after waking up this morning, I saw in my mind's eye an image of a man dressed in dark clothes. The man said, "There is enough material for a thousand days. In this case, it is better to start over again" (a thousand days is a cycle of time). He spoke as if comparing me with others in my position—like a cosmic doctor's diagnosis.

October 15, 1975
My tendency is to interpret my dreams on a purely personal level, but I'm beginning to wonder if that's not a mistake, in some cases at least. There is a drama going on within me, and "I" am only one of the participants. Sometimes it seems that I only have a minor role! I understand so little of what's going on.

October 19, 1975
I woke up at three a.m. with this psychotic dream. Felt utterly terrified, broken. Couldn't go back to sleep.

. . .

BHP: *Self-portrait,* 1982

"I lose my way on some stairs. As I finally find the right path, I hear terrible screams. It is an old woman, and she has lost her mind. The screams are loud, and very frightening. I pass a man on the stairs who appears to be in great grief. He says, '*You* wouldn't understand, but her egg is broken.'"

October 20, 1975

I have now come as close as a person can to the experience of the psychotic "break" without going over the edge. Never before have I had to fight so desperately to keep my grip on life. My inner world is a wasteland, a wreck. I am agitated and unable to concentrate.

October 27, 1975

I have *no* creative energy, have not written or practiced in over a week, and feel an enormous pressure partly due to my weekly music lessons and partly due to an inexplicable desperation.

> *Out of the depths have I cried unto thee, O Lord.*
> *Lord hear my voice.*
> —Psalm 130

November 9, 1975

This has been one of the worst days I can remember. I no longer hope for a quick recovery.

January 22, 1976

If I had been allowed to develop in a natural way, things would have been very different. But something happened when I was a child that caused me to deny the existence of certain parts of myself—mostly my maleness, the male animal that my mother didn't like and my father didn't protect. These parts became violent and destructive because their natural expression was blocked. Apparently the only way to deal with them is to *experience* them in the ugly form they have turned into. This is like doing penance for past sins, and is also a cosmic "working out" process. Perhaps this explains the inner, destructive rage that seems so characteristic of a neurosis: it's the dammed-up energy of the psychic elements that have been denied their natural expression. I wonder if this rage could get so powerful that the person would actually wish to destroy himself, as the only recourse left to end the tension. At any rate, what I have discovered in myself is the sickness of the age. Hitler had a picture of his mother *over his bed*.

March 19, 1976

Oh god, am I depressed inside: a deep, black drain on my energy. I need all my will-power to fight it. I know it will pass, but the waiting is awful. I guess it's the difficult times that make you strong. I feel almost a man now, as if I am no longer looking through a child's eyes. My outer world is a mess—far behind in school, withdrawn from friends and spouse. Even though this puts pressure on me, I've come to the conclusion that nothing is more important than this inner search. I must submit to it and simply wait. I feel in my bones that I will be a composer.

May 3, 1976

If I wanted to give up, I could start trying to convince myself that the situation is hopeless, and such self-induced desperation might be justification for all sorts of rash ideas and acts such as suicide or fits of depression. It takes the greatest strength to simply plod on day by day, with no real goal, yet trying to remain con-fident that something is working itself out.

May 24, 1976

The most difficult thing to endure now is the sense of dormancy—of expectation. I go through each day in a dream, waiting, always waiting. I'm beset by doubts, really plagued by them, like flies buzzing around my face that I'm never quite successful at scaring off. I'll just slap one, and then another rushes in. "What if I never get out of this state of limbo?" I ask myself. "What if I'm deluding myself, waiting for nothing, an empty pipe dream?" There's no sure answer to these questions. All I can do is try to hold on to my inner sense of self, and not allow the concentration to die.

Giving up is really a moral decision. Maybe I won't make it through this maze, but win or lose, I want to be able to say I've been true to myself.

July 26, 1976

I just had a strange thought. For a long time I have felt the presence of spirits around me, my "doctors," who have taken an interest in me and are trying to heal me. What if I am one of them, chosen to be sent back to earth, forget everything, and try to gain redemption for myself—*and them*?

October 8, 1976

Why do these words seem so cheap? Why can't I penetrate to the heart of things, so that my words have meaning? Why do I not *know* anything completely? Everything is half truth, half lie. Somewhere within me there is a pure thought, but it remains within. My back is turned to myself.

October 17, 1976

There is a way to write about yourself and not write about yourself. The way to achieve this is through total honesty. But how can this honest form of expression ever be fully realized, since it involves both conscious *thought* and relaxed, unashamed *feeling* in their purest states?

It's love that lies at the heart of this. Love holds the two together. If you can say to yourself, "I know who I am," then you know your feelings are genuine and your thoughts can penetrate and you can relax and live. And this feeling of identity is the greatest gift, caused by being at one with "God."

October 24, 1976

I feel very confused and unstable, jittery, for no apparent reason. This alternates with moments of great inner concentration, when I'm able to gather myself together, all the disparate elements, and focus my mind on the inner world—a kind of wordless meditation or prayer. There's a feeling of newness, of something fresh approaching, of dark, earthy, springlike energy.

Yet for the moment, I've lost touch with my feelings and instincts, my ability to perceive and react to the world. I'm barely able to carry on a conversation. I don't believe what I'm saying to people because none of my thoughts carry that instinctive quality of rightness. Thus I sit in silence, carried forward by the energy pushing up from within.

More than ever I feel the presence of the old and the new. The old personality, with all its mechanical, "coded" reactions and petty vanities, bent on pleasure and self-destruction, running from its own shadow—it seems decayed and sick, like a scab covering nearly healed skin, and must be sloughed off and destroyed. I feel another man inside, a real and honest man, still asleep. I don't know who he is, but I know he's strong and alive, and I can feel the rhythm of his breathing. . . .

October 27, 1976

It makes no difference that it wasn't my fault that I grew up with all these problems. As in other matters, blame is not important. What matters is that the problems are real, and that I must bear the responsibility for accepting the situation or changing it. If a man receives a debt from his parents, it is still there whether he blames them for it or not. The poverty is real, and analyzing where it came from can be a crutch designed to skirt the real issue.

November 12, 1976

There is a great wound inside me, a constant hurt and ache. In order to survive I've built walls around it, but now my survival depends on breaking down the barriers. The little boy cries out in pain, but no one can hear him. Then the damage is done,

and he remains inside, forever a little boy, forever crying out in terrible anguish. "Release me! Look at me! I've been wronged, a terrible injustice has occurred!"

Day by day, stone by stone, the walls come down. What has hidden in darkness must be brought to light. The old, forgotten wounds must be reopened. Where pain exists, life stands still. The rush and flow of life is waiting on the other side of pain.

December 27, 1976

I realized today that I look at every woman, especially my wife, and see my mother. Through some twisted, archetypal arrangement, my mother has an unnatural hold on me and refuses to give me up to another woman. This sounds like it's right out of a textbook, but it's goddamn true! Thus it angers me that I lie in bed with the woman I love, my body tense and unfeeling. I want to touch and communicate with another human being.

Incest is unnatural, not sex.

February 16, 1977

The truth is I don't really know where I am or who I am. Like a character in a drama, I participate but am blind to the meaning of my actions and the eventual outcome. I believe this is a process of healing. But I can't be totally sure. While I have no direct control over the process, I am the protagonist, and my actions and attitudes seem to hold the key to its success or failure.

July 23, 1977 [excerpt from letter to parents, copied into the journal]

"You said on the phone that with my intelligence and education I could do 'more for myself,' that I'm nearly twenty-four years old and it's about time I got my life together. Mom, you have to realize that the choices I make for myself may not be the ones you want for me. Whatever I decide to do with my life, whether I end up a bum begging for nickels or the greatest composer in the world, it's my life, and I can't live it according to your timetable or your notion of what success is. I have a certain faith in myself that I will work out my problems. If you truly respect my intelligence and education, then you must also respect my ability to make intelligent and educated decisions about myself and to accept responsibility for my mistakes. . . .

"This is the real reason why I've decided to send the money back. It's essential that I learn to be truly independent. I now know that whatever I do I will be basically alone and that I can't grow up having to apologize to anyone for what I've become."

August 9, 1977

I've been very sick the past several weeks. Doctors don't know what it is. I imagined a man, utterly cool and calm. He was aiming a gun at me, police-fashion with both

hands, so steady and unswerving that I knew he couldn't miss. It was Russian roulette, and there were six shots. He pulled the trigger. A blank. I felt a deep, animal-like fear.

I'm starting to feel better now, but I'm not the same as I was. How thin the thread of life is, and how easily it is snapped! Tonight I saw myself—a tiny, fragile piece of life, surrounded by an infinite black void, alone. I am a creature, with loves, hates, desires. This is my reality. Yet what am I in the face of this vast emptiness?

At the same time, I saw an image of myself looking up to the stars and feeling a deep hunger. There is something out there besides emptiness.

September 1977 [written on a loose scrap of paper in the journal]
> Seed
> in ground
> does it know
> Tree?

January 22, 1978

I saw another sunset tonight. There was a layer of thick, gray clouds just above the horizon. The sun slowly dropped into the clouds. They looked like a soft bed of cotton, and the sun was lying down in the bed, gradually sinking into it. The clouds around the sun were glowing. Finally it disappeared, and I thought it was gone until morning. But before long, I saw a little red half circle in the gray mass—a ghost sun! Finally this mirage went below the horizon too.

I've seen so many beautiful things lately. These many months of solitude have finally begun to pay off. But then it all seems to be slipping away, and I feel so afraid that my little spark of life will go out. I know a lot more now about what I want. I see it in the clouds, in the sunset, in the light shining on the snow, in the eyes of the people I know.

The sky is completely dark now—the sunset is only a memory. But *I* saw it!

January 24, 1978

I'm sitting in the employees' cafeteria at Wanamaker's. I like to come up here at lunchtime and try to calm myself down. The work is not that bad, as long I'm not too busy, but it always distracts me, makes me nervous. I need time to quiet my mind—this need becomes almost desperate at times.

As I sit here, unoccupied, sometimes I fall into a kind of trance, and I get very still. I don't even notice it happening, but I enjoy it. One day, after about an hour of this, a man came up and asked if he could borrow the paper in front of me. I was so deeply "submerged" that for a moment I couldn't answer. I had to pull myself back

up. He looked at me rather strangely. This was how I discovered how far I had gone into myself.

February 20, 1978

The habit of finding a place (preferably an interesting one), getting comfortable, and just sitting for a long period of time is becoming a ritual. There are times when it's necessary, and times when, even if I would like to do it, I can't. I love the feeling of calm it produces. I can feel myself gradually relax; my heart beats slowly, evenly; my breathing becomes deep and regular. If I get sleepy, I allow myself to drop off into a light doze, and interesting thoughts and images come to me.

I'm learning something, practicing—for what I'm not sure. I'm a beginner. I need a whole lifetime to really learn this. In light of recent dreams, it's interesting how penetrating into deeper and deeper layers of myself brings the possibility of the deepest, most magical calm, a calm that is open to the whole cosmos and at one with a divine order.

March 6, 1979

My life has become stagnant. I haven't felt the same sense of gestation the last few months, the sense that something magic is at work. I must battle this feeling of lethargy, weakness, which causes me to feel that nothing matters, that emptiness is my fate. I still feel like a person trudging forward toward an uncertain destination, but perhaps I've become blinded, hypnotized by the repetition of my steps, so that without knowing it my path has gradually turned back on itself.

March 17, 1979

Birth—I could write a poem about it. But not yet.

The darkness of the womb. The waiting, the hoping. Grasping for something intangible—the new world, seen as only a dim light, not knowing what it is, yet feeling myself changing, growing, preparing for it. The growth, the mysterious transformation: slowly, gradually, I begin to feel, to sense. The body—it has a form, a shape. Where am I? What is this place? The water—the womb ocean—floating, slowly moving, turning. The breathing—slow and regular rhythm—waves breaking, one after another, on the womb beach—the soft beating of the heart drum. These things measure my existence. Yet—no questions, no identity. Just being, floating, waiting.

Birth—I could write a poem about it. But not yet.

April 10, 1979 [dream]

"I decide to commit suicide. I take a slow-acting cyanide tablet and wait for the poison to act. I'm detached, almost curious. I begin to feel different. There are spots of

light on the ground, and it looks unearthly. *Then I see the door.* There is a bright light coming out of the crack below the door. I'm getting closer and closer to the door and the light; while it is beautiful, it is also terrifying. Something is horribly wrong. I feel my body and realize too late that I like it. Soon I will leave it, and I am incredibly sad. I think of my parents: I've left no note or explanation. I realize how this will hurt them, because they love me. I am slowly dying. . . ."

I wake up, and see the morning sunlight streaming into the room looking exactly like the light in the dream. I realize it was a dream, but it's still real. I feel a fear that is impossible to describe. It's time to get moving again. If I don't, I will die.

June 13, 1979
The morning was clear and crisp today, the sky a deep blue, and there was a bite to the air as though it were fall. It doesn't feel like fall, however—no death in the air. In a few more days the solstice will come again, and we will once more start that long swing downward into the deepest depths of winter.

My life is like a vast, hollow vessel, and each day is a drop falling from the sky. I grow a little every day, filling up my life as the drops fill the vessel. It's like a young tree struggling to grow into the shape that was inherent in the seed.

I enjoy this struggle for growth, though I'm a newcomer at it and I don't quite trust it yet. But a life is finite, and though each day brings something new, it also brings me closer to that moment, in some unimaginably distant place and time, when the last drop will fall, and the vessel will overflow. . . .

So every day is also a good-bye, a moment that, once experienced, will never return.

I'm still afraid to dive into life. Maybe I can hold back, just a little? But we all have to die. And it must be a joy to die knowing that your life is complete, you've given all you have, loved so deeply—really done it.

Or is death just pain, always wishing you had done a little more, never satisfied, a terrible rage?

August 18, 1979
I hear the warm, late summer wind blow wild and lonely outside my window. My heart is open, and the wind blows through my spirit, filling my sails. The ship begins to move.

September 3, 1979
Pretty good day today—felt very good after printing some pictures. Much more rooted now than I was at the beginning of the summer. I'm not just groping. Something is trying to take shape, to grow, to be born. A tiny wisp of a beginning, but it's something I can stand on.

I remember a TV program on plants, a time-lapse sequence of a new tendril from a climbing pea plant. It moves around in slow circles, blindly, until it touches something solid. Immediately a chemical reaction occurs, and it closes around the object and begins to climb. It can't stand by itself. To grow it must have something solid to support it.

Clouds, you are my gods.
Wind, you are my lover.
Trees, you are my soul.

Who is the silent person sitting
 beside me?
The chair moves, but I see no one.

October 18, 1979
I stared in the face of Death.
I felt his frozen fingers numb my heart.
I saw the cold, yellow light streaming in
 from the other world.

I survived.

January 8, 1980
Brian is back.

January 12, 1980
Impenetrable mystery. Dark, impassible forest. Blow, wild wind-god—shaking the trees to their roots—swinging back and forth, rippling, swaying, like a crowd of long-haired spirit women nodding their heads. Warm winter earth energy. A time for loving.

Who am I, that these thoughts, feelings come pouring out of me? The room is quiet, the candle burns, occasional car outside, life goes on.

My mind wanders back to the first dreams. From what deep source did they spring? What sense of love, of need, called them forth? A young man who felt the mystery in his heart and said *yes*. Yes! Yes! Yes! Yes! I *want* it.

What horrible sense of failure, tragedy, led me to the black pit? The pain of it! Naked, empty, homeless, wandering in the night. Must understand *no*. Come to know it.

I've forgotten the warmth, the light—gone too far. The solid earth, the gentle touch—all forgotten. Sinking, sinking, approaching orgasm of death.

Comes the sign, the dream, the shouting. Slap my face, wake up, wake up. What is the answer? I must know or die. The quiet voice whispers, "Just live." I have found a Friend.

Stubborn: "All right, I'll go back, but you must help me." Silence. But he she it they are there.

I watch the sun for the last time, say good-bye. "Thank you Father. Will you help me?"

No. Now I must find my own way, alone, but always carrying with me his gift, the knowledge—the *light*. I saw the light, the divine dream. I let it in, let it transform me, take me. I paid for this knowledge, always will pay. But I survived, I will survive.

It is a *mission*. To live this out. Who I am, who I may become, is the answer.

January 21, 1980

Got out my tree photographs again tonight. Realized there's something very precious in them. But I still feel so alone, isolated—who can I share them with? I need to start meeting people again. It struck me that pulling myself out of this painful introversion, learning to function normally again, finding my true, magical energy, meeting people—it's all connected.

I've been acutely aware of time lately, how the days pass, the world gradually changes—how this moment, this "twentieth century" world will soon be gone. All the people who walked through this earth, lived out their lives, then—gone! It's never sudden. One day, then another, another, and you look up—time has passed! The world has changed. I have changed.

Once horses, buggies, carts moved down these streets. But the days go by, things die, new things are born, only themselves to die. I try to step back from it a little, see it as an endless flow, a river. Step back further—there is an aspect of time, of experience, that never changes. Consciousness can extend down to the corpuscles, further, to the primeval mountains and lakes, to the stars. Time is a moment that lasts forever.

You can never know it all. But you can *be,* exist in harmony with this mystery.

Another idea: reflect it. Become its mirror.

March 13, 1980

I put some pictures on my walls tonight. A magical feeling. They seem to be looking back at me.

April 17, 1980

Made pictures again today—a warm, early spring day. I hadn't been out in a while—perhaps two weeks. Instead, I've been spending my time with people, showing them

my work. *It was time well spent.* People see. They react. Whatever's been happening in the woods, it's real.

Their reactions have given me additional energy, and conviction. Not to work harder, but with more honesty. Every picture has to be a complete thought, with the full weight of my conviction behind it.

This takes time. There's a rhythm of work and thought, and I have to give myself more completely to this rhythm.

Often the picture isn't ready to be printed right after shooting. So I wait, forget about it, remember, make a contact print, forget about the contact print, remember it, look at it, wait some more. There's a rhythm. One day, magically, I can see it! I have *distance* on it. I know that it's a complete thought. Then it's no longer mine. I must show it to someone, let them give it back to me filtered through their psyche. Then I'm rid of it, and can move on to another.

There's a wild man in me—he makes the photographs. Somehow I've managed to befriend him. But he has his own rules of behavior. If the time ever comes when I turn my back on him, rest on my laurels, smugly thinking that *I* took those pictures not him, then he'll turn on me. Perhaps abandon me, perhaps attack me, turn me to stone. *This could happen to me.*

The proper attitude is passivity: I'm a vessel, the world comes to me, fills me. I give it back, reflect it, in some form or other, dictated by my personality.

Which is not to say that once in a while I don't tear the picture from the rocks and trees with my bare hands!

April 22, 1980 [dream]
I have discovered a magical room, with a beautiful light shining all over it. The light source comes from an object like a stone. I marvel at it, hold it in my lap.

June 21, 1980
Solstice again! Recently reread what I wrote at last year's solstice—found it very moving. Maybe this is a reflective time of year for me.

I had another strange thought the other day, on the train, while coming out of the tunnel at Suburban Station. As the train gradually moved from darkness into the bright light of the sun, it flashed into my mind that perhaps death is like that—my death.

Beckett was wrong in his "life analogy" in *Godot* (woman giving birth straddles the grave; a brief flash of light, then darkness). Or at least he only expressed one part of the experience, one potential. Maybe *life* is a brief moment of darkness, a dark passage, in which the soul is torn from its union with the cosmic light (its natural state?) and united with, married to "matter," the earth.

July 21, 1980

Solitude. I've begun to find it.

The focus of my mind, my energy, is pulled inward. When I'm attentive in this way, a great calm comes over me, my eyes open, and I can really look at the world, observe. There's a sense of space in my spirit, enough space to let the myriad impressions of nature and humanity flow through me, and every moment is meaningful. Sometimes images are released—old memories come flooding back, dream-like pictures pop into my mind. The gradual turning inward, the concentration, creates a kind of tension, like a bowstring pulled tight. Is this the state in which true, disciplined, creative work can be done?

The passions of the heart are still present, but their energy is focused. The will becomes important, the sense of purpose: *I* want to do this—write this piece, read this book.

This calm could become icy, forced. It should never be used to cover up or repress feelings but to *harness* them, discipline them, set them to work.

I could also become arrogant if I'm not rooted, humbled by the mystery of life. I have to embrace life, love deeply and fully.

With the calm comes a terrible loneliness, a desire to touch and be touched.

For the first time, I feel a real relationship with a woman is possible.

August 31, 1980

Back from Montana—a long day in the air.

Today, on the plane—floating across the sky—the clouds, rising in thick columns, white layered masses and thin streamers, billowing and surging. A cloud in seat 11F, not a man, a little white cloud, slowly dissolving into the ether. "Would you like more coffee, Mr. Cloud?"

Then—an opening, a break in the clouds, but no earth, just empty space stretching down infinitely. No airplane now, just the little cloud moving silently across the sky.

September 2, 1980

I finished my registration at Penn today—remarkably simple. I dropped out of the place four years ago—hard to believe it's been that long.

Quite a moment. I thought back on my years of solitude, how far down I was: as one of my dreams said, "Visiting the people whose lives have failed." How desperately I wanted to be doing what I'm doing! I suppose I should feel grateful, but no- this is just something that's happening to me now, just as that was something happening to me then.

The only way I'm going to make a success of this year is to dive in. Activity is the thing. The photographs were passive—they came to me, I followed them. I love those

pictures—each one is a little story. But they came from someone still too sheltered from life.

God, I want to write some music! It's becoming a passion. And yet I feel afraid, knowing that to dive in to this art thing again means giving up my childhood, all the comfortable and self-indulgent playthings.

Women have never seemed so *real* to me as they did today. The characteristic shape of their bodies—their thighs so soft and fleshy looking, their breasts so many shapes and sizes. Who are these creatures, so different, yet so strangely complementary to men? What secrets do they contain? Why do they seem to be such natural "containers?" And can they mistake loving a man for containing him?

September 17, 1980
Raining tonight—the first extended rain in a long time. Rain—for some reason the sound, the *feel,* make me more aware of time and space. The sound creeps into my mind, making me slow down, turn inward. I want the rain to reach inside, rain inside my body. My guts are on fire, but the rain comes in, trickles through me, cools.

September 21, 1980
A thought—trying to formulate—consciousness, paradoxically, exists on two levels: in "earthly" time (*here* now, will be *there* tomorrow), and "cosmic" time, which is to say no time, or time as a mysterious flow *without direction.*

Birth, death—points of entry and exit—from what? Into what? The body grows, decays, dies. Perhaps one's consciousness also grows, flowers, dies. But is there another form of awareness, less personal, that remains?

Why is identity so important in all this? Why this instinctive urge to grow, to become?

October 26, 1980
The soul is like a muscle. It has its own rhythms of work and rest. To increase its strength, you have to push it to its limit. But you must give it time to rest, recover, grow.

The main thing is, *listen.* Your soul will tell you, if you let it.

November 8, 1980
A thought bubbled up to the surface coming home today, on the bus. I saw the people in rows, in front of me, the shapes of their bodies. I felt so aware of the oldness of things. Here we all are, flesh, blood, bones, matter in motion, each of us little vessels of life, little flowers that have grown haphazardly—out of what? Some incredible "substratum," the living soil that contains all life, all forms, as a potential.

Can a tree plan how it will grow? No more than I can.

I don't know what will happen next in my life-drama, yet I know that what's happening to me has happened countless times before to searching people. It's as though there's a map in my soul, an interlocking web of finite possibilities, all tending to move in certain directions. Certain *channels*. The water image. My struggle is to open up the channels for my spiritual "water," set the water flowing. I don't carve out these channels. They're already there, waiting to be found.

I don't have to control this process or understand it. I have to live it out, passionately, because that is my nature as a living being. There's no other reason for it; it's the great energy of life, the life-dream. To accept this is to accept my own finiteness, my own death. But then death doesn't seem so cold and empty.

I must never let myself forget where all this really comes from.

January 13, 1981

Tonight I feel deeply, intensely alone, more than I ever have before. It worries me, this solitude—will I become isolated? No—I know I have to go out to people, and I do. I need people now.

This aloneness is a kind of empty space around me. It's not a void, but like the emptiness of a vessel. The more I'm emptied, the more I can be filled. But this means giving up a certain control, a certain hold on the world. A vessel can't choose what it's filled with!

Is it possible to imagine emptiness as a way of life? Who, what would I be, if "I" were not here? What if I were just a vibrating, functioning creature, no little "me" always evaluating, praising, condemning, clutching, puffing up, shrinking back. . . . Maybe "I'm" not really necessary!

Where will my consciousness be in, say, thirty years? What will thirty years of life bring me? I only have vague feelings about it: darkness, intensity, concentration, power, more darkness, and one small candle flickering in an empty room.

February 8, 1981

Ten years to get me this far. A hard struggle, but now I have something to build on. Still wondering, after all I've been through—who am I? So much territory left to explore. I feel like a crippled man who has just been healed, or a sick man who has just regained his health. The world looks fresh, inviting.

The cast is coming off. My limbs are whole again. The old break still aches from time to time, but the danger is over.

June 18, 1981

It seems paradoxical. Yet here I am—this strange, quivering bit of fleshy humanity—aware, alive. The temporariness of it all stuns me. But it's less paradoxical if one

thinks of the *roots* of consciousness, which are in the nature of matter itself. If a rock has consciousness—energy—why can't I?

June 25, 1981

Sitting by the Wissahickon, wondering where my soul has gone. Looks like music is out, for a while. Just doesn't want to happen. This bothers me, but what can I do? A few things seem to be happening in photography, but that will take time. I don't mind being fallow—it's clear that I need a new direction in my work. But the fear is hard to deal with. Fear of the void, the emptiness. If I stop, let go, there will be nothing there, nothing inside.

I have to trust that at any given moment I will do what's necessary for my growth. Right now, I enjoy the light as it hits those bushes, those leaves. All my composer friends—the symphonies they've written—my own sense of inadequacy—none of it seems important.

My journey, my voyage—sometimes I forget. I let other people tell me what's important. This is the source of much of my unhappiness.

July 2, 1981

It rained last night, very hard—I went outside, on the back step, to look and listen. I was struck by the incredible fertility, warmth of the rain. The bushes, the lilies—the trees waving—the darkness punctuated by a single porch light—what a wonderful thing nature is, I thought.

Then suddenly it all turned into a kind of madness—the dark, evil underbelly of life. Plants seemed to clutch at me menacingly, flowers emitted a sweet poison. There was a feeling that if I took a step across an invisible line, nature would take me in, I would lose myself, and after a few sweet, orgasmic moments, death. I thought of the image of the "pods" from that sci-fi movie—how frightening—something growing, but evil, sick, yet in some relationship with us, with the more familiar, positive kind of fertility.

This thing that we call evil—what a mistake to separate ourselves from it, turn it into an enemy! It's part of us, perhaps even literally part of matter, earth. How I forget sometimes, or never fully learned: I am matter—I am of the earth—the plants are my brothers, we're all made of the same stuff. The darker side of nature—it extends into the very roots. It's not a force that can somehow be separated from the lighter side, then "dealt with." No, it's part of the thought, the poetry of nature—it's part of the structure of things.

August 7, 1981

On the plane to Missoula. I thought cosmic thoughts between Philly and Detroit—now, between Minneapolis and Bismarck, I'm bored. . . .

Thinking a lot about sex. I always expected that a sexual awakening would come in a rush, but not so. Unfolding is the best word. It's like a flower. For several days afterward, I feel changed—as if I'm growing, extending outward. Another petal, one small, beautiful piece of myself, has opened.

November 10, 1981

Photographed today, in Fairmount Park. I was determined to just be playful, take some chances, and not expect much to happen. But right away things started to jump out at me—I found myself composing, framing, working, in no way shooting what I had planned on shooting, yet still not shooting anything I had shot before.

A new door may open—but something has to be there to go through it! What's interesting is the *relationship* between conscious and unconscious thought. There's some kind of dialogue at work here. I'm as much a follower as a leader.

Standing in the woods today, leaning on a tree, ruminating on all this—I remembered how lost I felt last summer when music dried up, compared with how strong and fertile I feel now—and I asked myself, "How could I ever lose this?" Despite my problems, my bad days, my fears, I feel such harmony with myself. I knew the answer to my question: yes, I can lose it, if I stop listening.

November 25, 1981

I've spent a lot of time in the last week or so in choir rehearsals—particularly moved by the experience of singing a William Byrd motet, *Ne Irascaris*. It's a very slow, long, and steady piece, full of peaks and valleys, ebb and flow.

Other pieces, more bombastic in character and higher in range, tend to tighten me up. But when we begin to sing the Byrd, my whole upper body starts to resonate. I feel clear and open. But that's only the beginning. After several minutes of singing, a strange, trancelike state comes over me (as well as others in the choir). The repetition, the constant rising and falling, has a hypnotic effect. When combined with the words, which basically are a plea for mercy—from the Lord, to the Lord—the whole thing becomes a prayer. In the physical experience of relaxing and opening the vocal chords and chest cavity, resonating, breathing—the mind and heart open, as well as the body.

The music is full of such a simple and humble spirituality. It draws you into its world, and by the end, as a friend in the choir said, you melt. This makes me think that there can be nothing more important than this calm, simple, striving, yearning passion.

December 23, 1981

The clouds always look closer when I'm near airplanes. I guess it's because of all my plane trips, my memories of being up there among the clouds. On the ground,

everything looks fixed, immutable—the clouds are up, the earth is down. Mountains and other such places are high, unreachable, while down here, everything is depressingly familiar. But airplanes change all that. So here at the airport, I remember what it's like to float through the air, seeing the world from that strangely inhuman point of view.

I just realized why it's so important for me to keep a journal now. This regular recording of simple thoughts, feelings, observations, etc., can come from a deeper sense of searching, wondering, questioning, which in turn arises from one of those basic problems of life: identity.

The assumption behind this is that consciousness itself is one of the greatest mysteries, completely inexplicable in twentieth-century mechanistic terms such as "reason" or "intellect." How is it that this chunk of vibrating matter has become aware of its existence? What are the roots of that awareness, and why has it become tinged with more personal qualities? In becoming conscious, do you simply open doors to a much larger awareness of which you can only be a tiny drop? If so, then how does the door get opened wider? How do you increase the flow of energy through that door?

I don't have the answers to these questions! But I see the journal as a way for this particular budding consciousness to get to know itself. Apparently, identity is something you construct, through effort, as well as discover, through reflection. Perhaps you build, in your own way, but to a preordained or preformed pattern, a "plan."

Of all the thoughts, feelings, and observations that come to me in an average day, which are truly significant? Significant in the sense that they point toward substance, depth? It's very difficult to say.

Sometimes a fleck or two of gold appears as I turn the shovel. So there must be a vein, a mother lode. If I'm lucky, and persistent, I may find it—or grow into it.

January 7, 1982

Lately I've become more aware of some of the main characters in the "Brian-drama." It's as though there are many different, sometimes opposing players on a stage. I suppose you could just call them moods. Daily changes of season. But I believe they're much more specifically formed—they each seem to have unique qualities.

Even more fascinating is the fact that *I* am not *them*. I am something else. Actually, that sounds too unequivocal. They speak through my mouth, and at various times I become various combinations of them. They are the ingredients of my personality—they are me—but though I intersect with all of them, there is still something of me left over: a kind of gentle awareness, not controlling, but neutral.

I feel happy tonight, and an integral part of this happiness is a growing sense of union between myself, the "awareness," and these many facets of myself.

I wonder if this multiplicity of personality is what gives theater its mysterious, underlying power. All the characters in a play can become a projection of a single, archetypal individual, evolving, growing—or falling apart.

January 20, 1982

I've been thinking about humility lately: about the statement someone once told me, attributed to an old rabbi, that there are no saints or religious heroes anymore because no one can bow low enough to see God. When I first heard this it bothered me, because then it sounded like conventional moralizing. But last night it struck me that there is a powerful truth in those words.

I connected with the idea when I realized that, more than anything else, what I can do now that I couldn't do a few years ago is *listen*—to myself, my inner rhythms, my body. I've begun to learn a kind of inner concentration, and all the pictures I've made in the last two years have been a result of this interior listening. The energy of thought is turned inward and seems to disappear, but is actually in hiding, or better, gestation. Then it springs out, in the form of some feeling or psychic state trying to reveal itself—some bubble of psychic energy that has worked itself to the surface of the swampy soil of my mind. And when the bubble is released, I snap the shutter and a picture happens.

Each picture, when properly "digested," becomes a little moment of clarity. After enough repetitions of this process, a larger image gradually emerges: me. My tendencies, my likes and dislikes, my favorite metaphors. Something is gradually building, taking shape, as a result of this dialogue with myself. On the artistic level, I suppose you would call the results of this dialogue "style." But I prefer to think of it as identity.

I see this gradual accumulation of self-knowledge as a form of wealth. I am a wealthy young man when compared to the condition I was in a few years ago. But if I tried to acquire this knowledge by rushing in with a backhoe and tearing away at the earth, I would miss the important little clues, the nuggets that would lead to the vein. No, this process requires the most subtle, patient kind of listening, real "pick and shovel" work. Every spadeful of dirt is sifted through, pored over patiently, without much thought of the eventual result.

And mysteriously, most of the real digging and building happens elsewhere, silently, but all around, as if there are thousands of unseen partners. I can't predict what the eventual result will be. I just stick to my daily chores and try not to get in the way. I've developed an almost religious reverence for this growth process. It seems to require such spiritual attributes as devotion, patience, prayer—and humility: the paradoxical task of lowering myself so painfully close to the ground that enlightenment may occur. The "backhoe" approach—that's not humility. That's the blind and ignorant "fool rushing in," who knows no reality outside of his own ego. The

"pick and shovel" approach, the listening, the constant reflection and meditation—this is humility.

Self-appraisal time: well, Saint Bri, you've learned to bend down, but nowhere near the ground! You still want to stand up—to see on your own, do it all yourself, rather than wait and listen.

Subject for another day: the value of will, self-love, and arrogance.

February 8, 1982

I ran into George Crumb today in the music office. We spoke about my plans for graduate school in photography, a possible recommendation, a book of interviews someone is doing on him. Strange how this man can still make me nervous!

Eventually I calmed down and made an effort to really look at him. Turn on the antennae. What a presence he has! Beneath that quiet exterior, he is seething, bubbling—exuding the subterranean energy of consciousness. He's opened his inner doors wide, and the universe flows in. This is courage, conviction, of the best kind. After telling me how exhausting it was to complete all these interviews, he turned and said, with an odd matter-of-factness, "I think composers talk too much, anyway."

I'm aware the guy has flaws. But what a volcano, this druidic man full of night energy and García Lorca's Spanish blood. He sits there, so quiet, dreamy, good-natured, shy, inoffensive, imperturbably letting the busy world flow around him, while his wild-animal soul sits on its haunches by the campfire and howls at the moon, then fishes alone, at night, by the great river. After talking to Crumb, I became so much more aware of my own tension, my rough edges, my young man's clumsiness and instability.

The great gift all my teachers gave to me was *themselves*. They showed me that it was possible for people to free themselves and grow. I think this is what awakened the desire in me, set the seed to sprouting and reaching for the air and light. It's that "shock of recognition" that says, "I'm one of those too—he did it, so why can't I?" I was like the child who figures out that he's a person too, with arms and legs and all the other parts, and stupidly starts to walk, not realizing that he can't do it, saying yes after every fall, because the recognition of his own nature has awakened the archetypal urge to grow, to become. This urge to grow, this saying yes to life, which is rooted in healthy self-love and love of life is, to me, the simplest and clearest manifestation of the transcendent, the divine.

March 2, 1982

Very sick the last few days: intestinal bug, high fever, diarrhea. No solid food for two days now. The fever is gone, but I'm still weak, exhausted.

The whole digestive apparatus inside me has shut down. The internal warmth that comes from metabolism, the releasing of energy from matter (it goes in as

vegetables and meat and turns into swimming, walking, thinking, making)—the happy interplay of bacteria and hydrochloric acid that tears up the food, sucks out the good stuff, and turns it into me—my furnace: it's down to barely a candle now. Resting, after a successful battle with a foreign invader.

I wish there were some way I could thank myself for a job well done. Good going, guys, all you white cells and antibodies—a tough enemy, but we won the fight. Of course, you know we will lose the war, but we'll make them struggle for every inch of ground, right?

So it's true: I'm a cosmos, a universe of little creatures who live their entire lives inside me, countless generations. Each fighting their individual battles, splitting off and regenerating, never knowing that the purpose of it all is to keep me going. All these ironies of scale: millions of beings inside me, billions of us humans, somehow making mankind; one tiny planet in infinite, eternal space. Where does it end? It's more than this little blob of protoplasm can figure out.

Tonight, all is quiet. My face is pale in the mirror. My skin has no luster. I'm weak, dizzy. When the light and warmth of my body begin to weaken, I see death more clearly. But there's a lot of life still left in this corpus. I can't let the knowledge of what will happen keep me from enjoying the whole process every step of the way.

Yes—that's what I've been trying to say—*there are eyes inside me!*

March 24, 1982

Is it possible to become so open, so at one with your physical nature as well as nature itself, that death could simply be a release, a gentle stepping over a threshold from one kind of existence to another? If so, then what is the purpose of the individual, of individuality?

I sense that it's important, in fact of the essence, for individuals to grow and refine themselves into their purest possible form. Yet why, if the eventual result is to be released into the all-embracing, *featureless* cosmic consciousness? I suspect this only appears to be a paradox because I haven't yet learned to ask the right questions. At any rate, the importance of an individual in the face of this vastness is very small. *Any individual*—even the most highly developed.

Suddenly I see an image of an individual life as being connected to something, restrained, like a leaf to a tree, constantly blowing in the cosmic winds, wanting to be free, to drift without resistance in these mysterious currents, but unable to because of the connecting "branch." This hunger to join with the divine energy— is it satisfied at the point of death, if you're prepared for it? Is this the real goal of individual development? To become more and more open, so you flow into death like a stone that enters the pond silently, leaving no trace of splash or ripple?

April 13, 1982

Every day I'm more convinced that my consciousness, my identity, grow out of something at the heart of matter itself, some mysterious place where matter and spirit meet.

April 24, 1982

There's nothing more exciting than work! To be on the edge, growing, making, push-ing gradually into the unknown—to feel the creative, life-giving force blossoming within—to have the mysterious dialogue with myself—to know the joy of the tools and the materials—I stand back in awe at all this.

It brings tears to my eyes when I think of what I had to go through, where I had to go, to find this. But I *knew* it was possible. I wanted it so badly and refused to give up.

May 2, 1982

Sitting by the Wissahickon on a sunny afternoon, enjoying my leisure and lassi-tude, hermit fashion. There are many people around today. Just downstream, a man and his small son are fishing. On the other side, the joggers, strollers, and bikers stream by.

I'm nestled in a little nook where no one can see me, watching the light on the water, the luminous patches on the rocks and grass beside me, the translucent, glow-ing leaves silhouetted in the afternoon sun. The occasional murmuring of water flowing over a stone; the hammering of a woodpecker in the distance; the voices of children on the trail above me; the vague discomfort of my soft back on the hard, unyielding stone. These are some of the things my senses are telling me.

Mainly, the flow—the motion of the water. The dark water, filled with invisible and half-visible shapes, inexorable, steady. It seems to have a curious kind of identity today. It knows something.

Water—a natural dividing line, a border. This side, the other side. The river Styx separates the living from the dead. I look on the other side of my little stream and see trees, roots, grass, sun, clouds, the same as on my side. What's the difference? Is this what the water knows?

I sensed death, briefly, watching the water flow—as if now, this moment, is one of those life memories I will carry with me when I cross that river. Because I've experi-enced this lazy afternoon of reading, reflection, meditation—spent some time inside and outside myself, found the place where distinctions between "inner" and "outer" are arbitrary and unnecessary—perhaps I'll be able to come here forever, because I love this place so deeply.

Is God a kind of consciousness? Something here, beside me, yet so large that it's everywhere? Moon, sun, galaxy, universe—there too? The inner dialogue—the unseen but ever-present partner—what is this other consciousness? Why two—me

and it? Why the separation, the fall, then the gradual reawakening and reunion? Does God need connection as much as me? Is God lonely? Is this why, when you find your essential loneliness, you then understand the interpenetration of all things—the Zen paradox?

May 9, 1982

Sitting in the woods again, this time on a favorite perch below Penn statue in Fairmount Park, where I used to come for all those solitary spiritual experiences. . . .

Thinking about growth, decay, cycles of gestation and activity—the idea of nourishment, sustenance from "below"—the roots of things, roots that are connected to the earth—the roots of consciousness, the strange sense of the "ancientness" of the deepest layers of experience, as if that spiritual nourishment comes out of the lives of the countless beings who have come before. The great flowing of it all, like a river of desire, one man caught up in the current, becoming the current, struggling to see more clearly.

A song—is this what it's all about? Is a person's life a kind of song, if it's lived right? One is born, one sings, one dies and joins the Great Song, joins all the other songs that have been sung, joins the river of song?

We devalue memory, relegate it to a biological function. Perhaps there's another memory, tied to places and things, a memory that forms a language, the materials of a life-song. A memory that seeks contact, seeks expression, seeks *incarnation,* and is somehow connected to that nameless, unspeakable desire that is the foundation of religion.

May 18, 1982

I've learned that growth is a gradual building process, each new thing building on what came before. But sometimes I still feel lost, as if I'm groping for something, half blindly. It's not aimless, but neither is it completely focused. A couple of metaphors occur to me: a process of refining, as though a crude substance is being separated and transformed into something more sublime; also, a crystallization, in which elements gradually fall into place around a preexisting crystalline pattern. It's a strange combination: purposeful, individual, willed activity, circling around some deeper, impersonal pattern or process.

May 29, 1982

There are so many ways to fail. It would be so easy to be seduced by your own power and accomplishments, and forget the source. Or you could become lazy, lose a certain hardness, conviction. In other words, after the excitement of the initial contact with your creative energy, you have to learn, through persistence, sensitivity, and guile, how to remain open and keep growing.

As a young person, struggling desperately to stabilize your life and make a spiritual connection, things are always in crisis. In a way it's easier to be honest, because your survival always seems to be at stake. Later, life becomes more comfortable. The road is smoother. And your conviction is put to an even greater test, because comfort and safety are a tempting trade-off for the struggles of growth. And you appear to have the power to make this decision! It probably happens slowly, seductively, almost without being aware of the change. This is why a creative person must be hard and uncompromising, painfully honest, and not afraid of criticism.

Yet a sense of gentleness must also be there, in this wild struggle for growth. That's what I mean by listening: gentleness. I am not making this picture, we are. Yes, I search, analyze, construct, destroy—but out of a sense of love, wonder. The key is timing. Sometimes rock-hard discipline is necessary; sometimes inactivity, even indolence, will do the trick. Much of the real skill lies in knowing what to do, when. This part of the creative process requires the most creative thinking.

June 2, 1982

It's interesting that I haven't had many memorable dreams lately, considering the huge stack of old ones gathering dust in my closet. At one time all my energy went into dreaming. Now the dream life is still there, but the center of activity has shifted elsewhere.

Inside, just safely beyond the reach of my prying consciousness, there is a "factory," a hub, a center of energy, where diverse elements come together and fuse, giving off energy. A psychic engine, that's what it is, and it drives me more than I drive it. It drives me into activity, into making things, into reaching hungrily for growth.

I have surprisingly little control over this process. Yet I don't feel helpless or overpowered. It's actually a source of joy, because working becomes a recognition of and submission to powers greater than myself.

June 16, 1982

When I die, I want to become part of the sound of the raindrops dripping from the eaves outside my window.

July 25, 1982

Down in the woods at the Penn statue again today, in my little nook beneath the statue. It's on top of a large cliff, and looks down over the Wissahickon valley. It's early evening, hot, the sun streaming in at an angle leaving brilliantly lit areas next to gaping holes of darkness. The wind blows gently through the leaves, in small gusts, followed by periods of stillness.

I exist on two different levels here: the level of the voices I hear in the distance below me, the hum of cars on far-off roads—the people, the community where I live. Then there are the trees, the rocks, the sound of the wind, the light and the dark—the little spider I see crawling through his web—the woodpecker hopping nervously up the pine trunk—the brilliant blue of the jay—all this, a much older level of experience, a place where time is suspended, and the only reality is the eternal cycle of death and rebirth: fertilization, growth, decay, and memory. These things make up the soil, the hidden source of water and nourishment.

All the way back to the amoeba—my consciousness is made possible because of the weight of the infinitude of souls that have come before me, each one piling on the last, eon after eon, a gradual accumulation of experience and memory (and the consciousness of man is the barest, thin topsoil).

Lately I've wondered if this is not, somehow, the "purpose" of life: to live, fully and completely, so you can add your little drop of experience to the great ocean, to increase the store of potential consciousness in the universe. Maybe this is too teleological—I don't know. Yet I sense that, if there's any reason for all of this, it's that some divine energy (an energy whose roots are at the very heart of matter itself) was "lonely" and wanted to know itself. So the urge to grow was infused into the lifeless, chaotic earth, and slowly life began to build up the experience (the soil) that eventually enabled us to appear on the scene, and to begin to see the universe as it really is: see the galaxies, and the infinite space, and the incomprehensible time. See God.

And then *we* become lonely, and wonder who we are and how we got here, and our minds make the feeble attempt to range back to the origin of things, to find that first combination of organic molecules that somehow learned to replicate itself, or that first amoeba that split and became two. These are the real roots—the very cells that make up our bodies, the distant descendants of those Precambrian pioneers.

Why did it happen? Why am I here now, gazing out at the setting sun, thinking transcendental thoughts while fighting off the mosquitoes? There's no answer, except to live. Living is the answer, as well as the question. Live my life fully, and when it's over, join, add my drop to the river. Make it a good drop.

God is so full of love that he, or she, or it, wants to share love, to give it to other creatures. So have a good drink, and pass around the cup.

October 19, 1982

In my heart of hearts, I think always of the light, its consuming yet gentle magnetism. I feel it inside me, my own little bit of it, my spark. It makes me dream.

My whole creative life is a dance around the light. It's a kind of insanity, really. This light—it's taken possession of me. Made me crazy for it, just as it did my ancestors. I really don't care about anything else.

December 17, 1982

A sunny afternoon. I'm sitting inside watching the sunlight as it shines through the thin clouds, past the dark trunks and branches, and streams through my window. I've spent a lot of afternoons like this, alone, reflecting on the unearthly beauty of the light, the way it enters my room like a living presence.

I feel very aware of my body today: my legs, my stomach and chest, my mouth. How amazing that I can ingest plant-stuff, earth, and turn it into energy. Into me. I am earth. Earth given form and self-ness.

Odd—being so aware of my corporeality, I'm vaguely aware of states of being that don't involve having a body. Is this what I'm really feeling when I look at sunlight? These other states of being—call them spirits, even angels—are they streaming in my window with the sunlight, so lucid and bright?

Maybe the light contains all the lived lives of people, plants, animals: all the hopes and aspirations, failures and disappointments. One life lived, the best it could produce, the farthest it could see—distilled into one tiny drop of light, a thousand lives making one sunbeam pouring into my room. I think if I were quiet enough, I could hear them, first a whisper then, gradually, a roar, the voices of each life telling its story, making a sound like the wind blowing through the trees.

One day I'll join them—the voices. Hopefully I will leave life without regret, knowing that I've given all I have to give.

... Depth ...

DEPTH

Some people grow up with baseball, or Saturday-morning cartoons, or sci-fi novels, or classical music. I grew up with rocks.

There were file cabinets full of rocks in the basement. The garage had bags and boxes of rocks lining the walls, and many of these rocks had strange number combinations neatly printed on them in white paint. As a kid I looked at the numbers as if they were an alien code that was too complicated for me to understand, but if I ever figured it out I would know all the secrets of the universe.

Every paperweight was a rock, as were most of the knickknacks on the mantel above the fireplace. Even the refrigerator magnets were rocks—shiny pieces of polished quartz that I loved to rub with my thumb, or tiny bits of black lava that had been expelled from an ancient volcano, or Dad's favorite souvenir: stringy little blobs of brown rock called coprolites, which is the technical name for fossilized turds.

My father was a geologist—a petroleum geologist, to be precise—and I grew up not only with rocks but with time, measured not in days or weeks but millions of years. Geologists are historians. Instead of dynasties and empires, their raw material is found in the seemingly endless layers that run deeper and deeper into the earth, layers with colorful, hard-to-pronounce names that were always part of our household lingo: Ordovician. Permian. Cambrian. Pleistocene.

Dad had a geological map of the entire American West in his head. Driving down a highway was like a perpetual stream-of-consciousness monologue on the story of the earth. "See that cliff over there? That's the Permian limestone— almost 300 million years old." Or "The big rock that looks like an upside-down sailboat—it's a volcanic plug—the inside of a volcano."

"Where's the rest of the volcano, Dad?"

"Weathered away."

I tried to imagine how long it would take to wear down a volcano, but the idea was too big for me. Not for Dad. As he pointed at some nondescript

. . .

BHP: *James A. Peterson*, 1999

outcrop zipping by our windshield and said, "That rock is over 800 million years old," I could hear the excitement in his voice, and I was convinced that he really understood where that Precambrian granite had been in its life and where it would end up after another 800 million years.

Meanwhile our brown Buick station wagon had started to drift, and the tires were kicking up dust as they edged off the asphalt. Mom's job was to keep this guy in the here and now instead of roaming the ancient seas with the trilobites. "Dad!" she hissed, and he would give the steering wheel a little jerk. I appreciated her concern, but for some reason I was never worried. He always seemed to know where interesting things were located, and that included the car.

I especially loved fossil hunting. My father knew all the best places—not just where you could *see* fossils, but where the wind and rain had started to wear away the rock and you could actually pick up the shells and run your fingers over the ridges. We would drive down some bumpy dirt road, park the car under a tree, then spread out and wander aimlessly around, eyes focused on the ground, with those white "sample bags" in our pockets ready to be filled.

"Hey Dad—found a crinoid—a big one!" Crinoids were some kind of primeval underwater plant with a long stem and a giant flower on the top. Stems were easy—there were tons of them lying around. I always dreamed of finding a flower, but they were extremely rare.

My favorite fossils were the brachiopods. They were an ancestor of clams, I guess—they almost looked like shells you could pick up on a beach. Except they had lived so long ago that their bodies had changed into rock. I tried to imagine one of these elegant sea creatures as living flesh, scuttling around the ocean floor, living and then dying, its skeleton slowly being replaced by sediment, the sediment piling up, layer after layer, gradually turning to stone, sinking deep into the earth, then pushing upward with some ancient tectonic regurgitation, finally reaching the surface in this obscure place in Utah, where I could hold its lovely remains in my hand and wonder about its story.

The truth is, I never cared much about the taxonomic details. Even the fossils themselves started to look the same after a while. Mainly I liked the idea that there was more to the earth than what I could see—that where I was standing was just the surface, and there were mysteries in the dark depths beneath my feet.

There's something about the earth that invites you to dig. I really used to think that if I could just dig hard enough and long enough, I would surely get to China. And if I didn't make it that far, I'd run into some long-lost realm of dinosaurs or a forgotten civilization of aliens. Whatever was down there, it had to be prehistoric, foreign, and dangerous. At least that's what the heroes in all those novels and movies on the subject always discovered.

When I got a bit older, I learned that none of that stuff was real. Basically, the farther down you go, the hotter it gets. What we live on is like a thin layer of cooled-down foam that floats on all these much bigger layers made up of slow-moving currents of molten rock, with a core of solid iron the size of the moon. That was the truth about the mysteries down below. But my imagination wasn't satisfied with the geological truth. For a while I considered being a geologist like my dad, until I realized that the digging I wanted to do couldn't be done with a shovel.

My fascination with geology came from a feeling that not only was there more to the earth than could be seen on the surface, there was more to me. As a teenager I began to have strange dreams that bubbled up from unknown places inside me. I had no control over these dreams—they just happened—and they were full of insights and images that were way beyond my own puny experience. I was drawn to music, not only playing it but writing it, and I was shocked when musical ideas would occasionally just appear, from nowhere, ideas that had their own life and expressed thoughts and feelings that were more *me* than anything I could think up on my own.

A geologist like my father looks beneath the surface, trying to make the invisible visible. But there was something going on beneath the surface of me that was more interesting than any Precambrian granite. Maybe those primeval dinosaurs and ancient civilizations were really part of my own psyche, a part that I needed to dig into if I were to have any hope of being more than a shallow and embryonic teenager. Maybe what I really wanted to be was a geologist of the soul.

Depth. That which is below—below the surface. Why do we value the invisible depths over the visible surface? Why is below better than above?

Is it because you can't trust the surface, but the depths never lie? What if Psalm 130 said, "From the surface I cry to you—hear my voice"? Most likely that cry would be rather feeble and wouldn't end up on the divine "to do" list. But— "Out of the depths I cry to you"—or, the Latin version that rolls off the tongue with such authority, that poets and composers have been drawn to for centuries —"*De profundis clamavi*"—now *that* is an honest cry, coming from the very center of one's soul, a place of desperation where there is no uncertainty, no ambiguity, only hunger and loneliness.

Surface is the sand along the beach that drifts here and there with the wind currents. Depth is the granite underneath.

Surface is easy—not much effort needed to find it, and not very rewarding when you do. Depth is more difficult. Sometimes it emerges on its own, but usually you have to look for it. You have to dig.

Surface is static. Sterile. Frozen. Plant a seed in it and the seed never grows. Depth evolves. Depth is turning toward something, looking for something.

Depth is a process—a voyage from the outside to the inside. So it becomes a story. I'm not there now, but I want to get there. How do I get where I need to go? Am I digging in the right place?

The more you think about depth, the bigger the idea becomes, and the harder it is to talk about. So we resort to metaphors. The *I Ching* turns depth into a kind of poetic topography, suggesting that an entire mountain range might be lurking beneath a smooth plain: "The wealth of the earth in which a mountain is hidden is not visible to the eye." The Hebrew Bible often uses agricultural metaphors to describe a life lived on the surface, calling it "chaff swirling from a threshing floor" and "chaff that the wind blows away."

A more contemporary metaphor is "still waters run deep," an expression so stale that you'd hardly dare utter it in everyday conversation. But it's a potent image that says there are slow currents of thought flowing quietly beneath a serene surface. With depth comes tranquility.

If I say something stupid that has an aura of profundity, someone nearby will inevitably reply, "Wow, that's deep!" "Deep thoughts, dude." Or simply, "Deep!" The idea of depth is apparently so overused and abused that the word has become its own parody! But the fact that we poke fun at what only pretends to be "deep" suggests that we have an awareness of, a need for, *depth*. By mocking the false, we acknowledge our hunger for the true.

One of my music teachers, in the middle of a composition lesson, suddenly turned to me and said, "Do you want to know how I learned to write music?" He proceeded to tell me a story. He had been a composer for years, gone to the right schools, built up his career, and thought he was doing pretty well. But he was never quite satisfied, never quite sure he was doing what he was meant to do. Then the music started to dry up. He kept writing the notes down, but they were dead on the page, and eventually he stopped trying. Perhaps a year or two went by, and he was increasingly desperate. He'd begun to think that it was all over, that he'd have to find another path. Finally one night he sat up in bed, startled, sweating, in a panic, and said to no one in particular, "I've been writing someone else's music!" That's when he began to write his own music.

Something changed in this man's life. It was as though he'd unknowingly been living out another person's story and suddenly began to live his own story. Except it wasn't sudden—he had to spend years doing the wrong thing, living the wrong way, before he finally "hit bottom" and, in that moment of desperation and desire, began to see clearly.

That's usually the way it works. Depth doesn't just happen. We have to make mistakes. We have to go on a journey. Sometimes we travel in exactly

the opposite direction we should be taking, but this ends up being the fastest way to find what we're looking for.

Helen and I took her younger son out to dinner not long after he'd entered college. The subject of women came up, and we tried to draw him out about what he'd already experienced and what he hoped to experience. He'd been in love before, but nothing had lasted, and he had a feeling that something important was missing. "How will you know when you've found it?" I asked. He stared at his plate silently for a few seconds, then said, "Because it will have substance." We knew he would be okay when we heard that word—*substance*—because he wasn't going to settle for the surface. He was digging.

Geologists may be historians. They may be explorers who search for hidden treasure in the deepest layers of the earth. But they're also riverboat gamblers. I learned this from my father.

I used to watch him poring over maps in his basement office—not road maps, but the elaborate, colorful maps of underground rock formations that tell geologists what other geologists have discovered. Nowadays the maps are all done with computers. But Dad's generation of geologists made them by hand, using ink and colored pencils, compasses and T squares, and reams of data. They often acquired this data by hiking up and down rattlesnake-infested hills while identifying rock formations and measuring the placement and thickness of the layers. Dad never needed a treadmill or a Stairmaster to stay in shape. Well into his eighties, he could walk for miles up steep, rocky trails with a heavy pack on his back, and those tough geologist legs never seemed to wear out.

Geologists have to discern what's happening thousands of feet beneath the surface, based on spotty observations of what's happening aboveground, plus whatever they can learn when they explode some dynamite and watch the sound waves bounce around belowground. In other words, geologists theorize. They guess. And they're often wrong, spectacularly wrong, as demonstrated by all the oil wells that produce nothing but prehistoric sludge.

When they get it right, people get rich. That never mattered much to my father. We used to tease him about all the oil he discovered for other people: "Hey Dad, couldn't you have found a barrel or two for us?" But he liked the hunt more than the quarry.

My favorite snapshot of my father was taken during a camping trip in southern Utah. For me the trip was a chance to make a few more photographs. For him it was the culmination of half a lifetime of work. As I understood it, he had theorized that a certain oil-rich layer of rock would appear somewhere in the vicinity—a layer that shouldn't be there, based on what everybody else had predicted. If he was right, it would be big news in the geology world.

We were driving down a deserted backcountry road, when suddenly he told me to park the car. He jumped out, hurried over to a rock formation a few hundred feet away, and took a couple of carefully placed whacks with his sharp-pointed geologist's hammer. As he walked back to the car, he had the biggest, silliest grin on his face that I'd ever seen. He looked like a kid in a Norman Rockwell painting who had just caught his first fish or hit his first home run.

This was more than just work to him—the sheer joy of that moment was something deeper, more creative. He showed me the piece of rock in his hand, waved it under my nose. I could smell the oil. I still keep that snapshot on my fridge, held up with two trilobite magnets that Dad picked up at a geology convention.

When geologists make mistakes, people lose a lot of money, and the geologists have a lot of explaining to do. Dad loved to tell the story of the government folks who built a big expensive dam at the end of a valley. When the dam was finished, they started to fill up the valley with water, and everything was fine until the lake was about half full, when suddenly all the water disappeared. The government folks brought in trucks and tractors and covered the hole where the water went, started to fill up the lake again, and the same thing happened. So they studied the geology of the area more thoroughly, and discovered a vast network of limestone caves underneath the valley that could have held the entire contents of Lake Michigan. "They found a nice layer of granite and thought they were okay," Dad said with a smile. "But they didn't look hard enough."

I thought I knew what "looking hard enough" would mean for a geologist: assembling all the data, plotting it out on some maps, and figuring out what was happening belowground through a clear-cut methodical process. But that's not how he worked.

I know it sounds like a Hollywood cliché, but we had our best conversations while gazing at the flickering flames of a campfire in the wilderness. Maybe it was because we had worked up such a sweat earlier in the day, trudging up the trail. By the time we'd hiked several miles, set up the tent, gathered some firewood, and caught a few fish for dinner, we were so worn out that there was no energy left for chitchat.

It wasn't that we talked constantly. There were long silences as we stared, hypnotized, at the glowing coals inside their circle of rocks, while the low roar of the creek filled up the darkness behind us and sparks floated up into the branches above. The summer nights were chilly in the Montana woods, but we would build those fires into infernos, so hot that you had to blink to keep your eyeballs from overheating. Every now and then one of us would poke a stick into the coals, or grab another piece of wood from the nearby pile and toss it in

an empty spot, and the fire would be reborn. My father always knew how to put the right piece of wood in the right place. It was one of many important things I learned from him. My wife always asks me to build the fire in our fireplace, and I do it without thinking, thanks to Dad.

One of these wilderness evenings we started to trade notes about how it was done in our chosen fields. Not career stuff, but the underlying thought process. What's really going on when an artist pursues an idea or a geologist tries to find something deep underground? Why are some people more successful at it than others—successful in the way that the people who built that dam were not successful? What does it take to consistently hit the mark?

"All I can really talk about is how it works for me," I told him. "There's no formula, but there's a pattern to it. A kind of give-and-take. Over the years I've learned to listen to what's going on inside me and trust my instincts about which ideas are worth the effort. But instinct alone doesn't cut it. At some point I have to see what's going on, or I start to lose my way."

He'd been staring blankly at the flames while I struggled to talk about what can't be explained. Suddenly he looked up and stared at me instead, his eyes bright in the firelight.

"It's interesting what you're saying," he said. "I've seen the same kind of thing in my field. Some guys think they can figure it all out. They know all the right theories and come up with these brilliant conclusions based on all the right ideas. But half the time they're wrong. Then there are the ones who gather up the data, absorb it for a while, and make a big intuitive leap. They're absolutely sure they did it right—and they're wrong half the time too. You've got the rational ones and the intuitive ones, and both tend to screw things up."

My back was getting cold, so I stood up, turned around, and warmed it for a minute or two while he tossed bits of tree bark into the center of the fire. Finally I said, "Okay, smarty pants—so that's how those guys do it, but how do *you* do it? I guess it was just dumb luck when you found all that oil in Nevada, right?" Dad was the geologist who discovered the first Nevada oil field, back in 1954.

"Well, maybe. There's always luck involved. Except some people are a lot luckier than others." He grinned. "You've really got to do your homework with the facts—you can't just go in unprepared and expect to get it right, no matter how smart you are. But sometimes it's kind of mysterious how it happens for me. I bust my tail with the data, look at it over and over from every possible angle, and then kind of back away from it, leave it alone—and a solution just emerges after a while. It's like there's a deeper layer inside me that thinks better than I do, and I just listen."

I didn't know what to say, so I didn't say anything. Neither did he. But he looked at me, and I looked back, and we both knew what the other was thinking.

Artist and scientist, father and son—so different on the surface, but underneath, doing more or less the same thing. Struggling to find a balance between thought and instinct. Paying attention to a mysterious interior voice that turned us in the right direction. We were two guys who loved to think, but who did our best work when we were listening.

I became an artist because I thought it was the only way to find the truth about myself—to dig, deep down, below the granite, where the invisible water flows. Turns out my father heard the sound of the same quiet water. When he was searching the earth's interior for that ancient layer of rock where the oil was, he was also searching his own interior for the ancient layers inside him. Searching for depth.

Of all the gifts he gave me—all the knowledge, all the generosity, all the time and attention and love—that was the gift that made the difference. The gift of himself. His interior life. His search.

He would be profoundly embarrassed to hear me talk about all this. Talking was not what mattered to him. But like that moment of silence at the campfire, he always found a way of saying what needed to be said.

GOING HOME

We've been making the trip for almost thirty years now, from their house to the airport. It only takes a half hour or so, right through the middle of town, then a few miles out on what used to be the main highway. Dad has made this trip so many times that he's discovered every possible shortcut: turn left here to avoid the traffic downtown, turn right there to shave off a few blocks on a side street. Mom is perfectly content to let him drive, so she sits in the passenger seat.

Every time we perform this ritual I feel vaguely uncomfortable, sitting there behind my parents, watching the world go by. It reminds me of the many long trips we took when my brother and sister and I squirmed, fought, slept, and puked in the backseat, or the hundreds of times my parents drove me to piano lessons or baseball games when I was a kid. I don't want to admit it, but it's also comforting, for a few minutes, to know that I don't need to worry about where I'm going. Mom and Dad will make sure I arrive safely.

This year my flight leaves at eight in the morning, so we have to get up early. The sky is just starting to brighten in the east when my alarm goes off. Low clouds have moved across the valley, sealing it off like a layer of aluminum foil. The first hint that I'm in for a show comes right after I emerge from my shower. A small gap has formed just above the eastern mountains, and an invisible beam from the invisible sun has landed on a wispy puff of cloud, white and pink against a sea of dark gray.

We had decided the night before to skip breakfast and eat at the airport, so we leave as soon as I dress and close my suitcase. I glance out the window as we turn onto the road heading into town. I'm surprised to see that half of the nearby mountain is gone. A massive fog blob has slipped in under the clouds and is slowly consuming the large concrete "M" that sits strategically above the university campus, announcing to all the world that we are indeed in Montana. A friend of mine on our high school track team hated that "M" because every day, after school, his coach made the team sprint all the way up the long zigzag path.

Missoula. I was twelve years old when we moved here. When Dad first told me where we were going, I thought he said Methuselah. The place has grown quite a bit since then, but it hasn't changed much. Missoula is basically one of

those "Anytown, USA" kind of places, with a mall, a Wal-Mart, a Kmart, and most of the other chain stores and gas stations that every self-respecting American burg should have. One year when I was a teenager the town was abuzz because the first McDonald's had opened its doors, and finally we could have our very own made-in-Missoula Big Macs. A couple years later my friends and I took great pride in the fact that the Berkeley campus newspaper had anointed Missoula as the drug capital of the West, second only to Berkeley of course. It seemed very hip at the time.

When Helen visited Missoula for the first time we arrived at night, and I'll never forget her gasp when she looked out the big picture window in my parents' living room the next morning and saw the mountain looming above her. And that was just one mountain. Think of Missoula as a giant bowl with a few notches cut in the sides where a bunch of rivers flow in and out. The mountains are everywhere. Tall, jagged ones that often have snow on their peaks well into July. Shorter, grassy ones with smooth slopes and rounded shoulders.

Before my knees gave out, I used to climb the mountain closest to the house at least once during my annual summer visit. By the time I reached the top, I could see the whole city in miniature below me, but the sounds had completely died away. I would sit for hours with my back against a pine tree—reading, thinking, drinking in the silence.

"Is Helen picking you up at the airport?" Dad asks.

"Yup—we've got it all worked out."

"You're not going to need that sweater back in Philadelphia—supposed to be ninety-five there today." Dad was a meteorologist during the war, and one way he stays connected to his three distant children is to watch the Weather Channel and find out if it's raining or sunny where each of us lives.

"Thanks for the warning. Maybe I'll put it back in my suitcase before I check in."

Sometimes I try to move these conversations in a more interesting direction, but today there's an unspoken agreement between us that we're going to talk about the weather as much as possible. We had made this same drive a couple days earlier with my sister, and during her visit we learned that the latest round of chemotherapy didn't work. The tumors in Wendy's liver—the official term used by her oncologist is *sarcoma*—reappeared last year after a four-year hiatus, and her doctor has given her six months, tops.

Another gap in the clouds has opened up, and on the eastern edge of the valley a single gray mountain has turned bright green. A few sheets of rain are drifting across the band of pine trees at the top. But I've been looking behind me too much and my neck is starting to complain. So I turn around and stare

out the windshield again, checking off some of the usual landmarks as we pass: the old football stadium, our favorite gas station, and the movie theater that was turned into a church. The church fathers used to regularly display that classic line from Saint Paul on the big sign above the door: THE WAGES OF SIN IS DEATH. To us this seemed a bit grim for a brightly lit marquee, and the convoluted sentence always generated a few tongue-in-cheek comments about plural subjects and singular verbs whenever we drove by.

Just before we turn left at Dad's first shortcut, I see the elementary school. It was one of the bitter rivals of my elementary school, so I dutifully hated it, as instructed by the high-stepping eighth-grade cheerleaders whom I lusted after before I knew that lust was what I was feeling. Sometime in the last forty years an addition was built on the side of the school that faces the road, and the newer bricks look out of place next to the weathered surface of the original structure. The sign on the new building says, "Have a safe summer. See you on August 19."

As we drive by I think of all the children, generation after generation, going through those schoolhouse doors every day, then eventually heading out into the world. How many of them had the kind of rotten luck that life has inflicted on my poor sister?

Thanks to a hungry HMO that gobbled up the doctor-run clinic where she worked, Wendy was able to retire at age forty-five. She was weary of being a doctor (too many ridiculous lawsuits), but mainly she wanted to spend more time with her kids as they hit puberty. A couple years later the cancer showed up. First the surgeons took out the tumor—which was as big as a grapefruit— as well as a large chunk of her liver. After that she came within an inch or two of dying, twice, from infections caused by chemotherapy. Then her marriage fell apart.

The first love of Wendy's life is her children, but traveling is a close second, and it's not just recreation. Exploring places she's never been before has a religious intensity for her. After she recovered from the chemo, she went to Greece, Alaska, Tibet, Mongolia, and the Galapagos Islands. Then the cancer came back, and she lost another chunk of liver. Since getting the recent news from her oncologist about how much time she has left, she's already scheduled three more trips: Ireland, Seattle, and Iran. That's right—Iran. She knows very well that she could get sick and possibly die there, but as she told me during one of our late-night conversations, "If I'm not dead, I'm going."

My parents are understandably horrified that she's planning this trip, but I think of it as dying with her boots on. It sure beats sitting around the house and waiting for her liver to stop working, which is not a fun way to go. One of the more interesting benefits of being a doctor is that when it's your turn, you know

exactly what's going to happen because you've seen it a hundred times before. In that same late-night conversation she gave me a detailed, blow-by-blow description of how she is going to die.

After the elementary school come the rows of houses with well-kept flower beds, the dilapidated warehouse that I pedaled by regularly when I was a kid, and the bowling alley that we frequented right after we moved to Missoula. I remember Mom's bowling style—how she grabbed that heavy ball, held it out in front of her, then bowed down as if the distant pins were an audience and she was taking a curtain call. Usually she knocked down quite a few of those pins. Now, of course, her fingers haven't gripped a bowling ball in years, and she's happy just to take an occasional walk on one of their favorite paths in the forest just up the road from their house.

I look back to the east, and the formerly green mountain is again dark gray, like its neighbors. But another crack has appeared in the clouds, and this time the sunlight is raking across three or four peaks in front of me. The air is shimmering, luminous. The light is flowing out of the mountains themselves and into the valley below.

A few drops of rain hit the windshield as we turn onto the old highway. Almost there now. The hotel on the corner where the drive-in theater used to be—didn't we see a couple of Doris Day movies at that place? Then comes the rental car agency where Dad and I pick up a vehicle every year. We don't camp anymore, but we still go into the mountains, mainly to remind ourselves of all the fishing trips and backpacking and sleeping under the stars that we used to do.

The rain rolls in just as we pull into the airport and get out of the car. I actually enjoy the splattering of drops on my hair, my shoulders. I guess it's the smell, so clean and clear, as if the wind has just blown down from one of the snowy peaks above me.

The lobby is almost deserted. There's an unwritten rule in my family that if we arrive less than two hours early for a flight, the plane will leave without us. We eat our breakfast at our usual spot in the airport restaurant, then hang around for a while, staring at the pictures of Missoula's aviation pioneers.

From their shuffling of feet and sidelong glances I finally realize that Mom and Dad are ready to leave. We stand there for a moment looking at each other, not wanting to think about what might be happening the next time we get together.

"Thanks for another good vacation," I say, and it seems as if I've heard those words coming out of my mouth dozens of times before—probably because I have.

"Oh, thanks for coming," they both reply, and the ritual is complete. But this time they linger for a few seconds. Our eyes meet, and there's something extra in the awkward hugs we exchange.

I make it through security without having to remove my shoes or my belt, and I even manage to find a seat by the windows in the upstairs waiting room. As I gaze out at the storm sweeping over the mountains, I start to think about Wendy's two teenage daughters, growing up, falling in love, getting married, having children of their own. The thought of her not being there to see it happen is almost more than I can bear.

How can this world we live in be so beautiful and so sad?

I don't expect an answer to this question. But I feel an odd sense of peace that comes from the question itself: from seeing both the beauty and the sadness so clearly. As the plane climbs slowly into the clouds and the mountains disappear behind me, I push back my seat, close my eyes, and drift off into sleep. It's good to be going home.

. . .

Lee Nye (1926–1999), *Praying Clouds,* 1956. Gelatin silver print, 12 × 20 inches. By permission of the Estate of Lee Nye and Nye Imagery, Ltd.

THE END OF INNOCENCE; OR, HOW I LEARNED TO STOP WORRYING AND LOVE THE SCALPEL

A biochemist friend once told me that we all should be dead. In other words, when you study the processes and mechanisms of the human body, there's simply no way it should work. It's too complicated. There are too many things that can malfunction and too many enemies who want to do us in.

Viruses, for example: robotic propagation machines that force their way into the nuclei of our cells, turning them into factories that spew out millions of virus replicas. What a horror-movie scenario that is! Bacteria: voracious attack bugs that poison us with their biochemical excrement or see us the same way we see a cheeseburger and fries. DNA: rearrange a few of the billion or so molecules on one strand or another, and the result is progressive dementia, blood that leaks out uncontrollably from the tiniest wound, or muscles and nerves that gradually atrophy.

The more you ponder it, the longer the list becomes. Any of a hundred vital organs may decide to malfunction, and any of dozens of complex systems may decide to stop working. Passages get plugged up, airways get stopped up, blood vessels get clogged up, moving parts get frozen up, and before long the whole thing gets screwed up!

There's nothing like a little surgery to remind you of the obvious frailty of the flesh: the way a forest fire reminds you that wood burns, or how being hit by a truck reminds you that jaywalking is a bad idea. For me the adventure began with a sneeze. Helen loves to tease me about my multiple sneeze-blasts, expressing mock frustration because she never knows when to say "bless you." Well, this was a real doozer—maybe five or six in a row, each more explosive than the last. I smiled and, as always, nodded in her direction so she would know I was done. She dutifully said the magic words. And that was that—except for a funny, pinched sensation in the "groinal region" that didn't go away. I did a little exploring and, to my surprise, felt a strange swelling down there.

. . .

Thomas Eakins (1844–1916), *The Agnew Clinic*, 1889. Oil on canvas, 84⅜ × 118⅛ inches. Courtesy of the University of Pennsylvania Art Collection, Philadelphia, Pennsylvania

Hernia. It was the first word that entered my mind, but I dismissed the idea. Maybe I had an infected lymph gland—that had happened before. If I ignored it, surely the uncomfortable feeling would go away. It didn't. The swelling got worse; before long even standing up for a while began to be uncomfortable.

I finally went to see my doctor. When he asked me why I had come in, I said, "I think I have a hernia." He gave me an "I'll be the judge of that" look, felt around a bit, performed the classic "turn your head and cough" routine, then said matter-of-factly, "Yup, you've got a hernia—a big one too." Then he said what I was expecting, but for some reason the words were still a complete shock: "How soon can you have the operation?"

I could have just lived with it. That's what people used to do, with the help of some rather strange devices. But my doctor told me that once in a while the abdominal muscle will suddenly decide to squeeze off the protruding chunk of colon, which will then atrophy and burst open like an oversized pimple. After that comes emergency surgery, and if you don't make it to the hospital in time, death.

So I was going to have an operation, the sooner the better. Of course, it was only a hernia. How bad could it be? Well-meaning friends said things like, "Oh, a hernia—that's no different from a hangnail nowadays." None of these people had ever experienced hernia surgery, but they all assured me that it was routine, nothing like the kind of life-threatening operations that so many people go through. You don't even get admitted to the hospital anymore. You just amble into something called an "ambulatory surgery center," and after a few hours they've sliced you open, patched you up, and sent you home.

Helen's younger son was a med student at the time, so I asked him what the surgeon was actually going to do to me. He shot me a puzzled look and said, "You really want to know?" I told him that this is my way of dealing with fear. If I know exactly what's going to happen, I can at least have the illusion of being in control of the situation.

I think that was what frightened me the most: when I climbed onto the operating table, I would give up control of my life to a bunch of strangers who were going to hurt me (admittedly in a good cause), and there was nothing I could do except lie there and take it.

A few days later an envelope arrived in the mail containing a xeroxed chapter on inguinal hernias from a surgery textbook. I had thought the operation would be simple: make the incision, jam the gut back where it's supposed to go, and stitch it up. But the procedure is not so straightforward. The bulging piece of colon is actually hard to reach because it pushes into a little tube that allows some ductwork to pass through the abdominal wall. The scalpel first cuts through layer after layer of muscle and fat, and after some machinations

that I no longer remember, the surgeon sews in a little patch of plastic mesh that plugs up the hole.

I didn't make it to the end of the description. The diagrams were disturbing. That wasn't just a drawing, that was me, flayed like a cut of roast beef.

Yet what right did I have to complain? Other people I knew—my wife, my sister, my father—all had endured major surgery, and I imagined them saying to me, "What a whiner! Wait until you have some real surgery—then we'll see what you're made of." But as the fateful day approached, that queasy, sinking feeling just got worse and worse.

Why is it that surgeons always have to start so early in the morning? It must be part of the same macho mind-set that forces interns to work thirty-six-hour shifts. Perhaps it's meant to ensure complete passivity in the patients because they're so groggy. Whatever the reason, Helen and I left our house for the surgery center at six o'clock on a Monday morning. When we arrived we were surprised to see that the facility had been built inside a huge converted grocery store, leading to several comments about butchers and meat slicers as we walked in the door.

Of course I had to take off my clothes and put on one of those thin, backward bathrobes that make you feel like your butt cheeks are flapping in the chilly morning air. It had to be sixty degrees in the place, and I was freezing. I stretched out on the portable bed in my room, and soon a nurse came in to hook up the IV line. "So, I see our celebrity has arrived," she said with a grin.

A couple years earlier an eighteen-year-old kid and his girlfriend had ditched their newborn baby in a motel dumpster. It was in all the newspapers. The young man's name was Brian Peterson. The nurses had seen my name on their patient list and had been entertaining themselves with jokes about their famous hernia patient. It took me a minute to figure out what was going on, but when I did I pointed to Helen and said, "Yeah, and this is my teenage girlfriend." Actually, Helen looks at least ten years younger than me. But it had been almost thirty years since either of us were eighteen, and we all got a good laugh out of it.

I had my revenge a few minutes later. Canned music was playing in the background, I guess because some administrator had concluded that it would make the slabs of presurgical meat feel more relaxed. Suddenly I noticed that the song coming out of the speakers was the theme from the movie *Titanic*. I pointed out to the nurse that this was an interesting choice of music for people about to have surgery, and I was sure it was not an omen. This cracked her up, and when she stopped laughing she told me that usually her patients just sit on their beds quietly and stare into space.

It was a brave front, the gallows humor. Inside I was quaking and trembling. It took all my strength not to rip the IV out of my arm and run for the door. I kept repeating the mantra to myself, "It's only a hernia. It's only a hernia." But the words didn't register in my terrified brain.

It didn't help that I had to wait for what seemed like hours. Finally the anesthesiologist showed up, looking like he owned the place. As he launched into his obligatory speech about what was about to happen, I thought, "What a dour-looking dude he is." So I tried out the *Titanic* theme song routine on him. He looked at me like he was measuring my cranium for a lobotomy. I decided I liked the nurses much better.

At last the moment arrived. I said good-bye to Helen, and an orderly wheeled me down the hall into what had to be the most lifeless, sterile room I'd ever seen: bare white walls, big machines everywhere, cold fluorescent light, and a crowd of people with masks on wandering around looking very busy. Someone told me to take off my robe and hoist myself onto the operating table. So there I was—stark naked and flat on my back, with all these faceless men and women hovering over me. It was like a bad dream, but I wasn't asleep.

The surgeon bent down and swabbed my abdomen with some antiseptic, which struck me as a bit premature. What if the drugs didn't work and he started his nasty business when I was still wide awake? I looked up and said plaintively, "I'm still here!" From behind me I heard the voice of the dour anesthesiologist: "Don't worry, I brought my hammer." The guy had a sense of humor after all! His quip took me completely by surprise, and I couldn't stop laughing.

That's the last thing I recall, until I began to hear Helen's voice talking to the nurse, and the world slowly emerged again. Strange how the little things matter so much in a moment like that. What I most remember are the pieces of crushed ice that Helen gently put in my mouth to cool my throat. After a while the nurse wanted to know if I could pee, and as soon as I was able to demonstrate my prowess, I was free to go.

The first few days after surgery were the worst thing I'd ever experienced. I say this knowing very well that I only had a taste of how bad it can get. There was weakness and pain, of course, and I slept a lot—all of which I expected. What I didn't expect was the feeling of darkness that flowed through my body in great, slow-moving waves. The fact that the operation was actually a good thing that fixed a potentially serious problem didn't matter. Nothing could change the feeling of vulnerability, and nothing could comfort the primal rage of the violated organism.

This latter sensation—rage—was a complete surprise. But I wasn't alone. When I was sitting in the surgeon's waiting room for a follow-up visit after the

operation, I saw a grim-looking, middle-aged fellow making a scene at the receptionist's window. From the rather heated conversation, I figured out that he was there for another consultation due to chronic postsurgical pain and was upset about having to shell out the HMO copayment. At one point, while explaining why he didn't want to fork over the ten bucks, the man suddenly blurted out his wrath at the surgeon, sounding like a wounded child: "He did this to me!"

I had to admit that I recognized in myself this same sense of infantile fury, directed at the perfectly intelligent man without whom I'd have lived in constant fear that I would literally split a gut. I managed to keep my feelings to myself. But I was tempted to cut loose when the doctor casually informed me that now there was a similar hernia on the other side, and I would need another operation to repair it!

I suspect that many people who have surgery experience these same conflicting emotions about their doctors. Helen once had a similar reaction when her surgeon (whom she greatly respected) came into her hospital room the morning after a major operation and asked her how she was feeling. He was in a good mood because he and a bunch of his colleagues had been almost sure she had lung cancer. She didn't. He expected her to be happy and grateful, but she wasn't too friendly, and I didn't blame her. She was lying in a hospital bed, dazed and helpless, with a bloody eight-inch gash in her back and no less than four tubes emerging from various holes in her body. The poor doctor was confused. There was little room in his universe for anything other than appreciation for what he'd done.

For me, the worst part of the postsurgical experience was not a condescending doctor or pain from the incision but something that happened a couple days later.

At first I paid no attention to the problem. Like everyone, I had experienced it occasionally since I was a kid (when I told my share of Ex-Lax jokes), and I thought I knew what the experience was like. But as hour after hour went by and nothing happened down there, I got more and more upset. I had just had surgery, of course, and all I needed was to burst my stitches while straining to take a dump!

The pain began the second night after the surgery. Pain, you say? Later I told a friend at work what I had experienced; she said the same thing had happened to her after her first kid was born, and the pain was worse than childbirth. I believe it.

I couldn't sleep, so I watched TV all night, occasionally maneuvering myself off the couch and pacing around the room, trying to shake something loose. Finally I got so desperate that I picked up the phone to call the surgeon's office.

As bad as the pain was, the sense of embarrassment almost kept me from pushing the buttons. It was four in the morning, and I had to wake up this high-powered surgeon because I was "irregular." To make matters worse, he wasn't on duty that night, so it was his young female colleague who called me back a few minutes later. I know it shouldn't matter, but it only added to my humiliation that I had to explain my sorry situation to a woman. Men are supposed to be strong, after all. We don't complain because we're constipated.

Fortunately she was very calm, not at all aggravated as I had feared. Her solution? Enemas.

I had managed to live forty-seven years without this delightful experience. That was about to change. Naturally our cupboards were bare, so I had no choice but to drag myself upstairs and wake up Helen. She threw on her clothes, drove to a twenty-four-hour grocery store, and soon returned with the necessary equipment.

When she said her vows, I wonder if my wife could possibly have imagined that "in sickness and health" would include administering an enema to the man she loves while he was lying on the floor in a fetal position, in complete agony. But she did it without a word of complaint. She had only bought one box, figuring that would surely be enough. But the two bottles of liquid failed to dislodge anything, so she had to drive back to the same store (enduring a strange look from the guy behind the counter).

That was the longest half hour I had ever experienced. All of my education, accomplishments, intellectual powers—even my sense of who I am—were gone. I was nothing but a wounded animal, half naked and alone on the bathroom floor, unable to move because of the pain.

I'll now draw down the curtain on this scene, except to say that the second time things went much better. Later that day, after I had a few hours of sleep and knew that everything was working again, I went up to Helen, held her as close as I could, and wept uncontrollably. It was part gratitude for her help, part relief that the worst was over, and part a release of all the pent-up feelings of grief that came from the knowledge that I'm a broken and very mortal piece of flesh.

I had the second surgery a couple months later, and while I wouldn't recommend the experience, there were no surprises this time. Eventually my body started to regain its equilibrium. The fear and anger faded away, and the physical pain gradually subsided too, like a burned-out building along a highway slowly retreating toward the horizon.

Life flowed on as before. But it wasn't the same.

A few weeks after the second operation, Helen and I were eating dinner in a local restaurant. I found myself looking at our young waitress, and instead of

admiring her figure, another thought entered my mind: "This person is going to die." Just like me. Her body has the same flaws in construction as mine, the same microscopic enemies. She will endure all the indignities, all the pain that I did, that we all will. She seemed incredibly brave and beautiful to me, and I felt nothing but love, not only for her but for every person who breathes the same air and lives out the same story.

I turned back to the menu and ordered my dinner. But that moment stayed with me. Once in a while, when I least expect it, the feeling returns. Often it happens when I'm talking to someone I don't know, like a clerk or a waiter. I suddenly wake up from my self-absorbed stupor and remember that this person is my comrade, my brother in the trenches. Then I look him in the eyes, say hello, and for a few seconds we're two human beings, together.

Surgery, for me, was the end of innocence. But it was more than just a journey into darkness. For reasons that I still don't fully understand, the pain I experienced also made me more aware of how connected we all are, and how much love there is in the world.

I know how naive this must sound, especially to people who've suffered more than I have. If you watch the news regularly, you can't help but think that suffering usually just leads to more suffering, and there's no meaning in it. Yet my epiphany in the restaurant was real, and probably not that unusual.

Because I suffered, I'm more aware of the suffering of others, and I see more clearly how we're all passengers on the same bus. It's obvious—but it took someone cutting me up a couple times before I began to feel this simple truth deeply.

I'm not planning on having another operation or two in the hope of learning more about the connection between suffering and empathy. I'm perfectly happy to read about it rather than experience it. But I'm grateful for my first visit to the operating table—now that it's over. Maybe next time I'll be more open to the strange beauty of the experience.

THE DAY BILL DIED

Time slows down when someone's dying. If it's a leisurely death, that is. Everyone knows it's going to happen soon, but no one can say when. So mainly what you do is wait.

That's what we did, hour after hour, listening to his slow, choppy breathing, watching the sunlight move across the room, and mostly talking. With that much time we could get into the details of each other's lives. How's your job really going? What's happening with your kids? What are your plans for the next few years?

One night Helen and I had a little picnic at the foot of her father's bed. It was late, the others had gone home, and the hospital cafeteria had closed. So I grabbed a couple of sandwiches at the deli down the street. We put two chairs together to make a table, spread out a couple of napkins, and munched on tuna salad and Fritos. It reminded us of one of our favorite things—sitting on rocks in the Idaho wilderness eating our lunch—and we smiled at each other as we talked about movie stars' hairdos, a hundred ways to keep your man happy in bed, and other fun stuff we had learned in the magazines we'd been reading that day.

It was good to be alone together, except we weren't alone because Bill was there, but we were alone because he really wasn't there—at least in any form that we could recognize. We'd both read those stories about people who died and floated up above their hospital beds, then came back and described in great detail what the doctors were doing to save them. So it felt a little odd to have an intimate conversation while her father was only a few feet away, even though he was in a drug-induced sleep and his body was gradually shutting down. We occasionally glanced nervously in his direction, both of us thinking, "I hope he didn't hear that one!"

Two weeks earlier we had celebrated his eightieth birthday. He'd already been in the hospital for a few days. Carolyn, Bill's wife, had planned a big party, but

. . .

BHP: *Bill Mirkil,* 1998

of course he couldn't be there. He insisted we do it anyway. So Helen's son Eddy and his wife drove up from North Carolina, and the four of us spent an hour or so with Bill in his hospital room before the party. Helen brought a three-inch-round cheesecake with a single candle in the middle that she couldn't light because he was on oxygen. We all gave him his presents and sang "Happy Birthday." He was tired, but he managed to summon up a taste of his usual vinegar.

"So Eddy," he said, "can't you afford to buy your lovely wife a decent pair of pants?" She was wearing a shirt that ended just above her belly button, and her pants began an inch or two below her belly button. "Aren't those two things supposed to meet in the middle?"

We all grinned, and for a few minutes we forgot that we were being entertained by a guy who was too sick to go to his own birthday party. But he wasn't so sick that he couldn't be a little naughty. "You just need some more cloth—maybe you could trim off a few inches from the ankles and sew it around her waistline."

He had surgery a couple days later. When I saw him the next weekend, it was obvious he wasn't going to get better this time. I expected him to be weak, and he was. Surgery does that to you, no matter what shape you're in. But his booming voice was reduced to a hoarse, raspy whisper, and sometimes he trailed off in the middle of a sentence, stared into space, then looked confused, as if he knew he was supposed to be doing something but couldn't remember what. Then he would pick up a nearby book and page through it nervously, obviously thinking, "Maybe I was reading."

Once when I was alone with him that day he tried to make a phone call. He kept punching in the first few numbers, over and over, getting increasingly frustrated. If I had made the call for him, it would only have reminded him of how helpless he was—and anyway neither one of us knew what numbers to dial. So I just stood by his bed and watched his finger hit the buttons, until Helen's sister finally came in and rescued me. I couldn't believe this was the same man who had commanded the room at so many family gatherings, who had managed to fill up a bunch of Helen's cassette tapes with funny stories about his childhood, the Marines, his travels, and all the oddball characters he'd bumped into over the years.

It was just a matter of time after that, though as I said, no one could predict how long it would take. One doctor said he might hold on for as much as six months. Another one who was a lot smarter said, "Let's talk again in a few days." We paid more attention to the second one because we could see how Bill was going downhill, and because we knew he had, among other things, metastatic prostate cancer, a severely damaged bladder from radiation treatments,

lungs that were filling up with fluid, and a weak heart. He had also stopped eating, and though his throat was very sore, if he'd wanted to eat he would have found a way.

He'd finally had his fill of life. It was his time to go.

My first instinct when I'm sick, or when someone I care about is sick, is to call a doctor, figure out what's wrong, and get it taken care of. There's always something you can do to make things better, right? I had a hard time letting go of this idea when Bill was dying, especially when the doctor asked about the DNR order—Do Not Resuscitate. Bill had already made his feelings on the subject completely clear to his wife and daughters. Even so, we couldn't bring ourselves to talk about it in front of him, though at that point he was still conscious. So we all filed out of the room into the hallway, and as we stood there talking it over, I couldn't shake the feeling that despite Bill's wishes, we were doing something wrong. The others obviously felt the same way. Carolyn wasn't able to say what needed to be said. The doctor turned to Helen and her sister. They looked at each other. Silence.

Finally Helen started to describe the terrible pain her father had experienced in the previous week, and this gave her the strength to tell the doctor, "Go ahead—sign the form." I've never loved my wife more than I did at that moment.

We walked back into the room. Despite the drugs, Bill knew exactly what had happened. But he lay there calmly as the doctor asked him how he was feeling. "Your throat is hurting? Okay, we'll see if we can get you some lozenges."

"So, you think I have a couple days left?"

The doctor looked him in the eyes and said softly, "Yes."

"Thank you for your kindness."

I know he said other things to other people, but those were the last words I heard Bill say. By the next day he was asleep, and other than his breathing, the only sounds in the room were the steady bubbling of the oxygen machine, the occasional beep of a timer, the whir of the humidifier, and the low buzz of the clock on the wall.

It started to rain the night before he died, one of those cold, late October downpours that always remind me of how much I hate Philadelphia winters. The next morning was gray and miserable. We could barely see the trees in our backyard as we were eating breakfast. The phone rang. Our eyes met. It was Carolyn. Now Bill's kidneys had stopped working. As Helen put on her jacket and headed for the door, she stared at me with a look of fierce determination that, in our eleven years together, I had never seen before. "Well, I guess this is it," she said.

When I walked into his hospital room a few hours later, his brother and step-sister had already come and gone. Nothing had changed from the night before, except Bill had slid a few inches farther down the bed. All I could see was his head, surrounded by the rumpled white covers. Occasionally his eyes fluttered and his lips moved, as if he were talking to someone in a dream. But no words came out, and soon his eyes closed again as he settled back into that droning, rhythmic, inhaling and exhaling that had become the mantra of our lives.

By early afternoon the rain had stopped and the sky was starting to brighten. Suddenly the sound of Bill's breathing got rougher and he began to cough. In a panic we ran to get the nurse, but by the time she arrived the crisis had passed. She said these episodes were normal. But Carolyn had a feeling that time might be short, so she asked Helen to call our minister. Helen didn't want to bother the poor guy—it was Saturday, and he was probably busy doing whatever ministers do the day before they have to conduct two services. It turned out that he had been at a fund-raising meeting all day and hadn't even started his sermon. But he came anyway, around four o'clock, holding a prayer book in his hand.

I thought he would spend a few minutes with us, say a blessing, and leave. Instead Gary pulled up a chair and joined our little group that had gathered at the foot of Bill's bed: Helen and me, Helen's sister and her fiancé, and Carolyn. We broke the ice with the usual chitchat: traffic, wet leaves that made the roads slippery, people we knew in common. But there was a hunger in the room for something more. Helen began to speak about all the ways her father had been an example for her: how he had remarried after her parents' divorce and had selflessly cared for his second wife as she slowly died from cancer; how he had helped to fill the void after Helen's mother died; how he had always—well, almost always—been kind to people, both strangers and friends.

Her sister remembered how, as little girls, they had moved to New York City with their mother after the divorce, and she and Helen only were allowed to see their father every third weekend (I once asked him about this arrangement and he said, "It broke my heart."). Rather than let them travel alone, he always took the train from Philadelphia. Often he arrived at their door in a limo, which made them feel very special. Some fathers might have given up and drifted away. Not Bill.

Carolyn recalled their wedding only five years earlier, and how happy those years had been for her. I talked about the growing sense of peace I had felt in Bill despite his failing health—the feeling of brightness whenever he was in the room—and how I hoped I could leave the world with as much grace as he had found.

We didn't know it at the time, but later, reflecting on the conversation, we realized that we were all saying good-bye. Maybe in some way he was too.

I was lucky to be facing the window while we talked, because the clouds were finally breaking up outside and the late afternoon sunlight began to pour into the room—at first only fitfully, but soon with a steady radiance, shining through the cards and flowers by the window. The two cut-glass vases on either side of the windowsill began to blaze so brightly that I had to squint, and I could see every facet and angle of the glass surfaces with absolute clarity.

Light—more light—isn't that what Goethe was supposed to have said just before he died? Bill didn't need to say it, because you couldn't have asked for more light than there was in that sterile hospital room that afternoon.

After an hour or so the conversation wound down. Gary grabbed his prayer book and walked up to the bed. Leaning over, he reached under the blankets and found Bill's hand, gently stroked his forehead, then read a prayer from the book.

I had heard the phrase countless times in church and hadn't thought much about it in years. So I was surprised how grateful I felt when he said, "Christ have mercy."

The sun was going down as Gary left, and the yellow maple trees on the hills outside the window stood out against the graying horizon. The rumpled covers on Bill's bed were lit up with a soft twilight glow. His head was turned toward the window. The skin on his cheeks was smooth and clear, and he looked like a newborn baby asleep in his cradle.

Helen and I were exhausted, but we stayed for a few more hours. The nurse said he would probably last for another day or two. We knew he wouldn't be alone, so finally we had to go home and get some rest. The phone woke us up about one o'clock. Helen listened quietly, mumbled a few words, hung up, then crawled back into bed. She turned to me and said, "He's free!"

I know that people often die terrible deaths, in terrible circumstances, and there's nothing to be gained by romanticizing the process. Before watching Bill go through it, I wouldn't have believed that dying could be beautiful. But it was, for him at least, and that's the strongest memory I have of the man: not the confusion and pain he felt toward the end, but beauty, both his death and his life. I also remember his breathing. I'm haunted by it. Often I find myself listening to my own breathing, glancing down in quiet moments and watching my chest rise and fall, feeling my lungs slowly expand and contract as the air rushes through my mouth.

When I think of him now, I remember what a gift it is to be material, of this earth—eating, sleeping, touching, breathing it all in—then beauty and light at the end.

TALKING WITH GEORGE

Their house was a split-level with a two-car garage, a nice-looking lawn, and a grove of trees in the back—something that didn't exactly stand out in the suburbs. The first time I drove down Aronimink Drive and saw the place, I checked my handwritten directions twice to make sure I had the right address. As I rang the doorbell, I wondered if this was really where George Rochberg lived, the man who stood at the chalkboard and calmly pulled apart the opening melody of the Bartók Sixth String Quartet, then put it back together again; the man who knew more about music than anyone else I'd known, but who also loved to talk about American sculptors, medieval philosophy, and the autonomic nervous system; the man who was both an enfant terrible and an éminence grise of American music, a bad boy of modernism and a musical insurgent who thumbed his nose at the very thing he once championed.

Then I went inside. The first thing I noticed was art, on the walls, on end tables, even on the floor—paintings, prints, sculptures—much of it dedicated to the Rochbergs, given to them by their artist friends. On the left, just past the living room, was the music room, designed by a famous architect, with light pouring in from all sides on the big grand piano. There was an abstract painting above the piano by the same artist who made the picture in the music department lounge, a picture that was called *Painting with the Music of George Rochberg*. I was a greenhorn kid from Montana when I arrived at Penn, and I used to stare at that canvas for hours while I studied or talked with friends, trying to figure out the connection.

To the right of the piano room was a small, wood-paneled hideaway where they could have a quiet meal and watch the wrens nesting in the backyard birdhouse. They called this their cabin. Adjacent to the cabin was the dining room, which in turn led to the breakfast room, where they ate their cereal and scrambled eggs on the round wooden table that was made from the door of an old barn. Helen and I inherited this table when they moved to the retirement

. . .

BHP: *George Rochberg,* 1999

community, and I often think of their house when I'm wolfing down my own bowl of cereal in the morning.

Just beyond the kitchen was the stairwell down to my favorite place, the den. This was the sacred room they had made just for talking and listening to music. It had a stone wall that surrounded a fireplace, and there were niches cut into the wall where they had placed small sculptures. Over the years I spent countless hours in that room, and I loved to stare at all the books—hundreds and hundreds of them on every subject imaginable—while George sat in his chair near the window playing records and CDs, and we talked and listened and talked some more.

It would be hard to have a friendship where there was no talking. But George and I talked as if we had just discovered this thing called language, and if we stopped talking all the words might disappear. We talked for twenty years, and at the end we were still talking, like two dogs gnawing on a bone who knew the marrow was in there, and if we just chewed hard enough we were bound to find it.

Sometimes we talked on the phone. Sometimes we talked over dinner. Often we talked when our wives were with us, and they did some excellent gnawing themselves, though they had the good sense to rein us in when all that philosophizing got, well, obnoxious. Once when the four of us were at a restaurant, George and I kept at it even after the food arrived. He was in the middle of one of those long, slow-moving freight trains of thought that was heading ever deeper into the fog. Gene turned to him and said, "Sweetie, what do you want, a seminar?"

Gene could get away with that. He looked flustered for a few seconds, then smiled and broke off his discourse in midsentence. Pretty soon we were all laughing at some vaguely ribald joke, then nodding our heads in agreement about a writer or painter whose work we didn't like. I remember one dinner conversation when the unfortunate subject of our attention was the conceptual artist Sol LeWitt, who was famous for his repetitive geometrical drawings and sculptures with such wildly poetic titles as *Modular Wall Structure*. I was halfway through a lengthy rant about the spiritual poverty of minimalist painting when suddenly George's eyes lit up and he started to squirm like a kid who had to go to the bathroom. Finally he couldn't hold it in any longer, and said with a silly grin, "Yes, Brian, all that may be true, but brevity is the Sol of LeWitt!"

The place where George and I did most of our talking was the Ale House, a little dive of a restaurant in a strip mall not far from where they lived. He liked to work in the morning, so usually I picked him up around noon and we'd repair to the smoke-filled bistro for a beer and a hot meal. We did this so often that

Gene began to call these get-togethers our "Philosophical Lunches." We could just as well have stayed at their house and made a sandwich, but George had an ulterior motive. Gene didn't like it when he smoked. He knew she was right, but he would usually sneak in a cigarette after his fish-and-chips.

Sitting in the Ale House, surrounded by chatty secretaries and jaded businessmen on their lunch breaks, George and I talked about music and photography; cosmology and modern physics; our dreams; the presence of the eternal in art and life; and even, in our own ways, the immortality of the soul, which George was surprisingly receptive to given his staunch opposition to organized religion of any kind, especially Judaism.

We were standing in his living room after one of these lunches, tying up some loose ends from that day's conversation, when suddenly he laughed and said, "Brian, I hereby anoint you an honorary Jew!" He turned toward me, bowed, and said, "Some people are born Jewish, some people become Jewish, and some people have Jewishness thrust upon them!" Then he tapped my shoulder like King Arthur bestowing knighthood on Sir Galahad. To return the favor, I started to call him "Dr. Satori" (from the Zen word for enlightenment) and I referred to their house as the "Aronimink Satori Institute."

Our Ale House conversations usually began with something innocuous like politics or the news. He often asked me about my job, and we would trade notes about what it's like to be both an artist and a nine-to-five guy. He had a full-time job as a music editor in his thirties, and he told me he would come home from work dead tired, eat dinner with his family, take a nap, then write music well into the night. This was how he wrote some of his best-known pieces. I said that what he did in those years disproved Yeats's famous line in "The Second Coming": "Our best lack all conviction." "Maybe so," he replied, "but my family paid a price for it. Gene was the one who held it all together."

What we were really doing was warming up, like a couple of long-distance runners stretching their legs. A book one of us was reading might be all we needed to get things going, or maybe some random comment about art or life. Then we were off. First we worked over whatever got us started, then one of us would head down a different path, then we would bounce back to the previous place but from a different direction. Back and forth, his turn, my turn, the conversation unfolded. We were never quite sure where we were going, but it didn't matter. We knew we would get somewhere. I think that's why we were friends.

We were always trying to dig into something—see where all these crazy thoughts would take us. On a good day they would gradually lead us to places that we rarely shared with anyone and were barely aware of ourselves—to interior rooms that stayed locked up because what lived in them was too strange and mystical for normal conversation.

Most of the details of these encounters have disappeared from my inner hard drive. They would be impossible to reconstruct anyway. A few of the conversations stayed with me long enough that I was able to jot down the highlights in my journal, and these are the only ones I remember now. Mostly what remains of twenty years of gabbing are not the grand conclusions but the moments of intimacy and revelation. This used to bother me—somehow all that talking had to add up to something more concrete! But eventually I figured out that what was said was less important than the connections we made—with the ideas, yes, but mainly with each other.

One conversation began with how each of us got into the creative life. George mentioned that he was the only person in his family who went in that direction, and I told him it was more or less the same for me. "So you're the only maniac in your family too," he said. "The only one with conviction," I replied, and we laughed for a long time. From that innocuous beginning, we somehow worked our way around to the limits of human perception and the mysterious vastness of the known universe. Suddenly the image of an amoeba swimming in the ocean appeared in my mind.

"An amoeba doesn't have much chance of understanding the ocean," I told him, "but isn't that what we're all trying to do?" He stared at the wall behind me for a few seconds, then said that often an amoeba will thrash around and struggle, thinking all the time that it's drowning. But if only it would relax and float, the amoeba would somehow be "supported."

"You know, I struggled for years, sometimes violently," he said, "but it's only very recently that I've begun to float."

It was one of those conversations that felt like it would never end. So many tributaries of thought—yet somehow they all flowed in the same direction. We went from floating amoebas to Yeats's strange, cyclical theories of time in his book *A Vision*. We connected broad movements in history with the rhythms of tension and release in a classical symphony. Eventually we concluded that there is no other purpose to the great sweep of history—no other purpose in life—than consciousness. All the fundamental processes of growth and change that we experience, both collectively and individually, will eventually lead to the magical awareness and energy that is true consciousness.

Later, standing in his doorway as we were saying good-bye, George said that he could die with no sadness and only one regret: that he had never been the proprietor of his own fifty acres of ground, where he could watch the plants grow.

That passing reference to death was unusual for George. When the subject came up, he usually steered the conversation in another direction. Maybe this was because he had experienced so much of it. He rarely discussed what happened to him during the war (he was a lieutenant in the infantry during the

post-Normandy campaign), except to say that seeing all that suffering and death, and being wounded himself, was what made him so single-minded as a young composer, and so angry.

I never asked him about his son, Paul, who had died of cancer many years earlier, and I think George was grateful that I respected his privacy.

He only talked about Paul once. We had just sat down in our usual spot at the Ale House, and I could tell he had something on his mind. He reached into his coat pocket, pulled out the book of Paul's poetry that had just been printed, and asked me if he could read a poem. "Of course," I replied. So he did. Afterward he put the book down on the table and told me about his son, what kind of person he was, his many gifts, even his physical appearance.

George said that sometimes he sensed Paul's presence and talked to him. "Just the other day I was thinking about who Paul was, who he might have become, and I said, 'Paolo, you should have been here.'"

I told George about a man who had a near-death experience during a heart attack. He was someone I'd met, so the story had some credibility. First he saw the usual stuff—the tunnel, the bright light, etc.—then found himself surrounded by ethereal beings who said they would answer any questions he might have about life. He said he only had one—why? Why do we do it? What is the purpose of it all? The beings replied, "There's no purpose in life, except to give until there's nothing left to give."

What George said to me then was so surprising that I remember his words more or less verbatim. He waved his arms in the general direction of the dim, smoky interior of the Ale House and said quietly, "We have to realize that those beings, that light, are here, right now, all around us." He was probably thinking about his son.

I learned something about my friend that day. Despite his fascination with ideas, his love of all things intellectual, at his core George Rochberg was a dreamer who wondered about other realities and imagined other worlds. Everything he said, everything he made, grew out of a silent but deeply felt spiritual life.

Most people didn't see this side of him. I didn't see it that often either. But once in a while a door would open, and suddenly he was no longer Rochberg the composer, Rochberg the thinker—he was Rochberg the medieval monk, Rochberg the mystic.

One of these moments happened when I finally worked up the courage to ask him to sit down in front of my camera. I lugged my equipment into their house, set everything up, and as always we started talking. As I had feared, the camera made him nervous, and at first he retreated, staring blankly into the lens. Then I started talking about my garden, especially my oddball ideas about

the psychic life of sunflowers—how the rhythms of a sunflower's life are not that different from ours. This woke him up! He forgot about that big lens staring at him, and we meandered into one of those intense, revelatory conversations that were rare even for us.

He was in a dark mood that day, inward and reflective. At one point he asked me if I ever had moments when I felt that I just didn't belong here—that this world was not really my home. Then he began to talk about the woodworker Wharton Esherick, who was a mentor and close friend—how Esherick had become almost completely silent toward the end because "he had one foot on the other side."

A few years later the moment arrived when George had one of his own feet on the other side, with the rest of him not far behind. He'd had major surgery a week or so earlier, and Gene told us that he wasn't strong enough to have visitors. So I was surprised when she called and said he wanted to see me. He was so weak that he couldn't even sit up in bed, and I could barely hear his voice. We still managed to have a conversation of sorts, but I could see it was wearing him out and I didn't stay long. I reached out to shake his hand as I was leaving, but instead of our normal grip, he grabbed my hand, lifted it up, wrapped his wrist around mine, and looked me in the eye while squeezing our palms together with as much strength as he could muster.

He didn't say a word, but I knew what he was telling me. We're friends, he was saying. You and me—friends. He was also saying good-bye, though I didn't figure this out until a few days later, when Gene called us up and said he was gone.

The last real conversation I had with George was a week or so before the operation. He was in a terrible situation with no good choices. He had an aneurysm. If he didn't have surgery, he would probably die, but surgery at his age might kill him too. He and Gene had decided that the operation gave him the best chance at having more life. It was the most hopeful decision they could have made, and I would have done the same thing. But he had no illusions about what was about to happen, and he couldn't resist a bit of gallows humor. As he was describing his upcoming ordeal, he winked at me and pretended to be his surgeon: "The operation was a success, but the patient has expired!"

This time we mostly talked about art. What is art and the life of the artist really about, when you cut away all the detritus of fame and culture and ego—when you get down to what George called the "substrata"? At one point he turned to me with that intense look he got when he was on to something he cared about. "Art is about the *real*," he said, and balled his hand up into a fist for emphasis. In other words, whatever truth there is to be found in life, that's where art lives. The artist's job is to search for that real place, that authentic

experience, that sense of deep honesty, then find the clearest and most concentrated way of expressing it.

This is not an easy thing to do. It usually involves a solitary and maniacal and even painful journey, and no artist knows everything about it or gets there all the time. But the struggle is worth it, because when you do get there, the truth you find is solid, unshakeable, and truly yours. No one can take it away from you. It has an inner core that people recognize instinctively. It lasts. It is real.

So what do I take away from my twenty years of talking with George? Just this: that Truth, with a capital *T,* is worth fighting for. In fact it may, in the end, be the only thing worth fighting for. And often it is a battle, both with oneself and all the inner demons that lead us away from Truth, and with the world, with all its seductions both obvious and subtle—the seductions of career, of comfort, of power.

Who was George, when you get down to the "substrata"? He was a man who held fast to Truth. He scratched and clawed his way to it, and when he found it, he grasped it, defended it, sang about it, and in his flawed and very human way, held on to it with all his discipline and strength.

After he died, I read numerous worshipful articles and obituaries that described George as a musical reformer, a trailblazer, a rebel, a postmodernist, a neoromanticist. Though he loved to get on his soapbox about such things, I know that in his heart he laughed at all those meaningless labels, because he understood how unimportant and transient they really are. We don't care about George's music because he was a serialist or a tonalist, or because he happened to quote Mahler or Bartók or Beethoven in his string quartets. We care because we can feel, instinctively, that his music is *real* to the very marrow. The musical language he spoke was only a means to that end.

For the rest of my life I will take with me this gift from George: to hold fast to Truth—to be uncompromising and fierce in its service—and to do the work, with as much honesty and passion as I can bring to it. For that I say thank you, George—you were a true friend. Without you my own journey will be more solitary. But because I knew you, I see the path I need to travel more clearly.

MICHAEL AND ME

I started writing down my dreams as a teenager, but I rarely share them with anyone. Not long after I met Michael Rose I remembered a character in a dream who reminded me of my new friend. One day, on a whim, I read parts of the dream to him, including an odd phrase the dream character used: "mellied out." I had no idea what it meant, but I had dutifully written it down. Michael's face grew pale when I read this passage. He was so shocked that he couldn't say anything for a while. Then he told me that one of his high school nicknames was "melly." The date I'd recorded in my dream journal was roughly five years before I met him, when he was in high school.

I don't know what to make of this bizarre coincidence, except to say that from the beginning there was an odd sense of inevitability about our friendship. It's as though we were meant to be friends, and somehow always have been friends. There's no logical explanation for this feeling, just as there's no logical explanation for that dream. Yet this lovely inevitability didn't stop us from almost ruining our friendship ten years later.

I barely remember what started it. I think I was peeved because he hadn't returned a few phone calls, and he was peeved because of some things I'd said about his music. Nothing that two adults couldn't work out over a cup of coffee. But neither of us was willing to confront the problem, and feelings had built up. I unleashed the first salvo—a few days after he got married, no less. Instead of backing down, he counterattacked. Soon we were like Kennedy and Khrushchev locked in a terrible dance of mutually assured destruction. We dug in our heels, and over a period of several weeks the mood got darker and darker. Finally I gave in to my anger and told him in a letter that our friendship was over.

More than fifteen years later, when I think of that moment, I'm ashamed. I don't use that word lightly. *Shame.*

I expected him to be equally vindictive. Actually I wanted him to feel the same way I did—that's how far gone I was. Instead he called me up and said, "Brian, what are we doing here? Whatever it is, we have to stop." I still remem-

. . .

BHP: *Michael Rose,* 1999

ber the horror in his voice, and the love. The spell was broken. That was the day I learned how seductive anger is, how easily it can turn into hatred, and how quickly hatred can destroy something beautiful.

One of the first things I noticed about Michael was how he ate. He's older now, so he's much more civilized about it. But back then, a meal was an enemy to be defeated and absorbed—or perhaps a lover to be ravished. He would grab the menu from the waitress and scrutinize it line by line, selecting his prey with nervous anticipation. When his dinner arrived, he didn't just eat, he invaded. If utensils were necessary, he sometimes gripped both knife and fork firmly in his fists so the food could be propelled more rapidly into his mouth. When he was done, a halo of food scraps surrounded his plate—bits of lettuce, hamburger crumbs, an occasional blob of ketchup—and he would sit back in his chair with a look of satisfied exhaustion on his face, probably the same expression Caesar had after conquering Gaul. All the while we would be talking about Ursula Le Guin's latest novel, or perhaps the relative merits of Stravinsky's *Symphony of Psalms* and Bartók's *Concerto for Orchestra*.

Michael came from a family of doctors and scientists, and it would have been easy for him to follow the same path. But he fell in love with music in college, and nothing was going to stop him from living a creative life. Maybe that's why we were drawn to each other, though it could have been our shared interest in talking with our mouths full. We also liked to play and think, if possible at the same time, so a game of chess with a Brahms symphony in the background was one way we channeled our testosterone.

Michael introduced me to the joys and terrors of blackjack. Once in a while we drove down to Atlantic City with a few bucks in our pockets, both to experience the real thing at a casino and to ogle the cocktail waitresses. Not wanting to waste any of his precious time on this earth, Michael always brought along a book of poetry to read while the dealer shuffled the cards. As soon as he pulled the book out, the floor managers gathered around him like vultures eying fresh roadkill. Inevitably one of them had to examine the book—and the looks on their faces when they saw what he was reading! Unforgettable. They always turned the book upside down and leafed through the pages to make sure he wasn't cheating by looking at some cryptic crib sheet.

We met in a music history class at Penn: the romantic period—all those long-winded operas with endlessly warbling sopranos and oversexed tenors. We were both in our twenties—late for me, early for him—and were both music majors, so it was a required class. Michael got an A as I recall; I got an A- or maybe a B, mainly because in my paper on Richard Wagner I couldn't resist making a few nasty comments about Wagner's politics.

Our professor thought Wagner was one step below God and said there was a lot we could learn from the music, even though Wagner ended up becoming the state composer of the Third Reich. I knew the teacher was right, but it still felt good to take a potshot at all that overwrought Aryan mysticism. Michael and I enjoyed a few subversive moments in that class, and when it was over the two young Che Guevaras would drive out to his parents' house in the suburbs and toss a Frisbee or throw a baseball.

Michael can still throw a Frisbee about as far as I've ever seen one thrown, even though he's getting gray around the temples, and he mostly plays Frisbee with his daughter Maggie in the parks of Nashville. He moved away from Philadelphia to get his Ph.D. and eventually landed a job at Vanderbilt University, where he won all kinds of awards and teaches such funky classes as "Beethoven and the Beatles" and "Music and the Bible."

At first it was a bit strange for him to be a Jewish guy in the heart of the South, but he's adjusted. Once someone wrote an article about him on the front page of the student newspaper that focused on the way he incorporates his Jewish heritage into the music he writes. The article continued on an inside page, and the single-word headline at the top of the column was "Jewish." He showed it to me with a sad smile on his face.

Because we live so far apart I don't see Michael too often anymore. But we have some great phone conversations, which typically include a recitation from memory of a verse or two of a Psalm, in Hebrew; an analysis of the mythological implications of Charlie's Angels, Swamp Thing, and the Hulk; a reminiscence of his many hours of walking alone on the English moors; or the ins and outs of the latest Coen brothers movie. More often than not we end up giggling uncontrollably over some silly pun, then wandering into a very personal comparison of Judaism and Christianity.

The word *curious* just doesn't come close to describing Michael's mind. Learning, to him, is a way of digging deeper into the stuff that really matters. Why bother to fill your head with knowledge unless it gives you some insight into what makes your own soul tick?

Because he's such a good teacher, Michael once was hired to lead a group of people from the university on a tour of some of the musical capitals of Europe. The trip included a visit to one of the great shrines of opera, the house of my old nemesis Richard Wagner. Michael agonized for weeks over how to handle this, eventually deciding to give one of his standard music-history lectures. But then the moment arrived. There he was, a Jewish man in one of the centers of anti-Semitism, intensely aware of what Wagner's spiritual descendants had done to the Jews of Europe.

On the spur of the moment Michael asked the caretaker of the house if it would be okay to play Wagner's piano. She refused. But after he had spoken for a while to his group, the key to the sacred keyboard suddenly appeared, and Michael proceeded to play extensive excerpts from Wagner's operas while talking enthusiastically about their pure genius. Then my fearless friend set up a chair and started to speak to Wagner, as if the long-dead musician was actually sitting there. In the conversation Michael reminded Wagner of his unashamed bigotry and of all the wartime horrors that were inspired by Wagner's ideas.

"In the end," Michael said to the invisible composer, "I cannot forgive you."

Later, the caretaker told Michael that in more than twenty years of watching experts talk about the great man, she had never seen anything quite so moving happen in that room.

After Michael told me this story, I hung up the phone and sat on my couch for a few minutes thinking about our long friendship. Suddenly I remembered something he told me right after he visited the Holocaust Museum in Washington, D.C., for the first time. After describing the endless photographs of victims, the German soldiers who used Jewish babies for bayonet practice, and the huge piles of shoes, combs, and other belongings, Michael said, "You know, the most horrifying thing about the place was that I recognized in myself the same kinds of feelings that led the Nazis to do all those things."

Michael Rose is a man who can see evil for what it is and say "no," absolutely and unequivocally. Yet he also sees the real potential for evil in himself. Is there a better definition of a conscious life?

STEVE'S TRAIN RIDE

Sitting next to a composer during a performance can be dangerous, especially when the composer is Steve Jaffe and the concert includes something he wrote. Steve has mellowed now. But when he was younger, his wife and I had an unspoken agreement that each of us would give him a discrete jab in the ribs if things got out of hand.

He was perfectly well-behaved while someone else's music was being played. But then his own piece would begin. I learned to recognize the first signs of trouble: the lowering of the head, the closing of the eyes, the tightening of the neck, the clenching of the hands. The music started to flow, and Steve started to move—fingers, wrists, arms—while he conducted the piece in his head. Then would come the tiny explosions of breath, the low growls, the moans and grunts, punctuated by short, choppy movements of his shoulders and hands.

The people sitting nearby had no idea that the source of all this racket was the composer. More than once I saw someone in front of us turn around, glare, and even let fly with an emphatic "Sshhhh!" For a few seconds he remembered where he was. His eyes opened and he looked up, startled at the interruption. But soon the music pulled him in again.

I met Steve in 1974, the year we both transferred into the music department at the University of Pennsylvania. His composition lesson was right before mine, and each week I saw him through the little window in the door, playing four-hands piano with our teacher. I remember feeling a twinge of jealousy because his piano technique was better than mine, but I concluded that his music sounded like Bartók, which made me feel slightly superior. Mine didn't sound like much of anything, though at the time I didn't know it.

We shared a couple of classes, and before long we were friends. I'm not sure what drew us together. It certainly wasn't our backgrounds. He was a Jewish kid from Massachusetts who had studied music at a Swiss conservatory. I was a tenderfoot WASP from Montana who, until that fall, had never been east of Chicago. At twenty-one I was a year or so older, but West Philadelphia might as well have been Uzbekistan or Outer Mongolia to me. Steve became my guide as I learned how to survive the city. He convinced me not to worry, for example,

when my clock radio woke me up one morning with the news that a body had been found in a dumpster a couple blocks up the street.

For the first few months I lived in Philadelphia, just walking to the campus was such an assault on my senses that I rarely left my apartment except to go to class. So Steve showed me how to use the commuter trains to get to the woods, and I discovered trees and rocks and flowing water again. Suddenly this big scary place wasn't so bad anymore.

The biggest, baddest, scariest place was New York City, and eventually Steve talked me into going there, luring me with the promise of a contemporary music concert. The train ride was okay—I was already used to that. But being impoverished music students we decided to take the subway to the concert rather than a cab. This was how I learned that my friend trusts his instincts about where he needs to go. It's a strategy that works much better with music than subways.

Steve jumped on the first train that arrived, and I dutifully followed. Naturally it was the wrong one. I panicked when I saw the look of alarm flash briefly across his face, imagining every possible thing that could go wrong when you're lost in the city. But Steve simply got up, studied the overhead map, directed a question at a nearby passenger, and soon we were sitting in our seats listening to some very strange music.

He may not always take the most direct route, but Steve usually gets where he wants to go. He figured out early on that music was what he loved, and he's never left that path and never will. He began by playing guitar in a rock band, and as a teenager wrote his own songs and arrangements. When I met him he was already writing big orchestral pieces and organizing concerts. He was serious about life, and I was too. There was an unspoken sense of purpose that we shared, a feeling that being an artist was not just a career choice, it was a spiritual necessity, a calling.

I liked Steve because he cared about music, but I also liked him because he was so comfortable with his eccentricities. My other friends always wanted to have a beer when our classes were over for the day—Steve enjoyed taking walks and window-shopping. That's right—this intelligent, serious-minded musician could not stroll down a street without stopping in front of every store and admiring the merchandise. This was not what young men did to entertain themselves where I grew up, but Steve was, well, Steve, and I admired that, even though I used to glare at him when he got excited about a sweater or an antique clock.

. . .

BHP: *Steve Jaffe,* 2000

He seemed so at home in the world. I was introverted, unsure of myself, a bit of a misfit. Steve could walk into a room full of strangers, and within a few minutes he had struck up a conversation with someone and discovered that they both liked the music of Chopin, or had dated the same girl in high school. There was something fearless about him that fascinated me. He didn't need to figure everything out like I did—he trusted that life would take him somewhere interesting. He once told me a dream he had about a train that was heading into darkness, and everyone on it was so terrified of where they might be going that they all had turned around in their seats and were looking backward, not forward. But Steve was perfectly calm about it all and sat in his seat and looked out the window, whistling to himself.

It's not that Steve's train ride has been trouble free. He's had his share of bumps and bruises, especially in the girlfriend department. While his professional life was unfolding smoothly (compared to mine, that is), he still felt lost and incomplete because he'd tried and failed at love so many times. He had four girlfriends in those years, as I recall. Each time he fell madly in love, struggled to keep it going, then nearly died of grief when the relationship ended.

One of his girlfriends lived in New York, and I dropped by his apartment right after he returned from a visit with her. They had just broken up. He was agitated, pacing around his living room, occasionally breaking out in tears. To him what had happened was a personal failure, and there was nothing I could say to drive this thought out of his head.

I don't think I had much to offer him then anyway. I had been married for a few years, to the first woman I fell in love with, a woman who I thought was my ideal friend, my soul mate. Steve's pain was confusing, even threatening to me. All I could give him were a few smug platitudes about the spiritual dimensions of love, which was something I knew all about because my own marriage was so wonderful.

Ten years later it was my turn. My wife had, among other things, fallen in love with a Catholic priest who was also one of her grad school teachers. By this time Steve was happily married, a father, and teaching music at Duke University. Two or three times that fall I drove from Philadelphia to North Carolina and spent a long weekend at his house. What a *joy* it must have been for him to listen to me drone on and on about my dead marriage! But listen he did. "Tell me how you're feeling," he would say. "I really want to know." And he kept on asking me to talk, drawing me out, until he knew I was okay.

Steve has had many opportunities to take care of me in the thirty-some years I've known him, and he's never let me down. When I dropped out of school, it was Steve who convinced my teachers to give me incompletes instead of

flunking me. When I spent the next four years working lousy jobs and taking that commuter train to the rocks and trees, Steve stood by me, waiting patiently until I sorted things out.

We could easily have drifted apart when he moved away from Philadelphia. But every time I called him he called back, and every time he called me I called back, and pretty soon we got into a rhythm. Even now, if a week or two goes by and we haven't talked, something doesn't feel right. Sure enough the phone will ring. Though we don't discuss it, I can tell he was feeling the same way.

I count among my happiest days our two weddings. When I helped carry his chuppah—the symbolic house in a Jewish marriage ceremony—I was thinking about those dark years of girlfriend after girlfriend, and the words I wished I would have found back then, when he really needed them: "The pain you're feeling says a lot about who you are, my friend. There's something you're looking for, and I think you're going to find it."

A few years later I was standing at the altar the second time, my new wife on one side and my old friend on the other, the three of us singing a bouncy, exuberant Haydn hymn about the creation of the world. Music, friendship, marriage, religion—at that moment they were all coming from the same place, and we were all there, in that place. I had a hard time holding back tears, and I was glad Steve and I had hopped aboard the same train, because it was Steve who taught me what it means to have a friend and be a friend

Steve Jaffe loves music. Music is what keeps him alive. If he makes a little noise at a concert, it just means that what he wrote is so personal and so honest that all he can feel at that moment is the truth of what he's written. But he's not one of those self-absorbed artists who leaves behind a trail of tears wherever he goes. Steve doesn't separate the love he feels for music from the love he feels for family, for friends, for life. It's all one big love.

BUMPA'S BACK

The freeway was almost empty, and there was no sign of the usual congestion at the parking lot. The ticket counter was deserted too. "Only three days before Christmas," I said to Helen. "I know," she replied. "Where is everybody?" The plane took off and landed smoothly, and we only stared at the carousel for a minute or two before our bags tumbled down the ramp. We looked at each other and laughed, then blurted out more or less the same words: "Well, we must have done something right!"

We were early, so we had to wait a few minutes for Helen's son Eddy to pick us up. But we enjoyed watching all the little airport dramas unfold—the stony faces of travelers waiting for their luggage, the hugs and high-pitched chatter of people who hadn't seen each other in a long time. Soon we looked out the big glass doors and there he was, standing by the car and smiling, with the trunk already popped open. Now it was our turn for hugs and high-pitched chatter.

The babies were asleep when we got to his house, and it took all of Helen's willpower not to run upstairs immediately and wake them up. But we did creep into their rooms and look. The two-year-old, Ty, was sprawled out on his stomach, with one foot tucked beneath the covers, his cheek mashed into the pillow. The four-month-old, Ollie, was curled up in his crib, wrapped in blankets and barely visible, breathing quietly.

The house was calm—unnaturally calm. Every available surface of the living room was covered with baby stuff: toys, bottles, pacifiers, piles of unfolded laundry, more toys. Here and there a cell phone, TV remote, empty glass, or magazine poked through the clutter. We felt honored that they hadn't cleaned it up. We were family.

The four of us sat down in the living room and talked for a few minutes, but soon we heard Ty, mumbling and crooning to himself. Helen ran up the stairs and peeked around the corner of the hall outside his room, while I trudged along behind her. They saw each other at the same time. "Grammy!" and "Bub!"

. . .

BHP: *Helen with Bubbalishus,* 2005

came out simultaneously and we charged inside, where we were immediately introduced to all the stuffed animals and books that had entered his life since our last visit. In a couple minutes we were back downstairs. Ty and Helen grabbed small plastic hockey sticks and took up positions on opposite sides of the living room. Helen sat on the floor, her legs making a wide V.

"Come on, Ty, hit it to Grammy!"

A thunderous thwack, and the little ball shot across the room, bounced off a Grammy leg, and landed in a Grammy hand.

"Thcore!" His favorite new word, which he shouted out with both arms high in the air.

"Good one, Ty—here's the ball—let's do it some more!" Which he did, of course, over and over, thcoring and thcoring again.

I caught Helen's eye. "I guess when he's a teenager that word will have an entirely different meaning," I said. She grinned at me. "Yeah, you're right," she replied, and turned back to the game just in time for another thwack and another "Thcore!" There would be plenty of time down the road for those randy teenage years. Now it was his time to be a kid, and he was tackling the job with gusto.

I cleared a space on the couch and settled in for an hour or two of being "Bumpa"—watching the two of them play, yelling an occasional word of encouragement, getting up once in a while to join in, and talking to Eddy and his wife, Angel, about their jobs, Angel's family, real estate, religion.

The phone rang. It was Angel's sister in Wyoming. As they chatted with each other, I suddenly remembered a phone call from my own sister a little more than two years earlier. It was the phone call when she explained to me that she had finally decided to stop the seemingly endless rounds of chemotherapy. She had just told her doctor that she wanted the port taken out of her chest. The stupid thing irritated her skin, and always got in the way of her bra strap. After more than six years of surgeons cutting pieces out of her body and oncologists pumping toxic chemicals into her body, the tumors in her liver just kept "roaring back," as she said. There was nothing the science of medicine could do for her anymore. She was a doctor—she knew.

It was the phone call when I learned that my sister was going to die. Soon.

"I've had a good run," she told me. "But this is it. I don't want to add any more to the suffering in the world." It was the first time I wept, without shame or self-consciousness, the words pouring out of me. I told her that I was glad our friendship had a chance to grow, that I had learned from her that life is worth fighting for, that every decision she had made—every operation, every doctor visit, every drug—came from love, love of her teenage daughters, love of life. "You're a person with a lot of love," I said.

I think it took her by surprise—her rational, levelheaded brother cutting loose like that. Yet I was amazed at how calm she sounded. Her voice was almost normal—just an occasional quaver, or a quick intake of breath as she caught hold of her feelings. But my sister was always more comfortable with the concrete. She often talked about physical things—her pain, the chemicals and their dosages, her various symptoms. But she rarely said anything about what was going on inside. If I asked her what she was thinking about, her response was always curt: "Nothing too profound."

Only once, in all the years of her illness, did I manage to turn a conversation in a different direction. I had flown to Phoenix for a week to help her out during one of the more brutal chemo regimens, and we were sitting in her car, waiting for one of her kids to emerge from a music lesson. It felt very odd to be sitting in the driver's seat, but her doctor had said she wasn't allowed to drive. Somehow the subject of mortality came up. "Most people are afraid of death, Wendy," I said. "I guess it's mostly fear of the unknown."

"Oh, I'm not afraid at all," she replied. "Why should I be? The only thing that'll happen is that I will simply cease to exist." She was silent. "But I want to *live,*" she said, her voice rising, as her daughter appeared in the distance, smiling, oboe case in her hand.

Helen was twenty-nine when she lost her mother, and her father died a year before my sister did. Early on in our marriage, when the subject of death came up, Helen would jokingly called me a "pain virgin." She was right. I had read articles, essays, and books about death—I had talked about it, brooded about it, dreamt about it—but I had never been close to it, never known the true texture and flavor of grief.

When I talked to people who'd been through the death of a family member, they usually told me that the holidays are difficult. I believed them, and I was expecting to feel—something—a few flashbacks, maybe? Sadness? I was not prepared for the weight of the experience.

The first Christmas after Wendy died, as I was loading my car for the trip to the airport, my shoulders suddenly sagged, my head drooped, and for a minute or two I was barely able to walk or talk. I had no name for this feeling. When I finally got command of my faculties again, I realized that carrying the suitcases had reminded me of all the trips I'd taken to see her, especially the last two or three when she was failing. "Well, Mr. Emotional Genius," I said to myself. "So this is what they were talking about!"

Two years after she died, the physicality of grief—the heaviness in my body— was gone. But the memories were still there, just below the surface of the pond, and all it took was a pebble or two in the right place to dislodge them.

An hour after we arrived at Eddy and Angel's house—after Ty and Helen had worn themselves out with hockey and moved on to indoor basketball—the new-born, Ollie, finally woke up. Helen, of course, got first dibs. She started out by holding him. Enfolding would be a better way to describe it. After reality was confirmed, then came the sniffs (neck, toes, behind the ears), squeezes (arms, thighs), and smooches (hands, cheeks).

Knowing that he had temporarily lost the battle for Grammy's attention, Ty yelled out his second favorite new word: "Bubbalishus!" He had no idea what it meant. But he knew it was what Grammy always said when she was rolling on the floor with him, and with any luck it might win her back again.

A dark look flashed across Helen's face as her reverie was broken. She was a first-born child herself, and when Ollie was born she had decided that she would do her best to cushion his brother's expulsion from Eden. Ty had already figured out her weak spot, and moved in for the kill. "Bubbalishus!" he said again, and ran up to her with a hockey stick in his hand.

"Okay, Ty." With a sigh she held the baby out to me. "Do you want to hold him for a while?"

"Uh—sure."

Helen had children in her first marriage—I didn't. I'd managed to live fifty-two years without once changing a baby's diaper. When she handed him to me, she was careful to place one of my hands under his bottom, the other behind his neck. "See, it's not so hard—just bounce him a little if he gets restless."

I might as well have been holding a thirteen-pound rock. It reminded me of how I felt when I was a gawky teenager at a dance, surrounded by cheer-leaders and jocks. Surely everyone in the room was whispering to each other about how clumsy I looked.

He was far more patient than any of my old dance partners. We sat there for a few minutes, the two of us, a bit confused—sizing each other up. I had no idea how to communicate with a four-month-old, but I began to take him in—the heft of him, the smell. He watched me watching him, looked in the direction of the TV, turned toward his mother's voice, then back to me. If this was a rock I was holding, it was a curious rock, one that was asking, "What is this place where I am?"

Finally I forgot how self-conscious I was and pulled him close. I could never hug him the way Helen did, but at least he was no longer just a lump. He was a person. More like a seed of a person—but a seed that had already sprouted, who was beginning to learn about the soil where he was going to grow. And what would he grow into? That was the question, wasn't it? What would this baby become?

Nothing could be more common—another baby in the world. Would he be an accountant, a truck driver, or a Ph.D.? What difference did it make? We all have to be something. But this one, right here, this one mattered. He was a mystery, to himself, to us. The only way to find out who he would become was for him to live his life—and maybe, in some small way, I could be part of that.

Ty had finally worn Helen out, and she was ready for another dose of baby. As I was handing Ollie back to her, it occurred to me that I hadn't noticed the color of his eyes. They were wide open, staring at me, two islands of dark blue in an ocean of clean, lovely whiteness. I stared back at him, our eyes met, and suddenly another conversation with Wendy rushed into my mind, one that happened a week or so after I learned about her decision to end the chemo.

In my sister's house you always had to read the paper over your cereal bowl, and I had already braved the chilly morning air to retrieve both the Phoenix paper and the *New York Times* from her driveway. I was up early, at least for Phoenix (it was two hours later in Philadelphia where I live). Everyone else was still in bed. Then I heard the floor creak upstairs, and before long Wendy was sitting across from me, both our heads buried in the newspaper. She must have spotted some interesting tidbit, because soon we were talking instead of reading—one of those pleasant, forgettable conversations about a movie review or perhaps an article describing some far-off place she had visited.

We never made a lot of eye contact when we talked to each other—it felt more comfortable that way for a brother and sister—but at one point that morning she became animated and looked right at me. My spoonful of cereal froze in midair and my breath stuck in my chest. How had I not noticed this before? The whites of her eyes weren't white any more. They were yellow. The tumors had begun to affect her liver, and jaundice had already set in.

That was Thanksgiving. By the time I had returned a few days before Christmas, her whole body was a dull shade of greenish yellow, and she needed regular doses of pain medication to keep going. My parents, my brother and I, her daughters—we all told her to take it easy, but that just made her angry. She was fifty-three years old and she knew how she wanted to die: as if nothing unusual were happening.

We had to buy some food for Christmas dinner, and Wendy not only insisted on going, she took charge of the whole operation. So my elderly parents and I followed her slowly around the grocery store, smiling nervously as she dropped cranberries and stuffing mix into the cart, while other shoppers glanced furtively at this lemon-colored lady wearing an obvious wig.

She also insisted on making Christmas dinner. But by midday when we had all gathered to exchange gifts, she was unsteady on her feet, and she fell asleep on the couch before she had opened all her presents. Her cat jumped up on the

wide armrest and sat, motionless, staring at her while she slept. When dinner was ready, we decided the best thing to do was wake her up, but as we all gathered at the table, I could see that she was dreamy, barely there.

What do you say at the last Christmas dinner when your family is together and unbroken? I knew my family would say absolutely nothing. It's not that we didn't understand the gravity of the situation. We've never been very good at talking about what we're feeling. For two or three days I'd been obsessing about this moment. I had even written some notes down on a scrap of paper. But I couldn't think of a good way to sum up what it meant to have someone we cared about here, instead of not here.

The best I could do was raise my glass and stammer out a few words after we had all sat down: "I want to thank Wendy, not just for the dinner but for giving so much to the family." She looked at me with an ironic grin, as if she knew what a struggle that had been for me. "Thanks," she said.

That was probably the strangest meal I've ever eaten—strange because it was so normal. It was basically no different from dozens of similar gatherings we'd had in the previous thirty years, though my brother and sister had added two children apiece, he and I had different wives, and the location had changed a couple years earlier when Wendy's marriage had broken up. But there was the same banter about the loot we'd gotten for Christmas, the same embarrassing childhood stories dredged up.

A few minutes after my toast, Wendy's energy finally gave out. She excused herself and headed in the direction of her bedroom. I couldn't believe that we were about to just let her go, not having any idea if she would ever come downstairs again. I got up, walked over to her, gave her a hug, and said, "Merry Christmas, Wendy—we love you."

"Oh, thank you," she replied, sleepily, then turned and went upstairs.

"Hey Mom—have I showed you Rudolph yet?" Eddy's question jerked me out of my reverie. He snatched the newborn from Helen's arms and sat down on the floor by the couch. Then he held the baby high in the air, firmly gripping the tiny body below the armpits, and began to sing "RUdolph, the RED-nosed REINdeer," while bouncing the baby up and down in time to the music. They smiled at each other—more like beamed—father and son. "YOU would even SAY it GLOWS!" At that moment Eddy was both a kid who was showing his mom some new bug he had just caught and a deeply serious young man who was proud of his fatherhood.

When that game had run its course, Helen turned back to Ty. "Hey—how about some dancing!" Eddy picked up the remote, turned on the TV, and scrolled down to one of Ty's favorite shows. "We are the dinosaurs, marching,

marching," sang the woman on the screen. Helen grew up with *American Bandstand,* and she proceeded to rock and roll her way across the room, while Ty did his best to copy her moves. He bent both arms, bowed his head, stuck out his diaper-covered butt, and hopped up and down from one leg to the other.

It was such a silly and earnest approximation of dancing, and we all started to laugh. After a couple minutes of this, laughter turned into giggles, and Ty uttered one of his primal yells—a short, piercing cry that somehow, in one sound, combined joy, aggression, concentration, discovery, and complete and utter pleasure at being alive.

Helen couldn't take it any more. She grabbed him up, fell to the floor, and emitted her own version of the primal yell: "Bubbalishus!" They became one hysterical rolling mass, arms and legs flailing, while Eddy, Angel, and I gasped for air, our faces getting redder and redder, giggling uncontrollably. Only six or seven hours had gone by since Helen and I left our house, and we had already been absorbed into this happy place, where our fifty-something bodies felt thirty years younger and our fifty-something souls could almost forget what we'd already lost.

The Twenty-third Psalm famously says, "Yea, though I walk through the valley of the shadow of death, I will fear no evil: for thou art with me." These are brave words. I would even go so far as to say, true words. Yet in the psalmist's very need to say them is a hint of doubt. The person who wrote this psalm knew both the shadow and the fear, which is why the words have such clarity and strength. Anyone who doesn't fear the "shadow of death" has never seen it. I'm not talking about what may or may not happen afterward—I mean the thing itself, the process.

When my sister was dying the suffering was so intense, both for her and the people who loved her, that I actually became angry with God. I was shocked at my own feelings. I knew they were childish. "What a cliché," I remember saying to myself. The God I worship is not the bearded dude on the throne who rewards and punishes and has a big mysterious plan for everything. But who else was I going to blame for what we were going through?

After Wendy had gone upstairs to her bedroom during Christmas dinner, the rest of us spent the evening playing poker, occasionally checking on her as she slept. To everyone's surprise, she showed up the next morning for breakfast at her usual time, had her cup of coffee, and plowed through the stack of newspapers. Then she retreated to the spot where she was spending most of her days: the easy chair in her den, where both TV and telephone were nearby, and where her cat could easily hop into her lap.

She had a love-hate relationship with the phone. It would often ring while she was sleeping, and she always had to answer the same questions. "Well, I'm okay, I guess," she would say with a mix of patience and exasperation. "No, as long as I take my pills, there's not too much pain." Word was getting out among her friends, and she had a lot of good-byes to get through.

She especially loved to talk to her doctor buddies, because they all spoke the same language. "You know, I think I'm starting to have some encephalo-pathy," I once heard her say in an oddly cheerful tone, as if she were pleased to have made such an interesting diagnosis. I had to look that one up. Hepatic encephalopathy—something that people with cirrhosis of the liver often get. She had begun to notice what the Internet medical textbook called "intellectual impairment," as the poisons normally removed by the liver were building up in her bloodstream.

A few days after Christmas I drove her to the oncologist's office. At first she wasn't sure if she should go—not much point in it. But she changed her mind. She didn't tell me why, but after we arrived I realized that she had some good-byes to say there too. She chatted amiably with the nurses and secretaries, and I could see a kind of sad intensity in their eyes as they talked to her. I had expected some professional camaraderie—she was a both a "regular" and a member of the medical club. But these people really liked her.

I had learned quite a bit about my sister during my many visits and phone calls, but until the last few weeks of her life I didn't know how many friends she had. I did know that she was unhappy. Certainly someone slowly dying from cancer had every right to be unhappy. Going through a divorce in the middle of it didn't help either. But her pain came from deeper, less visible wounds, and I never understood them, largely because she didn't want to look at them herself.

She loved to read big Russian novels—Tolstoy, Dostoevsky—but she never fully grasped that she could learn something important about her *own* inner life from all the complex, flawed characters in these books. She had no interest in therapy or support groups, and her only solution to chronic insomnia was a high-powered sleeping pill at bedtime. Because she didn't know what made her hurt inside, she tended to act it out, and sometimes you had to have a thick skin to be around her. She could be short tempered and sharp tongued. If you put a plate in the wrong place when you were drying the dishes, you would usually hear about it.

But watching her talk to the people in the doctor's office that day, I remem-bered why I'd spent so much time in the previous six years trying to get to know her better. Those nurses weren't just colleagues—they were friends. There was a delightful simplicity to the way she talked with them. She knew about their kids, their travels, their husbands. I saw no hint of the usual class

distinctions between doctors and nurses. At one point I managed to take her oncologist aside and thank him for all he'd done for her. We talked for a couple minutes—he knew her whole story, of course—how painful her divorce had been, how much she cared about her kids, how fiercely she'd struggled to stay alive. I shook his hand, and as I turned to leave he said, "She's a beautiful person."

A few days later I left for home, and not long after that Mom and Dad left too. My parents, especially, didn't want to go. But we knew my brother and his wife, as well as Wendy's daughters, would look after her, and she had made her wishes clear. "I don't want everyone just sitting around and watching me die," was how she put it.

She insisted on saying good-bye to me, even though I had to take off for the airport at four a.m. on New Year's Day. Mom and Dad got up early too, and for several minutes the three of us stood there, not saying much, listening for any sign of life upstairs. "Go ahead and leave if you have to," said Mom. "We'll keep an eye out." But right on time we heard footsteps, and soon Wendy was making her way downstairs, carefully planting her feet on each step, hanging on to the railing with both hands. She had that grim look on her face, and I knew she wasn't in the mood for sentimentality. There was something that needed to be accomplished here, and by God we were going to get it done.

I started with Mom and Dad—gave each of them a hug—then I moved over and gave her one too: "Bye, Wendy"—"Bye, Brian." I tried to smile at her as I walked out the door. She gave me a little wave in return.

That was the last time I saw her, at least when there was still a "her" to be seen. A week or so later she finally conceded that she needed someone to be with her at all times. Not long after that, when her friend who was on duty went to the kitchen to make a cup of tea, Wendy fell and twisted her ankle because she imagined that someone was at the front door. Soon I was back in Phoenix. When I got to her house, she was sitting in her chair as usual, surrounded by a noisy group of family and friends. The place had an oddly festive atmosphere— but she could barely talk and showed no sign of recognizing me. After her friends left, we had to lift her into a wheelchair to get her back to the hospital bed that my brother had installed in her first-floor guest room.

I've forgotten a lot of what happened the next few days—mercifully. There were big stretches with nothing to do punctuated by moments of total panic. She had told us that she wanted to die in her house, and we were determined to give her this one last gift. But there were too many people dying in Phoenix that weekend, and we couldn't get a hospice nurse. Which meant we were on our own.

We were desperately afraid that she would hurt herself again. Often she was restless, mumbling to herself, and when she tried to get up someone had to gently press down on her shoulders. "It's okay, Wendy, you have to stay in bed," I told her when it was my turn, and she would settle down again, only to repeat the ritual a few minutes later.

At one point, without warning, she sat up, opened her eyes, looked at me, and said clearly, "Oh—I didn't know you were here."

"We're all here, Wendy," I replied. "Of course," she said. Then she sank back into the bed, and the pattern started up again. It was as though I'd been staring at the dying coals of a campfire, and suddenly a little flame had flickered up.

Occasionally there were other duties that no brother should ever have to endure, including helping her go to the bathroom and changing her diapers. As I said—I've never changed a baby's diaper. But I helped change my sister's. There wasn't enough left of her to know what was happening, but she knew something was wrong. "No, no, got to go!" she cried, over and over, as my brother and I struggled to lift her out of bed and onto the nearby potty. It was painful beyond words—to see this powerful, intelligent woman reduced to such utter desperation and helplessness.

Eventually we gave up on the potty—she was just too heavy—and decided to try the other option. Fortunately, my brother knew his way around a diaper. Mostly I just helped turn her when necessary. It was one of those times when you do what the moment requires, knowing full well that you'll have to pick up the pieces later.

The night before she died, we were finally able to get a hospice nurse. We still took turns being in the room, but we no longer had to worry about anything except trying to process what we were going through. Once I looked in when it was my father's turn to be with her. He was sitting quietly by the bed, stroking her hand, telling stories about her childhood in a soft, rhythmic voice.

The next day, in the early afternoon, her blood pressure was barely detectable. "There's nothing you can do now," the nurse told us. "Maybe you all need to take a break—get out of the house for a while." I think my brother and his wife went shopping. Mom couldn't bear the idea of leaving, so she stayed.

Dad and I drove out to one of our favorite places in the nearby desert. I found a shady spot, propped myself up against a rock, and began to write my sister's obituary. I put my notebook down after a few minutes and started to laugh. "I guess I'm not a pain virgin any more," I said to myself. I closed my eyes and thought about Wendy. Instead of the wreck her body had become, I suddenly saw an image of her as an innocent young girl in a brightly lit, green field, walking away from me. She was beyond pain, beyond sorrow, in

a beautiful place. She turned and waved good-bye, and I waved back. "Get on with your life," she seemed to be saying. "I'm okay."

I knew we needed to return to the house right away. We were just in time.

I'd always thought there would be an obvious moment of death. Too many movies, I guess. But for a few minutes no one was sure if she was gone. We all spoke in whispers and moved in slow motion, in and out of the room. Finally the hospice nurse told us what we had already figured out. Without pausing, without thinking, we gathered in the den, weeping and hugging. Two of Wendy's closest friends, a doctor and a nurse, washed her body and combed her hair. Within an hour, two people from the funeral home arrived, and she was gone. She had made all the arrangements herself a few weeks earlier, so all we had to do was make a phone call.

A couple days before she died, after one of those diaper-changing adventures, my brother and I sat down in Wendy's kitchen for a few minutes. We needed to calm ourselves down and try to take stock of our feelings. "You know, what we're doing," he said, "it's really not that bad, when you think of what happens to other people—in wars, hospitals, that sort of thing. Thousands of people go through this every day."

I couldn't disagree with him. Alzheimer's patients and their families endure what we did, but stretched out over years instead of weeks. Parents watch their little children waste away from cancer and other diseases. People do terrible things to each other with depressing regularity in the name of territory, religion, ideology.

Logically I knew that ours was a relatively civilized death. But logic works for math problems and statistics. It is terrible—terrible—to watch someone you love fall apart, piece by piece, a violent disintegration of body, mind, and spirit. At that moment, for me, it didn't matter what other people go through. The only thing in the universe that mattered was this person, right here—this person who was suffering, this person I cared about and was about to lose.

What a terrifying thing it is to love someone. I don't know how we do it. Maybe we don't. Or maybe we grasp tightly with one hand while holding the other hand behind our backs with fingers crossed. I know that's what I did. My sister's death taught this to me.

I've loved many people over the years. I've tried to ground my life in love. I even think of it as a form of worship. But I've also denied it. Why? In a word, fear. Fear of pain. Fear of going through what we went through with my sister. Fear of going through what she did, myself.

I was probably very young when it happened—a long-forgotten childhood revelation. One day I opened my eyes, saw that death was in the world, and felt

its presence in my own body. I don't know how other children deal with this experience, but for me the feeling was so terrifying, so shattering, that it threatened my emotional survival. So I built a wall around it, a big, thick wall with no doors or windows. Eventually I convinced myself that what I was afraid of wasn't there—and a tender place inside that had been growing withered and died. So I passed into adulthood, loving but not loving, living fully but secretly afraid of life.

I'm still afraid. But the fear is no longer hidden away. All it takes is a phone call from someone's sister, or looking a baby in the eyes, and I remember what I'm afraid of.

I've always tried to ground my life in love—yes—but that's the easy part. I'm not fully present on this earth unless I'm also anchored in the pain of love. Wendy's death, and the grief I continue to experience, have begun to heal me, to pull me back into life. The change has been quiet. Probably no one but my wife has noticed. But I feel things more intensely now—both pain and joy. The tender place is growing again.

Maybe something beautiful happens after we die, as I sensed a few hours before my sister's life ended. Or maybe the screen fades to black and we just stop living, as she firmly believed. Either way, the whole subject is a distraction. What Wendy and I would agree on is that life calls us to be in it. Life calls us to love.

I don't love an idea or a country. I don't even love people or nature. What I love is the big pine tree in front of our house, with its thick, uneven branches and rough-edged cones that litter our driveway every fall. Every day I spend loving that tree is one day closer to the day when there will be an empty place where the tree once stood. Sometimes I'm not sure if my heart is big enough to love that pine tree, in all its particulars, knowing the empty place will come. But isn't that the challenge we're given when we're born into this world? To deny that love would mean I am only a grim visitor, afraid to die and unable to live.

After a few hours of hockey, dancing, and baby holding, even the most dedicated erstwhile grandfather needs a break. So I put on my coat, excused myself, and started to walk. As I meandered through the neighborhood, random memories of what I'd seen since we got off the plane flitted in and out of my mind.

Eddy and Angel try to teach Ty how to pee in the toilet—he stands on the seat, aims, and shouts, "It's coming, it's coming!"

I'm talking to Angel while the newborn is still asleep, and I realize that she's only partly there. She's also in a state of quiet concentration, listening, ready to spring into action. "Was that the baby?" She runs upstairs to check on him. "Must have been the TV," she says, and we resume our conversation.

Helen's other son knocks on the door and strolls in. Ty yells, "Unker Drew!" and runs over to him. Drew picks up Ty, holds him high in the air, swoops him down to the floor, then raises him up again, both of them laughing and laughing.

I walked by house after house, most decked out with flashing lights, glowing plastic Santas, and the occasional reindeer. Probably there were similar things going on in every one of those houses. No doubt there was a lonely, sick, or dying person in some of those houses too. I had no way of knowing. What I did know was that the house I'd just left was a place where life was happening, where I was surrounded by love, swimming in it, and where I was adding a bit more to the mix.

When I walked in the door again, I interrupted yet another hockey game. Both Helen and Ty looked up, smiled, and said in unison, "Yaaaay—Bumpa's back!"

. . .

BHP: *Wendy Metzger*, 1999

... Hunger ...

HUNGER

I was born in the morning of the world,
So I know how morning looks,
 morning in the valley wanting,
 morning on a mountain wanting. . . .
Tell me about any strong beautiful wanting
 And there is your morning, my morning,
 everybody's morning.
—Carl Sandburg, from "Timesweep"

Thank God the piano was in the basement. When I pounded on the keys with my fists, the sound had to flow through the floorboards and walls before it reached the rest of the house. My parents must have heard the noise, but they never said anything about it. If they had asked me to stop, I would have ignored them, but I was grateful for their silence. At least they didn't get in the way.

Usually I worked at the piano when I was writing that piece, but sometimes I moved to the chair by the Ping-Pong table. I still had to pound, but pounding on the Ping-Pong table made such a racket that my ears started to ring. I didn't care. I was a teenager and music was pouring out of me. And what music!

All my life I'd been trained to be a good boy: considerate, sensitive, and in-offensive. I easily sacrificed my own needs for the needs of others. Anger and aggression were buried so deep that I'd almost forgotten they were ever there. But some instinct told me there was more going on inside, something that was foreign to my middle-class WASP upbringing, something I needed to find.

Then that music just blasted out of my brain. Repetitive, rhythmic, percussive, crude—it was everything I'd been taught I wasn't, but knew I was. My mind, my body were in the grip of something bigger than myself, yet I *was* myself, more than I'd ever been before.

It was happening! I was a wild man! I was an artist! Nothing could stop me from pounding out that piece, and I pounded and pounded and pounded some more—pounded loud, pounded soft, pounded fast, pounded slow, pounded out

. . .

BHP: *Trees, Stones, Water and Light #1*, 1979

227

counterpoint, pounded out rhythm, pounded until I'd pounded all the pounding right out of me.

When it was finally finished I smiled inside, took a deep breath, and got ready to do it all over again. But this time the door I'd opened slammed shut in my face. Instead of the lush creative oasis with the juices flowing, I was wandering in the desert, lost, like that famous cartoon with the man in rags crying, "Water, water!"—except it wasn't funny. I was dying inside, and I knew it.

The only thing I could do was keep on trying. So I tried. Again and again the same thing happened. I found that if I pushed myself—wrote down the notes day after day, even though there was nothing inside telling me what notes to write—kept at it, forced it, attacked it—then maybe a spasm or two of music would leak out. It was rape, not love, and my soul responded accordingly. Each time, when it was over, I had died a little more.

I was like a man with a blocked windpipe struggling for breath. Once in a while a trickle got through, just enough to remind me how desperate I was for oxygen. If only the healing of my soul had been as easy as a spiritual Heimlich maneuver! One big squeeze and the air flows freely. That was not how it happened for me.

I began to see that writing or not writing music wasn't the issue. My problem ran deep, right down to the core of who I was and how I'd been formed by the world I lived in as a child.

I needed to learn more about myself. I started to read Freud and Jung and anything else I could find about how the soul worked—mythology, psychology, theology. I began to dream—big, powerful dreams that said to me, "The game is afoot, young man." Surely I was onto something now! If music couldn't heal me, if Freud and Jung couldn't heal me, the dreams would heal me. Meanwhile I kept on writing down the notes day after day. Occasionally music happened, but less and less, and I still wrote the notes down, and each day I did took me further into the desert.

I was alive. But I wasn't alive. Finally, I broke.

Imagine a man whose leg had been shattered as a child. Shattered, and then he grows up, with the leg still broken. Barely able to walk, the broken leg hanging at a crazy angle, and the man just limping along, so accustomed to the limp that he thinks it's how everyone walks. Eventually he figures out that something is wrong, but how does he fix a part of himself that's hopelessly, permanently broken? He goes to the leg doctor, who says the only way to heal it is to break it. Once it's broken, it can't be used until it's ready to hold weight, and even then, he'll have to learn how to walk all over again.

So the leg was broken. It happened on a night in October of 1975. I was twenty-two years old. I remember only a feeling of terror, impossible to describe

to someone who hasn't felt it, but later, when I saw crazy broken people walking down the city streets, I wondered if I had tasted what they felt when their souls ruptured.

We all have a deep, hidden connection to something that feeds us and holds us together. When that invisible umbilical cord is severed, the ground opens up and all you can see beneath you is darkness, and there's no longer a wall to hold back the darkness, and it comes inside and there's nothing you can do about it except scream into the darkness.

My wife left me. That was not a huge surprise. She had gone to college for a year or so—after I broke—and not told her friends that she had a husband. Later I found out that she'd also been enjoying the company of a horny guitar player, and eventually that marriage died.

Looking back on it, I don't blame her for leaving. I wouldn't have wanted to live with me either. She took off for Germany, ostensibly to study philosophy, but really to escape from this self-absorbed self-proclaimed spiritual seeker who had dropped out of the Ivy League and was busy selling cameras at a department store for a couple bucks an hour, who had told his mother and father that he would rather be a homeless psychotic beggar than accept the gift of their money and their love, who spent his spare time either watching *Star Trek* reruns or wandering aimlessly through the woods and creeks and meadows of the Philadelphia park system—who appeared to have lost his way entirely, but was beginning to find his way though no one else could see it.

The dreams saved me. The dreams gave me hope. I wasn't any good at anything else, but I was a virtuoso dreamer. Two, three, four dreams a night—and I wrote them all down. I even numbered them. I admit it. I thought, someday all sorts of Jungian types would, you know, want to study them and write their Jungian treatises on them full of cryptic mythic references and lots of Jungian jargon. It was something to hang on to while the rest of my life was falling apart.

There was a logic to the dreams. They told me that something was going on besides the sad tale of a failed artist who was sinking into oblivion. The dreams were ancient and powerful, full of symbols and stories and wisdom beyond anything I had ever imagined. I was a sailboat and the dreams were the ocean, and all I could do was lower my sails, let go of the wheel, and trust that the currents would take me somewhere.

They did take me somewhere. It took a couple years of wandering in the dark, but finally the windows began to open and a little light came in.

I don't remember when it began, but it gradually took over my life, until I was feeling the urge, the necessity, to "meditate" at least two or three times a day. That was the only word I could think of to describe the experience—

meditation—but there were none of those mantras and rituals I'd read about. Mostly it just happened when it wanted to happen, and if I didn't take the time to let it happen I felt tense and miserable inside, like a dammed-up creek or a bud that needed to unfurl.

This urge—I would even call it pressure—would build up inside, and I had to find a quiet place where I could close my eyes and sit, undisturbed, for at least a half hour, sometimes longer. After a few minutes I began to feel energy flowing into my body—as if a beam of light was focused on the inside of my skull. I was a vessel and the light poured in, burning me, cleansing me, scouring me out and filling me up.

Once in a while I felt the urge at lunchtime in the department store cafeteria, which earned me some suspicious glances from the other employees. I'm sure they thought I was stoned, but I wasn't. There was no way to convince them otherwise anyway.

I still have no idea what it was or where it came from or why it happened to me. I just know that it was beautiful, and it pointed the way out of my dark night of the soul. Day after day it happened, for many years—the most ecstatic experience I've ever had or ever hope to have. Except for that moment in the woods when I actually saw on the outside what before I'd only felt on the inside.

It was late fall or early winter—November or December, I think—1978. Three years into this terrible journey, and still no end in sight. I was alone, with barely enough to eat and barely paying my rent, living almost entirely in a lonely dream-world, convinced that something important was happening to me, and probably in some borderline condition between sanity and madness.

I didn't have a car, so as usual I took the commuter train from my apartment in West Philadelphia to Germantown, where I could easily walk down to the forest, a forest almost as wild as any Montana wilderness. I was sitting on a hill high above a creek, my back against a giant maple tree. The weather was warm, and I could sit as long as I wanted. So I sat, quietly, and waited for it to begin. It began. I felt the light enter my body—but this time it was different. My eyes were closed, and my head began to tilt upward as great waves of energy flowed into me.

Even though I knew I was sitting, somehow I was also standing up. I opened my eyes and looked through the bare trees to the glowing late afternoon sky across the valley. Suddenly my body crumpled, fell away, rolled down the hill, disappeared—but I was still standing there, staring at the light in the sky! I existed, separate from my body! Then I saw, as if for the first time, the trees. They were not just trees, they were entities, souls, like me. Their branches were straining, straining toward the light, and the light was beautiful beyond words.

Beyond words. I stood there for what seemed like an eternity, drinking in the beauty. The beauty of the light.

The trees, straining, reaching—they were *hungry*—hungry for the light.

What was the sun, really? Was it just a big ball of gas in the sky, powering the earth's systems through hydrogen fusion? It was that, and something else. What was a tree, really? Was it just a photosynthesis machine that ingested light so it could grow? It was that, and something else. At that moment I was a tree, and I was hungry too. The light poured into me, and I opened all the doors of my soul and let it in, and the whole universe was nothing but light and the hunger for the light. All I could do was give myself to the hunger.

It would be easy to call this the bizarre illusion of a half-crazy misfit. I wondered about that myself, even when it was happening. But I knew that I was seeing the universe as it really is. I still believe that, even though the experience that day is now a distant memory. The starting point, the ending point, the primordial condition of the universe is hunger, not a hunger that gnaws at the gut because it's so empty, but hunger that in the very act of being hungry is filled, yet is never full.

There was no longer any question about whether or not beauty exists, or whether or not God exists, or any of those useless problems that have occupied the minds of theologians and philosophers for millennia. There's no need to think about it when you're in the middle of it. When you *are* it.

I was both inside myself and outside—but there was no longer any inside or any outside. There was no separation any more. I was joined with the universe. But I was still me, standing there on the hill, arms spread wide, seeing the light.

I wondered if what I'd seen was "God"—but that word was stupid and empty because there was no name for this thing, no way to wrap it up neatly, put it in a box, and give it to someone else. I've spent my whole adult life trying to box up the experience and give it to others, through music, pictures, words. Nothing I've done comes close to what I felt that day. It's never easy to communicate what goes on inside our skulls, and the best anyone can do will always be a glimpse, an approximation. I know that. But I keep trying. I can't help it. It's what I need to do with my life.

I don't necessarily expect anyone else to understand or care about my unorthodox spiritual life. I'm not trying to change anybody's mind, save anybody's soul. I only know what happened to me, and how it saved me. Until now I've told no one about this experience except Helen, who deserved to know how crazy this guy was that she was marrying. Why am I talking about it now? Because carrying around the memory of that day has been a burden, and I need to unburden myself. Because I'm fifty-four years old and I have Parkinson's

disease, and I can't pretend to know how much longer my brain will work well enough to tell this story properly.

Why do babies learn to walk? Because they're hungry.

Why do children learn to talk? Because they're hungry.

Why do teenagers bounce from one thing to another, flounder and fall and get up again? Because they want to grow.

Why do young people hook up and shack up and break up and hook up again? Because they want to find love and won't stop until they get it.

Why do we build buildings, have babies, start businesses, make lives? Why do we dive in instead of standing on the shore? Because we're hungry for life and won't stop until we've grabbed our piece of it.

Why do artists put words on paper, put paint on canvas, put hands in clay? Why do they dream of creating something where before there was nothing? Because they want to join the choir, add their voices to the song.

Why does a sunflower follow the sun across the sky, tilting its head one way in the morning, the other way in the afternoon? Because it's hungry for the light.

Why did I pound on the Ping-Pong table, put notes on paper day after day even though it killed my soul, drop out of school, push away friends and family, endure brokenness and loneliness and humiliation, wander in the dark for years until I finally found my way out? Why did I do all these things? Because I had something inside me that wouldn't leave me alone, something I needed to find and needed to be. Because I was hungry.

Sometimes a question becomes a foolish question because we're desperate for an answer, but the question is so big and scary that we're afraid to answer it. Or maybe the question is so big that there is no answer. What would you say if I asked you, "Why are we here? What is the meaning of life?" You would probably laugh out loud. I would too if you asked me those questions, because even asking them seriously is silly and pretentious.

But I know the answer to the big question. I really do. The answer is hunger. Hunger is the center, the core, what it's all about, where you need to be. Nothing good happens unless you're hungry for it first.

Life can be a fog. Hard to see where you're going in a fog. Hard to see your own hand in front of you, your own footsteps behind you. Hunger breaks through the fog. Hunger brings clarity. Hunger opens your eyes.

Hunger. I want this. There must be an "I" for hunger to be born. Hunger tells you who you are, where you must go, what you have to do.

You can have more talent and brains and nerve than anybody else, but without hunger you'll be going in the wrong direction after a few steps.

But how do you find hunger? How does it find you? Sometimes hunger and suffering are close friends, and hunger and grief are sister and brother.

A doctor friend of mine who was diagnosed with MS quit his job and became a painter. Now he's in a wheelchair with only one good arm, but he's still painting.

Another friend was in a miserable marriage, but she didn't have the strength to break it up and make a life for herself. Her brother-in-law died, and it affected her so deeply that she finally ended the marriage and went to art school.

Another friend was doing very well managing a business. Then his brother died of cancer, and he went back to school and got his Ph.D. so he could do cancer research.

A man who wanted to be a novelist, who dabbled at writing, instead became a textbook editor. During World War II he almost died in an airplane as it landed at night on an island in the South Pacific. Afterward he paced around the airstrip, thinking about his life and what he wanted to do with it. That's how James A. Michener became a writer.

The stories aren't always so dramatic. Sometimes hunger is more like a seed that falls to the ground in a garden. The seed sprouts and starts to grow. The gardener thinks it's a weed and pulls it out, but it comes right back. Each time the gardener pulls it out, it only gets bigger, until he finally gives up and lets it grow, and it crowds out the rest of the plants and turns into a big apple tree. Then the tree blooms and produces lots of tasty apples.

Hunger, real hunger, is always fruitful. It turns a meaningless life into a fertile life.

And hunger, real hunger, only happens when you stop fooling around and get serious. That's why hunger and death walk hand in hand, always together.

It began with such infinite subtlety—like a breeze on a hot August afternoon that stirs a few leaves, then dies away. Except once this breeze starts, it never stops blowing, and just gets stronger and stronger until it finally becomes a Category Five hurricane that flattens everything in its path.

I injured my right arm many years ago pounding nails in my basement, and I taught myself to write with my left arm because the other one needed a rest. The left arm began to get more tired than usual after writing for a while. By then the right one was fine, so I switched back and never gave it a thought.

A few months later the limp kicked in—again, with such subtlety that at first I didn't notice. When I did, I assumed it was because nothing worked as well as

it used to except my brain, which was humming along like a perfectly tuned Porsche on the autobahn. Or so I thought.

The limp worsened, until people I hadn't seen in a while started to notice. A friend said, "Hey, Bri, what's wrong with you, MS or something?" We both laughed. Helen's younger son, an ER doc, had a feeling about it and suggested a neurological workup, but I scoffed at the idea. "Must be my flat feet," I told him. He just shrugged his shoulders.

Finally Helen convinced me to see my internist. After a few inconclusive tests he sent me to a neurologist. She had a repertoire of difficult tasks for me such as touching my nose and wiggling my ankle, and she even tickled the bottom of my feet, which seemed a bit flirtatious.

My biggest concern was that she would scold me for wasting her time and kick me out the door. Instead, she sat down across from me, looked me in the eyes, and said, "Now comes the hard part. I think you have Parkinson's disease."

I was fifty-three years old and I'd never had a serious illness, never broken a bone, never spent a day in the hospital. Most of my relatives had lived into their eighties and nineties, including my parents, who loved to brag about how healthy they were. "Must be all those good genes," was how Mom put it. "I only wear jeans on weekends" was my typical response.

I walked out of the neurologist's office with a twenty-page handout in one hand and a box of pills in the other. The disease can be hard to diagnose, which is why the doctor said, "I think." But if the drug works, there's no doubt. You have a dopamine deficiency in your brain. You have Parkinson's.

I made the mistake of reading all the fine print on the folded-up insert in the box, and the list of possible side effects was so alarming that I was sure I would immediately die. It was the only time in my life that I'd been desperate for a drug *not* to work. But it did. Helen noticed the change right away. "Brian, I think the limp's not as bad."

That was when I first saw the look. Not exactly fear. But more than concern, even more than anxiety. It was a profound uneasiness, a quiet apprehension in her eyes when she glanced in my direction.

I saw a lot of variations on that look when I started to share the news. I learned how people react when they find out that someone they know has a dread disease. There's the initial flash of shock and horror that flickers across the physiognomy, then the quick recovery and, usually, a goodly dose of concern. In that moment I become someone new in their eyes—I become a sick person instead of a healthy person. I hated this at first, but when I began to adjust to the idea myself, I didn't mind the look anymore, because I knew it meant that this person cared about me.

My wife cares more than anyone, which is why the look was so painful when I saw it for the first time. Not only had my own world been busted up, hers had too. Instead of being married to the Rock of Gibraltar, she was suddenly married to an island that's sinking into the sea, and no one can tell us how soon it's going under.

Everyone who gets a scary disease has a story, and mine is typical. I've read dozens of them now about Parkinson's, and they follow a familiar pattern: this is how I found out, this is how I felt about it, this is how I changed.

So how did I feel about it? Terrified. Parkinson's is terrifying because of all the nasty things it does to mind and body, but the scariest thing about it is, you don't know how scared you should be, at least in the beginning. Some people's lives are destroyed in a few years, others go for decades with only a mild tremor. Most people can count on several good years when the symptoms are mild and the drugs still work—doctors call this the "honeymoon period"—but after that life gets more and more difficult.

One guy I met who'd had the disease for seven years was taking thirty pills a day. He had a hard time walking and talking, and he wasn't doing much traveling any more. Another guy had brain surgery after eight years. Yes, surgery—they poke some wires into your skull and zap the part of your brain that's not working right. For some reason it calms things down, for a while at least.

I might be one of the lucky ones who sail through the rest of my life with barely a ripple on the pond. Or I might not. Even the best experts can't tell me what's going to happen, which is why the disease was a meteor that smashed into my comfortable suburban home and turned it into a smoking pile of rubble.

I'm a planner. I store things up. I invest my energy now so I can cash in later. This had always worked well for me. It was no longer a good idea.

Like most people who get this kind of news, the disease forced me to redefine myself. I changed. Not dramatically, as it turned out. I already was living the life I wanted to live. But Parkinson's took everything I was and focused it, tightened it up. Parkinson's was like a chemical agent that was poured into a beaker, reducing the liquid inside to its essential elements. Parkinson's made me desperate, and desperation made me hungry.

My own story is a case study, not an archetype, but it's so similar to so many other stories that there has to be something deeper going on. Why do pain and uncertainty tend to concentrate the mind? Why does death force us to make the hard choices that mean leaving behind something comfortable and starting down an unfamiliar path?

It could go the other way, and I suppose it does, though you don't hear those stories as much. Death comes in the door and, as the saying goes, you live like

there's no tomorrow, dipping your toes in whatever pleasures you've missed. Most likely you'll burn yourself out (if you survive), and you'll still end up asking those hard questions and making those hard choices. William Blake was talking about this particular path when he said, "The road of excess leads to the palace of wisdom."

Or death comes knocking, and you close the door, bolt it shut, and retreat into the shadows. A friend of mine who's seen a lot of death (he's a priest) tells me that some people just get bitter and angry when they're dying, and sometimes those clichés about seeing the light on your deathbed with family and friends gathered around are just that—clichés.

But it's the other reaction that interests me—the one that strips away illusion, causes us to let go of trivial things, and focuses our attention on what matters. If you don't know what matters, your mind gets focused on finding out. Maybe this happens because, after all, it's only logical: you make the simple calculation that there's not much time left, so why not spend it wisely? But there's more to it than that.

When you've found your true hunger, all the pieces suddenly fit together. What you're doing is who you are.

When you've found your true hunger, and are living it out every day, life has a deep sense of resonance. You smile at the universe and it smiles back. This is the smile at the heart of things. Seek and ye shall find.

Saints are obsessives. They are focused in their neuroses and dedicated in their instincts. In some ways, they are like other people, only hungrier. They tear apart the world with raving teeth to feed their own spiritual longings. Rare, very rare, is the meek little saint who persists in the hardest task of all: being moderate and kind, living low but not obscenely low. Saints have no balance. There is an egoism to their sacrifice.
—Louise Erdrich, from *Tales of Burning Love*

I've been dancing around something since the first word of this book, but now I need to declare myself. Wind up and let it fly.

People throw around the word *God*. I don't know what they mean. What I experience, I've never found a name for it, though God knows I've tried. This book, these essays, are my attempt to talk about what can't be talked about, to put meat on the dry bones that my Sunday school teachers called religion and God.

What I want to say is, forget the words, forget religion, forget God even, and focus on hunger. Find out what makes you hungry. If you're not sure, then start eating. Chances are you'll discover something that tastes good. When you do,

listen to it. Follow it, even if following it leads you to places in your soul that you didn't know about and wish you'd never seen. There's something good on the other side, and true hunger will take you there.

There are hungers for power, for fame, for immortality. There are hungers that say everyone must be like me, or I must never grow old, or I must *know* more, *have* more, *be* more than anyone else. There are compulsive hungers, possessive hungers, narcissistic hungers, evil hungers. Hitler and Stalin were very hungry men.

How do you tell the difference between false hunger and true hunger?

Whatever is nourishing, whatever is honest, whatever is beautiful, whatever has depth—that's what will make you hungry, and it will be hunger you can trust, hunger that will water the apple tree and then the fruit will grow.

Artists can help with this search, because artists are some of the hungriest people around, and their work is the incarnation of their hunger. But all kinds of people are hungry. Teachers, scientists, CEOs, janitors, politicians, priests, housewives—anybody who's trying to lead an honest life and give something real to the world—that person is hungry. And that person has found God. That person is a saint.

I don't care about the trappings of religion. I don't care what's normal and proper. Usually what's normal and proper is the furthest thing from the God I worship. And whoever or whatever God is, I don't think that entity, if it even is an entity, cares the slightest bit what name we give it or whether we're Catholics or Baptists or Hindus or Muslims or Jews or even atheists. God wants us to be hungry.

There's a story in the Bible about a well-fed religious guy who congratulates himself on how he's played the game the way it's supposed to be played, a guy who gives to the right causes, wears the right clothes, knows the right people, and talks the right way—not like that lowly loser dude over there whom nobody likes, who's kind of beat-up looking and sad, who doesn't play the game and make the scene. The loser dude just stands there silently, staring at the ground, suffering, alone. Finally he looks up, opens his arms, beats his breast, and says, "I've got nothing left and nowhere to go. Lord, help me!" No other words—just, "Help me!"

This man is hungry. Stripped of pretension and delusion, naked before the universe, he knows nothing but his own humility and emptiness, his need to be filled.

You're more likely to find hunger among the misfits and rejects than the popular and the satisfied. Like the prodigal son who takes his father's money and leaves home, some people need to spend all they have and eat cornhusks and dirt before they finally turn their lives around. And when they do, don't

expect their hunger to be pretty. Don't expect a hungry person to also be a noble person or, sadly, even a moral person. All you have to do is read about the lives of artists to learn that sometimes the hungriest people are so obsessed with their hunger that they forget about everything else, and they hurt people, often the people who care about them the most. They hurt themselves too, and sometimes kill themselves, both slowly and quickly.

I do not excuse the terrible excesses of hungry people, but I can understand and (usually) forgive, because hungry people are the people who have the most to give, and in their giving they give birth to the world.

There are many paths to hunger, but they all begin and end with the same question. Who am I, really? What do I want to rip out of the living flesh of life like a wolf with an empty stomach and gorge myself on? And what do I want to give back to life when I'm done eating? These two things go together—the taking and the giving—and until I learn what I want to take and what I have to give, I'm living someone else's life, not my own. I'm a seed that doesn't know if it likes sandy soil or rich brown loam, or if it's a spruce tree or a sunflower.

As I was driving home from work the other day, I looked out my windshield and saw the usual sights: the street signs and housing developments, the occasional gas station and strip mall. Suddenly there it was again, only a glimpse, but the real thing—what I've been remembering and writing about that happened in the woods so many years ago. The bare trees were reaching, grasping for the sky, and the whole universe was yearning, striving, wanting, needing. It wasn't painful or empty; it was beautiful.

That yearning—I first felt it as a boy when I picked up the phone to call the viola player and began to learn that art and religion are two trees growing from the same root system. I felt it when I read Whitman in the bus station—when I saw the light in the clouds and heard the sound in the trees—when I lost my way, found my way back, and started to do the work I was given to do. Music—photography—writing—job—marriage—friendships—every meaningful thing I've done comes from this yearning.

God is love. Fine. We know that. But God is also nourishment, honesty, beauty, depth. And hunger, especially hunger.

Does the G-word bother you? Get over it. Doesn't matter what name you use. What matters is what's real for you, what's serious, what you can't live without, what gets you going in the morning and keeps you up all night. When you find it, you'll be hungry for more.

So find your hunger, listen to what it tells you, follow it wherever it leads. Then you'll be born into this world, and even though there's plenty of terror and horror and pain, the universe is still beautiful, and being alive is a miracle,

and it's not just a smile at the heart of things, it's a big fat grin that says YES! YES! I'm part of it all, present and accounted for, one more insignificant lump of conscious matter, living, playing, working, growing, loving, hurting, dying. . . . And when someone says, Hi there, how're you doing, you say, Well, I'm happy to be here, friend. Happy and hungry.

POSTLUDE

I began this book lamenting the double life I've been leading—curator and artist. I end it with the two halves of my life having declared a truce, sometimes eying each other suspiciously over the fence with guns drawn, but more often meeting halfway across the demilitarized zone, where they lay down their weapons and swap stories about the bad old days of tribulation and combat.

It's been a long journey from outright warfare to, if not cooperation, then perhaps tolerance and respect, with a few signs of acceptance, and even occasional moments of peace. How did it happen? Not sure. The best explanation for the relative calm I feel nowadays is that I worked so damned hard at being an artist in previous years and I've begun to feel that much of what I have to say as a photographer has been said. Also, like our dog Sparky who terrorized us as a puppy, maybe I outgrew my anger and learned to play well with the other dogs.

As I outgrew my anger, the museum grew out of its own puppy stage; instead of only one curator there are now four, along with a staff of educators, two registrars, a marketing department, a facility manager, and even a preparator (the fancy museum word for the guy who installs exhibitions). I still have thirty or forty exhibit projects in the pipeline at any given moment, but I don't have to spackle and paint the walls anymore, and I've managed to carve out more time for the fun stuff: research, writing, publishing.

Actually there *was* a moment when I stopped all that frantic bucking and jerking, and instead of trying to throw that cowpoke to the ground and trample him to death, I settled down and actually learned to enjoy the idea that we have to work together to get things done. (You'll have to forgive the convoluted rodeo metaphor—I grew up in the West, and was fed a steady after-school diet of Roy Rogers and Gene Autry movies by the local TV stations.)

. . .

Salvador Dalí (1904–1989), *The Basket of Bread,* 1926. Oil on panel, 12½ × 12½ inches. © Salvador Dalí. Fundación Gala-Salvador Dalí/Artists Rights Society (ARS), New York. Collection of the Salvador Dalí Museum, St. Petersburg, Florida, 2006

Those of us who work on the museum assembly line like to describe our place of employment as the "exhibit factory." My epiphany occurred when I began to think about art as a form of spiritual nourishment, very much related to the "daily bread" that's enacted in the communion ritual every Sunday—the idea that led to the first essay in this book.

What is an exhibit, really? It's a ritualized form of nourishment in which an organized grouping of paintings, sculptures, photographs, etc.—often referred to, interestingly enough, as a *body* of work—is offered to the public in the hope that its aroma will be so tempting that it simply must be tried.

I don't work in an exhibit factory—I work in a nourishment factory! Okay, it's not exactly a factory—we don't actually make the bread—it's more like a retail outlet, a distributor. A restaurant! We take bread made by other people and package it, spice it up with text panels and clever design, and do our best to get a few people in the door who might want to have a bite. My job as a curator is to decide what the menu will be and present the various dishes in the most beautiful and elegant manner possible, so the food will be more likely to taste good going down and leave a nice feeling inside as it's being digested.

How incredibly lucky I am to hang my hat in a place whose very existence is an incarnation of the idea that art is a form of nourishment, nourishment that feeds the soul just as daily bread feeds the soul. Every e-mail, every phone call, every meeting, every annual budget—all are done in service of this nourishment ritual. My role is not that different from one of the acolytes who carries the bread and wine to the altar, or maybe the organist who understands the underlying rhythms of the ceremony and picks the right music to consecrate the moment of communion.

And now my job has even led to the creation of this object you're holding in your hands, which is certainly an unorthodox museum publication. There's nothing scholarly about this book, no research and no footnotes, no essays about the right way to run a museum or the right way to train museum professionals. It's mostly a bunch of stories that add up to one story—mine—the story of an artist who became a curator, who kept on being an artist, who finally realized that the two professions kneel at the same altar.

I've done my best to make it a nourishing story, though I know that many people will find it difficult to swallow. Plenty of artists and museum folks will be horrified at the idea that what they're doing is even remotely religious, and plenty of religious folks will be equally horrified at the idea that religion and art have anything in common. The artists only have to utter the words "Jerry Falwell and Pat Robertson," and the religious types only have to utter the words "Robert Mapplethorpe and Andres Serrano," and that's the end of the conversation.

All I can say to both camps is, keep an open mind and you might learn something from each other. I sure did, once I got past my own prejudices, which were considerable.

One more thing about these stories: as I said in the Prelude, many of them were written over a ten-year period, and each one was born out of the feelings of that moment, a moment that quickly passed. In one story, for example, Helen has surgery and we confront the possibility of cancer, but we dodge that particular bullet. In another story, I have a brief brush with mortality through hernia surgery, but after some difficulties, I recover and life goes on.

These days, Helen and I are no longer dodging bullets—they've hit home. Instead of dealing with the emotional consequences of hernia surgery, I'm coping with Parkinson's disease. Helen may not have cancer, but she has an aortic aneurysm that could rupture at any moment, yet is not quite big enough to warrant the terrifying surgery that the doctors say is inevitable. My parents finally moved out of their beloved house that I wrote about in "Saying Good-bye," and three weeks later my father kissed my mother good night, fell asleep, and never woke up.

I could go on, but I'm sure you get the point. The words in this book are as true as I can make them, but whatever truth they contain grew out of the particulars of the moment when they were written. So I kept the particulars unchanged, even if it makes the sequence of events seem disorganized in a few places. If the stories are organized at all, it's more on the order of a gradual movement from innocence to experience rather than an obvious chronology.

Perhaps in the future I'll explore those bullets not dodged and try to decide if, in not dodging them, I've been unlucky or lucky. That's another book. The life stories in *this* book are about moments that have already come and gone. I wrote these stories mainly to help myself be fully present in those moments, so I'd be better able to remember, and eventually let go.

Letting go. In a way, that's what this whole enterprise is about for me: living fully, remembering, then letting go. Maybe all these words are more about dying than living, though if I've learned anything, it's that you can't have one without the other. The story continues.

ACKNOWLEDGMENTS

One definition of *acknowledgment* (admittedly an obscure one) is "the act of admitting paternity." In the case of this book, it's easy to acknowledge the paternity of my "baby," not only because I had so much assistance with the birthing process but because so many good folks have helped change the diapers. So in the spirit of the more customary definition—"an act of appreciation"—I gratefully acknowledge the many people who helped me recognize the telltale aroma and clean things up. Eight people read the five core essays and shared their thoughts with me, and their generosity made me a much better father: Howard Brunner, Elisabeth Gentieu, Bill Hollis, Steve Jaffe, Jo Katsiff, Alex McCurdy, Helen Mirkil, and Michael Rose. This group includes seven teachers, six writers, five artists, three gardeners, two doctors, a psychoanalyst, and a priest. I'm lucky to call all eight of them friends.

Paula Brisco has edited all but one of my books, and each time the experience is more enjoyable. She is a serious, disciplined thinker about words. She is gentle but has strong convictions. She is able to leap lame metaphors at a single bound, stop a powerful cliché, and proofread faster than a speeding bullet (how did she let me get away with that silly Superman riff?). It's hard to believe I've only seen her twice in twelve years, but that's the beauty of e-mail and the telephone. Thanks, Paula.

Dennis Lee, a Canadian poet and essayist whom I met only once, for some reason decided I was worth the trouble and, through an incredible series of letters, tried to make an honest writer out of me. Thank you, Dennis.

Jeff Wincapaw is one of those rare designers who has good ideas but also listens. After four books, you'd think we'd be sick of each other, but instead we've become pals. Hats off to Jeff and the other folks at Marquand Books, including Ed Marquand, Sara Billups, Jeremy Linden, Marissa Meyer, Marie Weiler, and freelance proofreader Pat Scott.

Bruce Katsiff, the rest of the staff at the Michener Art Museum, and especially Bill and Andrea—thank you for caring about me and believing I could do things that I'd never done before.

If they were still around they might not admit their paternity, but I need to acknowledge four spiritual fathers who helped me connect the personal and private with the collective and the communal: Paul Tillich, Henri Nouwen, Thomas Merton, and Saint John of the Cross. Their ideas flow through these pages.

SOURCES

A docent once asked me what style of footnote I recommended and what my feelings were about "ibid." When I told her I wasn't even aware that there *were* different styles and that I just did what my editor told me to do with the "ibid." thing, she gave me a look that was somewhere between disappointment and pain. Apparently one of her teachers had criticized her footnotes, and she was looking to me for some much-needed validation. I was a curator, after all, and if curators know about anything, it's got to be footnotes.

I suppose footnotes are a necessary evil in scholarly texts. No one ever reads them—I'm convinced of that—but still, they send a message. "This is not just *me* talking," the footnote says. "Someone else said it even better than I can, and if you flip to the end of the essay and find the right number, I'll tell you where you can locate those very same words yourself." In other words, the writer didn't just make this stuff up—it's, you know, the real deal, bona fide, legit.

I decided early on that there would be no footnotes in this book. The main reason was because my entire goal as a writer was to make it just *me* talking. I didn't notice until I'd finished the thing that here and there I mention some writer or other, or an art movement, or maybe a painter or two, and that if I were reading this book, I might be curious to learn more about this painter or that movement.

For those curious folks, here, then, is an alphabetized list of some of the sources that I've mentioned in these essays:

Charles Baudelaire: essays on photography in *Photography: Essays and Images,* Beaumont Newhall, editor (Museum of Modern Art, 1980); *Classic Essays on Photography,* Alan Trachtenberg, editor (Leete's Island Books, 1980)

William Blake: *The Marriage of Heaven and Hell,* from the Laurel Poetry Series, *Blake,* Ruthven Todd, editor (Dell, 1960)

Chuang Tzu: *Basic Writings,* translated by Burton Watson (Columbia University Press, 1996)

e. e. cummings: *Eimi* (Covici, Friede, 1933)

John Donne: "Meditation XVII" (No man is an island, entire of itself. . . .), in *Devotions Upon Emergent Occasions and Death's Duel* (Vintage, 1999)

Georges Duby: *The Age of the Cathedrals: Art and Society, 980–1420,* translated by
 Eleanor Levieux and Barbara Thompson (The University of Chicago Press, 1981)
Ralph Waldo Emerson: essays including "Nature," "Experience," "Circles," and "The
 Over-Soul," in *Essays and Poems by Ralph Waldo Emerson,* Peter Norberg, editor
 (Barnes & Noble Classics Series, 2004)
Louise Erdrich: *The Painted Drum* (HarperCollins, 2005)
Frederick Evans: an Evans quote from *Camera Work* (No. 4), reprinted in *Frederick H.
 Evans* by Beaumont Newhall (Aperture, 1973); the 1903 essay "Evans—An Apprecia-
 tion" by Bernard Shaw, in *Bernard Shaw on Photography,* Bill Jay and Margaret
 Moore, editors (Gibbs Smith, 1989)
Daniel Garber: Catalogue Raisonné, by Lance Humphries (Hollis Taggart Galleries,
 2006)
Federico García Lorca: *Selected Poems,* translated by J. L. Gili (New Directions, 1955)
Emmet Gowin: *Emmet Gowin: Photographs,* by Martha Chahroudi (exhibition cata-
 logue, Philadelphia Museum of Art, 1990)
The Holy Bible, King James Version: Genesis, Jonah, Psalms, Matthew, I Corinthians,
 I John; specific references include Psalm 1, the Sermon on the Mount (Matthew 5–7),
 Blind Bartimaeus (Luke 18), the Pharisee and the Tax Collector (Luke 18), the Prodi-
 gal Son (Luke 15)
Hudson River school: *American Paradise: The World of the Hudson River School,*
 introduction by John K. Howat (Metropolitan Museum of Art, 1987)
I Ching, or Book of Changes, translated by Richard Wilhelm, introduction by C. G. Jung
 (Penguin, 1989)
George Inness, by Michael Quick and Nicolai Cikovsky Jr. (Los Angeles County
 Museum of Art, 1985)
Luminism: *American Light: The Luminist Movement, 1850–1875; Paintings, Drawings,
 Photographs,* John Wilmerding and Lisa Fellows Andrus, editors (Princeton
 University Press, 1989)
The Matrix, written and directed by Andy Wachowski and Larry Wachowski (1999)
Rainer Maria Rilke: *Letters to a Young Poet* (Dover, 2002); "Archaic Torso of Apollo,"
 in *Duino Elegies and Other Selected Poems* (AuthorHouse, 2008)
David Rosenberg: *A Poet's Bible* (Hyperion, 1991)
Carl Sandburg: poems including "Timesweep" and "Fog Numbers," in *Honey and
 Salt* (Harcourt Brace, 1967)
Otto von Simson: *The Gothic Cathedral: Origins of Gothic Architecture and the
 Medieval Concept of Order* (Princeton University Press, 1974)
Susan Sontag: *On Photography* (Picador, 2001)
Paul Tillich: the sermon "Loneliness and Solitude," in *The Eternal Now* (Scribner,
 1963)
Vincent van Gogh: letter to Theo van Gogh written April 3, 1878 in Amsterdam.
 Translated by Robert Harrison, edited by Robert Harrison, in *Van Gogh's Letters,*
 http://webexhibits.org/vangogh/letter/6/121.htm

Doc Watson: his song "Keep on the Sunny Side" was one of the famous traditional
songs included in the 2000 Coen brothers movie *O Brother, Where Art Thou?*

Walt Whitman: poems including "Out of the Cradle Endlessly Rocking," "I Sing the
Body Electric," and "Song of Myself," in *Leaves of Grass* (1855)

William Butler Yeats: especially the essay "Rosa Alchemica," in *Mythologies* (Scribner,
1998); *Yeats: The Man and the Masks,* by Richard Ellman (Norton, 2000)

The need is for nothing less than the infinite and the miraculous, and a man does well to be satisfied with nothing less, and not to feel easy until he has gained it. . . . So let us go forward quietly, each on his own path, forever making for the light.

—Vincent van Gogh, from a letter to Theo van Gogh, April 3, 1878